Sonia

Caitlin Press Inc.
8100 Alderwood Road,
Halfmoon Bay, BC V0N 1Y1
www.caitlin-press.com

Text and cover design by Vici Johnstone
Printed in Canada

The correspondence of A.Y. Jackson and Naomi Jackson Groves with Sonia Cornwall is copyright Carleton University Art Gallery, Ottawa.

All efforts have been made by the author and publisher to acquire permission for quoted material. In some instances the original source could not be found or contacted.

Caitlin Press Inc. acknowledges financial support from the Government of Canada and the Canada Council for the Arts, and from the Province of British Columbia through the British Columbia Arts Council and the Book Publisher's Tax Credit.

Library and Archives Canada Cataloguing in Publication

Salloum, Sheryl, 1950-, author
 Sonia : the life of bohemian, rancher and artist Sonia Cornwall, 1919-2006 / Sheryl Salloum.

ISBN 978-1-927575-90-1 (paperback)

 1. Cornwall, Sonia, 1919-2006. 2. Painters—British Columbia—Biography. 3. Ranchers—British Columbia—Biography. I. Title.

ND249.C644S24 2015 759.11 C2015-903566-X

Sonia

The Life of Bohemian, Rancher
and Artist Sonia Cornwall,
1919–2006

Sheryl Salloum

CAITLIN PRESS

With love for Alyssa and Kirk

Contents

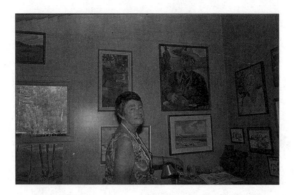

Sonia Cornwall in her Jones Lake studio, 1981.
Courtesy of the Museum of the Cariboo Chilcotin.

Introduction

On March 16, 2006, winter still had the Cariboo in its chilling grip. At eighty-six, Sonia Cornwall had just returned from a trip to Mexico. That vacation had given her a reprieve from frigid temperatures, the opportunity to learn more about another culture and the challenge of painting new vistas. After three weeks away, Sonia was anxious to share her new work and experiences with family and friends. To that end, Carsten Sorensen, a retired goldsmith, was driving from his Deka Lake home to visit Sonia at Jones Lake Ranch (approximately 22.5 kilometres south of Williams Lake). Like many who knew Sonia, Sorensen was much younger but rejoiced in spending time with the dynamic octogenarian. He drove to Williams Lake once or twice a month and always stopped to visit. Sorensen felt that even upon first meeting, "She was a person you felt like you had known forever." Sonia always regaled Sorensen with stories of her life, past and present, and the effect was like "an artist painting a verbal description." The "magic"[1] of her tales always created a vivid impression for Sorensen, as it did for others. Sonia's paintings were also stirring, and Sorensen felt that she "poured everything into the moment" when capturing a scene. Having lived near Williams Lake from the age of two, Sonia knew the area intimately, including "every tree" and "row of poplars"[2] on her property. Like Emily Carr, Sonia exalted in the Cariboo landscape. In 1904, Carr visited 150 Mile House and praised the "open and rolling—vast cattle ranges, zig-zag snake-fences and beast-dotted pasturage with little groves of cotton-poplars spread here and there" amongst the "ethereal, living gold"[3] of the vegetation in autumn. The bold simplicity of Sonia's art captures such vistas and offers fresh interpretations of the area and the peoples of the Cariboo and the Chilcotin. Her work compels viewers to, as Canadian poet Al Purdy's words urge, "Look here / You've never seen this country / it's not the way you thought it was // Look again."[4]

That March morning a south wind was blowing, presaging snow, but Sorensen joyfully anticipated the warmth of the big wood stove, Sonia's deep "cured in cigarettes and alcohol"[5] voice, her hearty laughter, and the ever-changing panorama outside her living-room window. Making his way up the rutted, narrow three-kilometre driveway, Sorensen unexpectedly met a vehicle leaving the ranch. Inside was a grim-faced man. Uneasily, Sorensen wondered who he was.

As he neared the house, Sorensen's discomfort increased. Where was Sonia's dog, Joey? At the approach of any vehicle, Joey was like a whirling dervish, "in front of the car, behind the car, on this side of the car, that side of the car,"[6] barking and snapping his protection of Sonia and her home. When he reached the house and could not open the ever-welcoming and never-locked-to-company door, Sorensen's heart sank. As he stood bewildered on the front stairs, John Miller, Sonia's son-in-law, appeared.

That morning John had been tending to the herd as calving season had begun. When he entered his mother-in-law's basement some time before 7:00 a.m. to get a bottle and feeding tube because there was a struggling newborn, he noticed that Sonia was not up. John assumed she was still tired from her trip home and knew that in a few hours he would see her for coffee, as he did every morning. He would then relate the busy goings-on in the cattle's "maternity ward," and she would entertain him with anecdotes from her holiday. After feeding the cows, John returned the nursing equipment to Sonia's basement. As he was leaving, John noticed the bathroom door was ajar. Sonia was lying on the floor. After calling her name and not receiving a response, John checked her pulse and breath. Finding neither, he dialled 911. Upon the ambulance's arrival shortly thereafter, two paramedics confirmed that Sonia was deceased. Then two Royal Canadian Mounted Police officers drove up in separate vehicles. One stayed only a few minutes. Next, coroner John Andrews and his attendants arrived. Andrews determined that Sonia died of a major catastrophic event such as a massive heart attack or stroke. Assured she was not at a crime scene, the remaining RCMP officer left the ranch. The coroner's attendants soon departed for Williams Lake with Sonia in their van. In his journal, John recorded, "After a little more discussion the coroner remarked on all the paintings"[7] in the house, as the female constable had done earlier. John enquired if Andrews would like to see a few paintings by A.Y. Jackson (a member of Canada's famous Group of Seven). Andrews did, and they spent a short, sombre time viewing the art in Sonia's bedroom before he departed.

Hearing John's news, grief overwhelmed Sorensen. John, sorrowing himself, suggested that they go inside. While awaiting the arrival of Mabel, John's wife and Sonia's daughter, from work in Williams Lake, the two heartsick men sat at the kitchen table, drank coffee, talked and reminisced.

A colourful character whose family has substantial pioneering roots in British Columbia, Sonia is an icon of that province's Cariboo region. She is one of the few women inducted into the Museum of the Cariboo Chilcotin's Cowboy Hall of Fame. Atypically for the first part of the twentieth century, she worked alongside male ranch hands ploughing fields, driving cattle and mending fences. Isolated and therefore mostly

self-taught, she eventually produced a vast body of artistic depictions of the area. Along with her mother, Vivien Cowan, and A.Y. Jackson, Sonia co-founded the Cariboo Art Society in 1945. Following her mother's example of welcoming creative individuals to her home, Sonia invited a who's who of Canadian artists to her houses at the Onward Ranch and, later, Jones Lake Ranch. Several became close friends. During her life, Sonia had many adventures and encounters that she reiterated and detailed in her correspondence, journals and art. Her interactions with artists and ranchers are of historical interest and significance, and their recollections help shape her life story. Sonia's work is a unique record of and tribute to rural life.

Sonia's celebration of life drew a large, eclectic mix of individuals. Her family wanted the gathering at the 150 Community Hall to reflect Sonia's agricultural and creative passions as well as her love of entertaining and interacting with a wide range of people. Along with a display of Sonia's chaps and cowboy boots, the family had tables laden with food. They asked Sonia's friend and fellow artist Harvey Chometsky to hang a selection of her paintings, but Chometsky found the spacious facility still felt impersonal and devoid of Sonia's engaging presence. Sonia's daughter Mabel Cornwall reflects, "Harvey kept driving back to the ranch house declaring, 'More paintings. We need more paintings.' We helped him load his car four or five times."[8] Eventually the walls resembled those in Sonia's studio and, once again, she thereby provided solace and inspiration. In David Zirnhelt's tribute (one of many), he emphasized that for those who knew Sonia, "life was richer … because of Sonia's immense friendship," and the impact of her art would "never fade."[9]

Over the years Sonia's watercolour and oil paintings, as well as her pastel sketches and mixed media images, were shown throughout British Columbia; since her death, exhibitions of her art continue in public and private galleries. Sonia's bold and evocative work reflects the stark features of the semi-arid topography of the Interior Plateau. Some of her art also depicts bygone cultural and agricultural practices, thereby making her portrayals vital to the history of the Cariboo, the Chilcotin, BC and Canada. An unorthodox, compassionate, creative and intelligent individual, Sonia has left an invaluable legacy of art and a compelling chronicle of a distinctive Canadian life.

A Wild Irish Type

Shared round fires, tables and anywhere people congregate, stories entertain, entice, soothe, educate, warn, glorify and preserve memorable occasions. The Cariboo and Chilcotin abound with oral histories. As Sonia grew up, her personality was shaped by tales from both of her parents, Vivien Tully and Charles George Cowan. Her mother's conveyed the remembrances of an artistic, adventurous and resolute individual. Her father's, some confabulated, many amusing and every one fascinating, were those of an early Canadian adventurer. Sonia never tired of her parents' narratives and often retold them throughout her life. From her mother, Sonia garnered a passion for art; from her father, she developed a deep connection to the natural world.

Charles Cowan (1869–1939) was born in Wells, Norfolk, Great Britain, to an English mother (Sarah Fewster, whose forebears were the long-serving mayors of Hull) and an Irish father.[1] Noted for his eloquence, a trait his son seems to have inherited, Reverend William Cowan was a rector in Londonderry, Ireland, for sixteen years. Charles attended school in England and then Foyle College in Ireland. By his own account, Charles was not a distinguished scholar. He was "a wild Irish type, full of energy and … rebellious of restraint,"[2] whose dreams of daredevil escapades were fuelled by the archaeological explorations and South African military campaigns of Sir Charles Warren, an officer in the British Royal Engineers. In addition, letters from Charles's older brother, Bill, who had immigrated to the United States and settled in Minnesota, caused Charles to yearn for exploits of his own. At age fifteen, he asked his mother if he could join Bill. In spite of her reply to "Forget this nonsense,"[3] Charles booked passage on the steamship *Anchoria*. Eleven days later, he landed in Philadelphia. His mother had apparently contacted friends in that city. The teenager was surprised to find two elderly women at the dock, waiting to take him home. There, a photograph of his mother induced such a fit of homesickness that Charles nearly sailed back across the Atlantic.

After a short stay in Philadelphia, Charles boarded a train to Gaylord, Minnesota, and while in transit read a riveting tale about the adventures of a tenderfoot in Arizona. Bill was not at the station when Charles detrained and evening was approaching. Before disappearing and leaving the lad alone on the platform, the stationmaster said Charles had two

options: spend the night by himself at the station, or hike down the track for a mile or two to Bill's cabin. Charles opted for the latter. Setting off down the rail tracks, all he could see was a darkening expanse. After about a mile, thunder alerted Charles that a storm was approaching. Soon he came to a trestle over a swamp, where he heard "extraordinary" and strange "croaking." As he proceeded along the trestle, a light appeared in the distance and the bridge rails began shaking. The water beneath looked deep, and he worried about what fearsome creatures might lurk there. Charles had no choice but to run "for dear life, jumping from tie to tie until I could hear the roaring wheels behind me." At the last moment, he leaped, landing in a slough where "those horrible gurgling noises started again." Picking his muddied self up, Charles continued down the track and, as the lightning increased, he thought he saw a distant dwelling.

Stepping off the tracks, "the loneliness and stillness of the place" alarmed Charles. Coupled with memories of the hazards the Arizona tenderfoot had experienced, he "grew hot and cold alternately" and "began to imagine I was lost." He then tripped against a hay stook and realized that he had mistaken it for a dwelling. As the storm worsened, "the rain like a Niagara ... fell straight down in sheets." Charles took cover by burrowing into the straw: "suddenly everything about me started to creep, and move, and send forth a most sickening odor. I rushed terrified from the straw, out into the storm, allowing wind, rain, lightning and thunder full play about me." Not knowing what creature he had encountered and not wanting to meet the animal again, Charles continued over the fields, becoming more drenched with every step. Then "a new and strange cry arose from all around me. It called weirdly, gradually drawing closer, getting more and more eerie as it approached, howling hideous 'wolves' came uppermost in my thoughts—animals wild and dreadful, roamed all about, roaring, and smelling most horribly until I fell asleep in a bundle of wet grass and water." When he wakened in the morning, Charles viewed a shack nearby and realized his surroundings were far less menacing than he had imagined. Instead of ferocious wild beasts, he heard Bill's wolfhounds barking a friendly welcome. The skunk's hideous stench still pervaded his clothes, so he threw them away "laughing aloud ... [at the] funny approach" he made to his brother's shanty. Although small, non–life-threatening animals such as toads and skunks and his own imagination had terrorized him, Charles still yearned for wild adventures.

After a week at Bill's, where Charles learned such chores as chopping wood and herding cattle, he travelled to Faribault, Minnesota, where he worked for a prosperous agriculturalist. On that farm, Charles mastered skills that he would later use in the BC Interior. He did everything from grooming horses to milking cows. Charles insisted he "hadn't an

idle bone in my body, and liked work, out of doors especially ... and I took the keenest interest in every job." When his pay increased to fifteen dollars a month, Charles dreamed of becoming as rich as his benefactor. Quickly promoted to accountant for the farm's produce business, he thereby acquired another valuable skill. After a year and a half, Charles was still a tender-hearted kid yearning for home. He quit his position and sailed back to Britain. After a short time, Charles became restless and returned to America. He followed that pattern for decades.

From New York, Charles took the train to Asheville, North Carolina. Due to his sociability and adept storytelling, an older man on the train invited Charles to his lush property. According to Charles, there were so many water features, rockeries and flower gardens, "the eye was forever feasting with rapture and surprise whatever direction it looked." The beauty of the estate caused the young man to hope he would one day own such a successful farming operation. After a short visit, the enterprising sixteen-year-old purchased mules and a covered wagon that he outfitted with pots and pans. He employed a young African-American as a cook and started for the Allegheny Mountains, "reaching within a few days the highest and wildest spot in the mountains." Charles excitedly moved "along the trails, where black bear, wild turkeys, rattlesnakes" and other wild creatures he longed to encounter habituated. He came upon the daughters of a backwoods "Tar Heel" (a nickname for North Carolina residents), and the girls' warnings to stop saved Charles from gunfire. The young women's father mistook Charles for a sheriff snooping around on behalf of the "Revenoo" officer. Employing his charm, Charles won the mountain man over and tasted his first swig of applejack: "It was raw ... and burnt all the way down, but lay comfortable and warm where it lodged." Staying with the family for a few days, Charles saw his first raccoon and ate his first fried squirrel. After leaving them, Charles acquired a hound named Tom and hunted deer, possums and raccoons for his meals as he made his way back to Asheville. There he skilfully recounted his experiences to another young man who eagerly purchased Charles's mules and outfitted wagon. With the money, Charles headed back home and decided that he and his brother Bill should farm together in North Carolina. Only seventeen, Charles persuaded his father of the viability of the enterprise.

Reverend Cowan travelled to North Carolina and purchased approximately one hundred acres of river land in Tahkeeosteh Valley, about thirty miles from Asheville. Charles built a small house, barn, corncrib and stable. He further erected a fenced-in area, stockade style, near the house. He hired an African-American woman as cook and cleaner. One day he set off to revisit the old Tar Heel. He was greeted warmly and "drunk

with the joy of being young and free, anxious to live in a world of my own," Charles received "a sweet little privilege"—a kiss from one of the girls. He later talked the old man into selling his hundred-acre property, upon which Charles built a small log structure that eventually became a "picturesque mountain house." Bill joined his enterprising brother soon thereafter; Charles convinced Bill that besides the two hundred acres they now owned, they should lease another hundred acres of bottomland.

Life was full of promise and Charles "began to feel the power that goes with the average young man starting up for himself in America." Bachelors, he and Bill also enjoyed "the rustle of a nice dress, [and] a drop of moonshine occasionally." Working long, hard hours, and using two bull-tongue ploughs, they developed the land. Their financial returns were never what they hoped, and numerous mishaps beset them. One accident could have cost Charles his vision or his life. He was riding up top beside the driver of a coach-and-four (a carriage drawn by four horses) "when bumped down into a deep rut we went, the front wheel on my side almost disappeared in a mud hole. I was pitched off, my foot sticking between the single tree and ... my head acting as a sort of brake under the front wheel. I kicked without avail to free myself and allow the heavy coach passage over me—no such luck. I was held tight, the horses out of control, galloped on running a straight course away, my head ploughing along in the muddy road under the front wheel." When something on the road frightened the lead horses, they turned around, toward the wheels, and the carriage suddenly stopped. Badly bruised and nearly blinded by the dirt that filled his eyes, Charles took several weeks to recover.

During three years of hard work, Charles and Bill successfully built up their farm, growing and marketing corn, sorghum and cabbage. Then disaster struck: during heavy rains, the Tahkeeosteh River[4] flooded its banks, washing away the young men's crops. With some financial help from their parents, much local advice (which they did not heed) and working "harder than ever," the men again undertook the cultivation of their land. Their optimism and determination resulted in lush summer crops the next year. Unfortunately, heavy rains again caused flooding along the Tahkeeosteh River. The lost harvest and dreams for the homestead he lovingly called the "chosen spot" threw Charles into a deep depression. Then the mail brought an unexpected cheque from his uncle Charles. Without a word to anyone, the gallant departed on a trip to Mexico through South Carolina, Alabama and Louisiana. He hoped the sojourn would help him sort out his plans. In New Orleans, he booked passage on the Southern Pacific Railway to Juarez. From there he intended to travel to Mexico City, cross the Gulf of Mexico and be back in North Carolina in eight to ten days.

What happened next was as unreal as a scene from a western. At the railway station, Charles "heard several shots, one after the other, and noticed men running with rifles in different directions and two men fall dead ahead of me on the street. I turned back for my hotel [and] as I entered the door the proprietor shouted, 'Go to your room and lie flat upon the floor.' Not needing any second order I ran upstairs, entered my room, lowered myself down until stretched flat on the floor. The only place I could find away from the window was under the bed, an ignoble position, to remain for an hour and a quarter." While a few pieces of plaster dropped from the ceiling and he waited for the pre-revolutionary melee to stop, Charles flipped through a magazine and read an article, "Mounted Police of Canada in Search of Two Desperate Indian Murderers." The "thrilling episode" greatly impressed him.

Upon his return to North Carolina, Charles discovered that Bill had moved from the area. Despondent, Charles faced an overwhelming "nastiness of obstacles" and knew he could not continue alone. "Staring melancholy, through the window I saw the garden, the clear water creek … the bridge I had built … the creeping vines … the beautiful flowers…. All this beauty was made at some personal labour, out of the rough heights of the mountains, cleared of roots, and stone. I loved it and felt as if my heart would break to leave it." Then, with the optimism of his youth, Charles recalled the article on the North-West Mounted Police (NWMP). Energized by visions of heroic feats by men in red serge, he returned to Great Britain for a short hiatus before heading to Canada.

In 1889, while dining at a Winnipeg hotel, Charles saw a six-foot "dragoon" in a full uniform. He and the police officer, whose name was Gossette, had a shot of whiskey, and then several more. Charles recalled that as the two relaxed beside a fireplace, the man confirmed that he was a member of the NWMP. Charles was duly impressed: "As he uttered these words, the big clock on the wall was striking nine, the room was full … and many eyes were riveted upon the red coat, as if he held one of the most important commands, and certainly I was at his side, ready for any orders he might give." As the evening progressed, Gossette became inebriated and "required some tact to handle." Retiring to the privacy of the officer's room, the men quenched their thirst with more alcohol and discussed the NWMP. Finally, Gossette passed out. Drunk himself, Charles decided that Gossette was "a thoroughly good fellow" and "a rattling sound policeman." As Gossette slept, Charles dressed in the officer's uniform and decided that he looked acceptable.

The next morning Charles discovered he had enlisted for five years. The "first task" of officers of the day was to "recruit rank-and-file members"[5] for three- or five-year stints. Gossette had signed Charles on while

the naive young man's judgement was hampered. When Charles had his required medical examination, he was registered as being five foot ten and one-half inches tall, 146 pounds, with a chest girth of thirty-four inches. The minimum chest measurement was thirty-five inches but the examiner wrote that he thought Charles "would develop."[6] Indeed, by 1894, Charles had increased his weight to 160 pounds and his chest to thirty-five and one-half inches.

Gossette assured Charles he would have the time of his life. When Charles indicated some hesitation, Gossette promised that drill sergeant Maloney would make him a "new man" and riding master sergeant Melcher would teach him to ride without reins or stirrups, adding, "Man, you'll love it all." In Regina, Charles quickly discovered his romantic ideals were quite different from the realities of enlistment. He sarcastically quipped, "Within a month I believe no man living could attempt to compete with me at either sweeping a stable out, at burnishing a button, [or] at producing and laying a kit on the bed, for full inspection." He learned that the officers had "to take all as it comes: kicking horses, dirty fatigues, bullying drill Sgts. and even your canteen beer." After basic training, Charles joined "G" Division in Fort Saskatchewan. Along with one hundred other officers, he soon found an esprit de corps that extended to "each other, half breeds, scouts, full-blooded Indian trackers, interpreters" and specialist civilians such as miners, trappers and guides.

Charles did not have many exciting experiences while in the NWMP. The most memorable was following the trail of two men who robbed the Cariboo and Ashcroft stagecoach of its gold-dust cargo. Thinking the thieves were heading to northern Alberta from the 150 Mile House area, Charles waited with other officers, scouts and trackers near the Yellow Head Pass. The bandits changed course and another detachment caught them in southern Alberta.

Now a corporal, Cowan did drink and carouse, and while in training he did sometimes "absent himself" and neglect his stable duties. In January 1892, he was "guilty of conduct unbecoming" his rank when he swore at an officer. Five months later, he was drunk while in his barracks and demoted from corporal to constable (the rank of all new recruits).[7] He was eventually promoted back to corporal.

Charles's first assignment was the remote Hudson's Bay Company (HBC) post at Lac Ste. Anne, approximately eighty miles west of Edmonton. There he hunted ducks, fished and boated on the lake. He billeted with the HBC trader and his family. The Taylors regaled him with tales of early Fort Garry, the Red River and the Northwest Territories. Thus, Charles learned much of the history of Western Canada "in a most charming and easy way, amongst dear kind friends." He respected the

NWMP, stressing the institution "had something distinctive … something in tone, character, and general makeup…. Rarely have I ever seen, or even heard of a Mounted Policeman drawing his pistol, or trying in any way to bluff or intimidate … and it is a well-known fact that in the eighties the Mounted Police prevented more crime without killing than any other body of Police in the world." After five years of pay at fifty to seventy-five cents a day (reasonable for the time) and work days that lasted "from reveille at 5:50 or 6:00 a.m., to sunset"[8] (or longer), Charles signed on for one more year. In spite of the "most severe hardships" such as travelling by snowshoe or sled "over barren wastes of windswept snow or over muskeg and Tamarac swamps," he relished the freedom the work afforded. He learned the basics of hunting, tracking and moving with pack trains. Furthermore, Charles developed an abiding interest in the natural world.

Many First Nations people, particularly the Cree and Stoney (Iyarhe Nakoda), frequented the HBC post at Lac Ste. Anne to trade their furs. Charles quickly became fond of the Indigenous people and learned much about Canada's fauna and flora from them. He also attempted to speak their languages and mastered their words for moose, caribou and bear, among others. "I had given them to fully understand my hobby of Natural History, animals and birds, my interest in their life—big game habits—the mountains, pack horses, outfitting to go on hunting trips, until it became instilled in their minds, much as my own." As he watched the First Nations people pack up for their journeys home, Charles yearned to travel with them. In later years, he would live and travel with Indigenous people in the rugged country near Jasper, Alberta. He would publish stories about his exploits in magazines such as *Field* and *Rod and Gun*.

The loneliness and the rigours of travelling through all temperatures on foot, horseback and sled took their toll. Charles left the NWMP in 1895 and embarked upon his freedom as "enthusiastic as a schoolboy." He decided upon a life of game hunting, trapping, guiding and searching for animal species, with winters spent in Great Britain. Charles finally found the life of adventure for which he had yearned. He started travelling into areas known only to First Peoples: "Nature drew me to her and the freedom of travel with the pack horses, the sight of the rivers, lakes, and mountains, the blaze of the sun, the vastness of the forests, the solitude of the night among the icy peaks of the Rockies, all fascinated me."

On one excursion, Charles discovered a new species of mountain sheep. He did not shoot the animal himself, but sent the skin (black with a white patch on its rump) to the Walter Rothschild Zoological Museum in England (now the Natural History Museum at Tring). Some suggested naming the new species *Ovis cowani*, but *Ovis liardensis* was chosen after

the Liard River where the animal was found.[9] Charles's record-breaking moose trophy also went to the Rothschild Museum.

When the 1899–1902 Boer War erupted in South Africa, Charles's sense of nationalism overwhelmed him. He and his friend Evelyn Penrose "tossed a coin to see who would go."[10] Charles won and saw battle with the 61st (South Irish) Company, 17th Battalion, Imperial Yeomanry.[11] During the campaign, he distinguished himself, earning a medal for bravery and the nickname "Deadwood Dick," which was shortened to "Deadwood" by his friends and family. His Colonel, Lord Longford, explained the moniker: "He's so daring, he'd charge a stone wall."[12] Some of the skirmishes Charles engaged in were so bloody that several men individually suffered as many as twenty-six bullets.

After what he called his "canter" through the war, Charles succumbed to typhoid fever. Once he had recovered, he started guiding British nobility on hunts for bear and moose trophies in Alaska and the Yukon. A photograph of one expedition shows "a portion of a record bag of twenty-three Alaskan bears, seven moose, and seventeen mountain sheep"[13] killed during an Alaskan trip Charles took with the Hon. John Cunliffe-Lister (a brother of Britain's Lord Masham). Through his exploits, Deadwood also befriended Lord Egerton of Tatton, whose Highland Ranch at 105 Mile House he later managed.

During one of his earliest trips, chronicled under the title "With the Indian," Charles travelled with a large "party of sixteen, men, women and children." He and his First Nations companions trekked to "the head waters of the Saskatchewan, Athabasca and Fraser rivers." Each day they shot mountain sheep and goats and dried the meat in preparation for winter. With temperatures dipping below zero and snow sometimes falling, Charles respected "what the natives can endure: what cold, what fatigue, and sufferings, what hunger and deprivations." After setting off with just one of the Aboriginal men and three horses, Charles and his companion had their survival threatened by a blizzard:

> The atmosphere was filled with drifting snow, making it impossible to see a yard ahead of us; the wind struck the lake with such force as to blow the snow from under us, and the lake became a sheet of black glare ice. The horses could no longer travel, and were lying down, bleeding freely from their mouths, which were cut and lacerated from the many falls on the ice. The increasing cold was unbearable. We unloaded the horses and piled the loads in the air, and then we dragged the horse by the tails and slid them into position, making a wall high enough to create some shelter. The saddle blankets we

put over the horses, our own bedding we wrapped round our-
selves, and lay down on the ice, back to back, with the horses.
Night came on … and a dreadful longing for sleep … the last
end. The gusts of cold wind, sleet and snow drifted furiously
over the lake, as Jack and myself, leaving the horses to their
fate, made for the shore.

They lit a fire, ate some frozen meat, and found the horses the next morn-
ing. Charles stayed over nine months in the mountains, taking "much sat-
isfaction in the feeling that I was alone; the only white man in the valley."
He happily trapped, enjoying the "sound of my snowshoes going through
the great forests of fir trees, where that strange stillness of Nature always
prevails, where that rasping caw of the raven, or the wild yelp of the coy-
ote, brings one to a standstill for the moment."[14]

Charles adventured in the North for several years. In another article,
"Two Thousand Miles Down the Yukon River in a Small Boat," he de-
scribed leaving Vancouver, BC, via the Canadian Pacific Railway (CPR)
steamer *Princess Mary* in 1905 and making his way to Skagway, Alaska.
From there he journeyed 111 miles on the White Pass and Yukon Rail-
way until he arrived in Whitehorse. Then he navigated boat 4560 along
the Yukon River. Equipped with three Winchesters, he and his compan-
ion, "E" (likely Evelyn Penrose), shot grouse, bears and other animals for
their meals and furs. During that extraordinary one-month journey, they
were discomfited by "millions" of mosquitoes, met "an irregular flotilla of
Indian crafts"[15] on their way to a potlatch, survived rapids and stopped at
mining towns such as Dawson City.

In 1906, Charles became part of a famous piece of BC history: the
murders of two First Nations men in the Hazelton area—Alexander
MacIntosh, a packer, and Max LeClair, a well-known guide and game
hunter who had worked for Charles for eight years. A local man, Simon
Peter Gunanoot, quickly disappeared after being accused of shooting
both men. The NWMP and a posse, which included Charles, took off
after the fugitive. They did not find him, nor did other law enforcement,
and Gunanoot survived in exile for the next thirteen years. As a result, he
became a BC legend. When Gunanoot finally turned himself in and went
to trial, he was acquitted.[16]

Why Charles gave up being a guide and sportsman is not known.
During his winters in England and through his contacts with Lord
Egerton, Charles joined two men's clubs, the Wellington and the Sports.
In those British clubs (and others), he seems to have met several no-
blemen interested in buying property in Canada. Initially, he managed
some British investments in Ontario but then moved west. He became

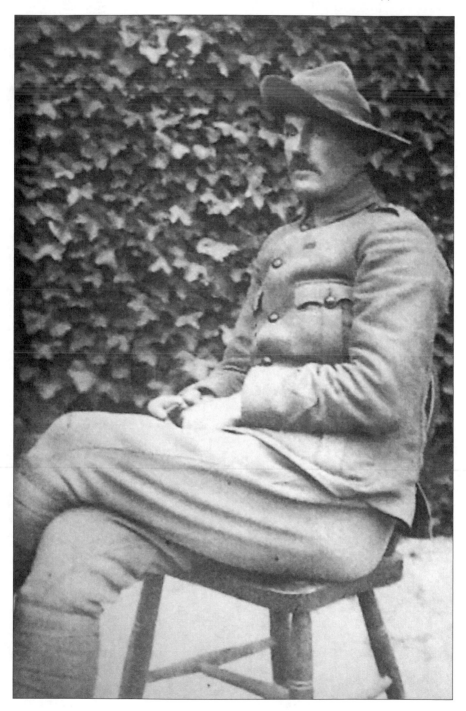

Charles George Cowan in what appears to be his South African War uniform (note the British puttees), circa 1899–1902. Courtesy of Colleen and Tom Hodgson.

a partner with Evelyn Penrose and settled in Kamloops, where they ran the Cariboo Trading Co. Through that enterprise, Charles eventually supervised ranches at 100, 105, 111, 134 and 150 Mile Houses. According to one article in the *Daily Province*, "Radical taxation legislation initiated by the Asquith Government, uncertainty as to the future, coupled with a high regard for Canada as a field for investments are … the chief factors which are diverting vast sums of British capital to the Dominion."[17]

In 1912, Charles arranged for the Marquess of Exeter (also known as William Cecil) to purchase the Bridge Creek Ranch from Syd and Frank Stephenson. Lord Egerton bought acreage adjoining Exeter's in the 100 Mile House area. Together they had fifty thousand acres on which to raise cattle and "meadows capable of yielding 4,000 tons of hay yearly."[18] Michael Cecil, now the 8th Marquess of Exeter, explains that, at the time, his grandfather wanted "to invest in Canada because it was fashionable to do so as an English gentlemen."[19] "Old Cowan," as the Cecils fondly referred to Charles, and Lord Exeter were both members of London's Junior Carlton Club (a gentlemen's club founded by members of the Conservative Party, 1864–1977). In fact, they may have first met there. The Cecil family knew Cowan as an enthralling big-game hunter, adventurer and raconteur. He could entertain people for hours with tales of his exploits. He was, therefore, a frequent guest at the dining tables of British high society. Once, perhaps at the Cecils' or another home, a host family's lack of knowledge about Canada resulted in a humorous occurrence for Charles. When the servers brought covered dishes to the table, the hostess joyously disclosed that her son had so often described the dish they were about to eat, she was sure it was a Canadian delicacy. With a flourish, the plates were uncovered and Charles found himself staring at a mound of baked beans.[20] His reaction is unknown, but Sonia enjoyed recounting that incident.

Charles constantly travelled to the Cariboo to check on the properties he managed, but he returned to Great Britain every winter. Vivien said, "Having crossed the ocean sixty-four times he was well known by the shipping companies and even had a free ticket given to him from Kamloops to England one time by the C.P.R. because he had mentioned them in one of the many articles he wrote for *Field, Rod and Gun*, etc., in regard to his exploring and big game expeditions. He would usually reserve an ordinary stateroom and on board would be given his choice. Such was his prestige." Amusingly, on British soil Charles dressed in tailored garments, even sporting a monocle for a time; in the Cariboo, he wore "old tweeds plus a 'Stetson.'"[21] But Charles's vagabond days ended when he fell for a vivacious and much younger woman.

The Tully/Cowan Family

Vivien Tully (1893–1990) was the fourth child born to Sonia's grandmother, Alice Tully (nee Morphy). The Morphys lived on a large Toronto-area estate called Cedarhurst, where they raised two sons and five daughters. According to family lore, the girls were tall and so beautiful that young men became regular churchgoers in order to observe them Sunday mornings.[1] Alice was eighteen when she married John Tully, who was thirty-nine. Raised with governesses and servants, and privately schooled, Alice (1860–1957) was witty, well educated and a talented pianist and conversationalist. Ordinary tasks such as cooking, household chores and financial management eluded her, however. As a result, Vivien often had to look after practical tasks such as selecting her mother's clothing for her and fixing Alice's hair. Vivien recalled that when her brothers had the measles, Alice, unaware of the danger to her daughter, put Vivien into bed with the boys "to amuse them. My mother scarcely knew or cared about germs." Vivien had three much older brothers (one of whom died young). Being the only daughter and the last child, Vivien was the pet of the family.

Like her mother, Vivien was a fun-loving, spirited woman, but some remember her as being imperious. Maybe that was because Vivien had grown up hearing that she was descended from Irish royalty. Vivien's paternal grandfather retired from the Irish Navy and then headed the Holyhead Steam Packet Company in Wales. The family had servants and led a privileged life. Vivien's father settled his family in the American northwest and was not so lucky in his career. He had a life of financial vicissitudes but reared Vivien on tales of his aristocratic forebears.

Vivien's cousin Sydney Strickland Tully was a distinguished Canadian painter of her era. Sydney's sister, Louise, was known for her wood and silver carvings. From an early age, Vivien was also interested in art. Her mother encouraged Vivien and one year sent her to Saturday painting classes. Later, Vivien enrolled at the Portland Art Museum where she studied watercolour techniques. Vivien believed that course gave her "a good foundation" and taught her that the medium should be "fresh and free." Alice did not foresee a career for Vivien, only marriage, and stressed that her daughter should be a "lady." Alice gave her instructions such as not to walk too quickly because that would make her "look like a shop girl."

She taught Vivien to be witty and interesting and gave her the following instructions for formal parties: "First you chat with the person on your right and after a little the same with your left-hand neighbour." (Several people in the Cariboo remember Vivien doing just that at social gatherings.) Vivien's father always spoke of her being presented at court. Vivien could never understand how a North American girl would meet the King of England. Moreover, while Vivien felt prepared for upper-crust functions, her parents did little socializing; therefore, Vivien had few opportunities to practise her expertise. Years later, however, those unproven skills were useful in her relationships with the British aristocrats her husband knew and when Vivien and her daughter Drusilla (Dru) met King George at Buckingham Palace in May 1951. During her childhood, Vivien also benefited from an intellectual atmosphere, as her parents' interests in world affairs often led to lengthy dinner table discussions. Furthermore, Alice's hobbies in gardening, music and writing would later interest Vivien. She grew up listening to Alice's stories and verses, as did Sonia and Dru and their children. An indication of Alice's skill was that at age nineteen, she published her first story, "The Yellow Dress," in Toronto's *Saturday Night* magazine. When in Oregon, Alice belonged to the PEN Club, and the editor of the *Oregonian* read Alice's stories aloud at club meetings and printed her verses in the paper.

Sometime during the Great War, Violet (Vivien's cousin) and Harry Mytton moved to Kamloops, BC, where Harry managed a cattle ranch at Brocklehurst in North Kamloops. In 1918, they invited Vivien to visit. Little did she realize that trip would transform her life. Vivien viewed North Kamloops as "a big sandy flat area covered with sagebrush, as well as hay meadows. A flume ran for miles to carry water to irrigate the meadows." Violet and Harry lived in a three-storey, English-style house and employed a cook, a gardener and a chauffeur. Vivien spent her time picking armfuls of pink peonies, playing tennis and "being whirled around" in the Myttons' "big car, on expeditions to friends in the country or shopping at the one and only little 'dry goods' store, aside from the scantily filled Hudson's Bay Co." Besides learning to ride a horse and drive a car, Vivien recorded helping Harry "drive five hundred head of cattle to the summer range up in the hills above Kamloops, near Lac Le Jeune." She did not then know that she would become a rancher's wife. She also recounted hunting coyotes for sport, an activity popular with the early British settlers in BC's Interior. Vivien learned that the Kamloops elite devoted Sundays to polo matches on "the Indian Reserve fields." Some of the prestigious visitors Vivien met at the Myttons' included Frank Ward, an owner of the Douglas Lake Ranch near Merritt; Colonel Pragnell, the inspector of Indian agencies; and Frederick Fulton, the federal Attorney

General. The Fultons would eventually become friends with Vivien and her future husband.

Charles Cowan and his partner, Evelyn Penrose, bought and developed property for wealthy English investors, thus becoming well-known businesspersons in Kamloops. One day when Vivien was in Kamloops picking up the mail "at the funny little wooden post office on the main street.... Violet said, 'Oh, there's C.G. Cowan back from England.'" After Violet introduced her to Charles, Vivien exclaimed, "It was truly love at first sight! I was enthralled by this big, handsome, charming man, with his aura of London still about him.... He, leaning in the car window radiating his forceful character."

Shortly afterwards, the Myttons hosted a garden party to raise funds for the Red Cross. An orchestra was organized, a dance floor built, Scottish pipers paraded by and seven hundred of Kamloops' society attended. Although she described herself as shy, Vivien performed two solo dances, one barefoot and with veils reminiscent of Isadora Duncan, the American pioneer of modern dance. Prior to the fete, Vivien "drew a pen sketch of a pretty girl's head on a card with the inscription, 'Admit one nice man'" and sent it to the enticing bachelor. Charles did not attend, but he would read about Vivien's dances in the local papers. He was already smitten, and after his death, Vivien found the invitation in his wallet. Charles was fifty and Vivien only twenty-five; when he began to court her, she admitted that "the attention and admiration from such a romantic man" overwhelmed her. Included among the gifts he gave her was a white owl he shot while travelling through the Cariboo, and a horse.

Their engagement was big news in the small town, and Vivien recalled some of Charles's tenants surrounding her on the street "clamouring to know if it were true ... laughing and teasing us in such an affectionate way. He was ... looked upon as a bachelor for all time." When Vivien and the Myttons were invited to the Douglas Ranch for some game hunting, Vivien's betrothal was announced. She wrote that "immediately champagne was brought forth at dinner amidst a hubbub of excitement!" The wealth and practices of such elite personages "thrilled" Vivien "to the core."

Charles wanted to spend his usual winter in England, but he did not want to go without Vivien. They married at the Myttons' "Home Farm" on December 18, 1918, and left for London via New York. Vivien found London somewhat "grim" but was soon dazzled by the sights and dining with her dynamic husband at exclusive men's clubs such as the Cavalry, the Naval and the Wellington. She quickly added tailor-made clothing to her wardrobe. Deadwood (as Vivien fondly called him, partly because of his heroic nickname and partly because he jokingly signed

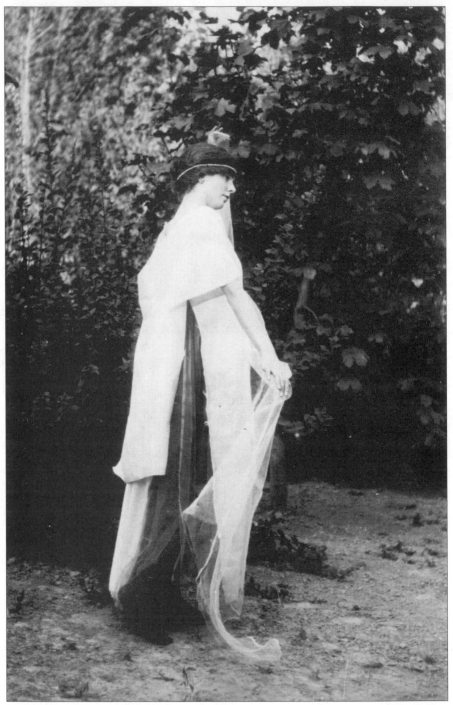

Vivien Tully dressed for her dance with veils, Kamloops, BC, 1918. Courtesy of the Cornwall Family Archive.

letters and notes to her as "Deadwood/Your old stick"), presented her with several furs, including a sable. The couple visited such nobility as the Marquess and Marchioness of Exeter, at whose home they ate from gold plate. Some of their British acquaintances bestowed them with gifts, and Lord and Lady Egerton's wedding present was one hundred pounds. The Egertons' son, Maurice, often dined with the Cowans and entertained Vivien with stories of war espionage. Deadwood also took Vivien to the Rothschild Museum to see his record-setting moose, mounted and on display. He confided to her that after he shot the moose a grizzly bear ate one leg; ever resourceful, Deadwood shot another moose and attached one of its legs to the larger trophy.

Upon their return to Canada, the Cowans resided in Kamloops for one year. Deadwood's house was a bungalow on Columbia Street with a room and bath for the hired help. His English clients often stayed with him and found the home cozy with panelled walls in the dining room and two fireplaces. He had an English china dinner set, good silverware and some select English vases. Besides his house, Deadwood had a stable for his purebred horses. He owned the entire block, thereby providing pasture behind the house and stable.

Bob Miller and his wife worked as his chauffeur and cook-house-keeper. They were necessary to Deadwood's life prior to his marriage because he often entertained overseas clients and he did not drive. Deadwood had one driving lesson but became so frustrated that he never drove again. Miller not only chauffeured for Deadwood, he also cared for the horses. Daily, Miller groomed the animals and polished saddles and halters. The harnesses were Irish-made and Vivien bragged that they once had belonged to the Duke of Devonshire. Miller's other chores were to wash the Cadillac each time Vivien used it and polish the family's shoes every day; Vivien said, "They shone like horse chestnuts." For the first fifteen years of the Cowans' marriage, the Millers worked for them and only left during the Depression, when Deadwood could no longer pay them.

Within four months, Vivien became pregnant. The Cowans added a nursery to their home (with a fireplace) that opened onto the garden and lawn. Sonia Evelyn Drew Cowan was born on November 22, 1919. Although Vivien was well, she stayed in the hospital for one month and then had the help of a trained nurse for a month afterwards. When Sonia was six months old (May 1920), Deadwood took her and Vivien on their first trip to the Cariboo. He had business to tend to, and he wanted to have Vivien and the baby along. Vivien wrote that the trip covered approximately 170 miles of rough road and she prepared "as if ... going on an expedition to the Himalayas.... Food ... as there was no guarantee ... of human

habitation for fifty miles at a stretch. Lots of rugs as D. [Deadwood] liked fresh air, couldn't stand 'fug' and so we usually travelled in an open car." The car did not have a heater, so heated bricks wrapped in cloths warmed their feet. According to Vivien, the Cadillac had "wire wheels," leather seats and a running board.

Always wanting to look smart, Vivien attired herself in a leather coat and a chiffon veil two yards long, which she wound round her neck in imitation of styles seen in *Vogue* magazine. Sonia's tummy was swathed in a flannel band, a shirt ordered from London and then a barren coat, "which consisted of a wide band of flannel, on to which was gathered a skirt open at the front and feather-stitched all around, then a long white petticoat, trimmed with real lace and then the long white dress, both of sheerest 'nainsook.'" If the weather turned cold, Sonia wore a knitted jacket. Vivien also packed the baby "a dressing gown of pink satin, lined with 'nun's veiling' and embroidered with forget-me-nots." At the time, Sonia was likely one of the best-dressed children in the Interior.

Where others, including Emily Carr, documented travel to the Cariboo in a bouncing and uncomfortable stagecoach,[2] Vivien's descriptions provide a rare glimpse of travel by car in BC's Interior during the early twentieth century, with an added female perspective on food, lodgings and decor. The Cowans' trip took them through Ashcroft and Cache Creek, which to Vivien was "a dry, dusty place, all sagebrush and prickly pears, with one tiny log cabin store and post office combined beside the road and a mile further on a dismal looking motel." She thought the "motel a very primitive affair: tiny cabins and outdoor plumbing, all very dingy. One descended to it from the highway by wooden steps, as it was in a hollow on the edge of the Bonaparte River and sheltered by tall cottonwood trees. Above on a cliff was a sign outlined with stones and bits of a wagon—'The Bar U.' … It was altogether a very barren and unprepossessing place and one felt it was full of rattlesnakes at every step, as indeed it was." They then travelled north and, although it was mid to late spring, the countryside was at first still leafless and covered with snow patches. Deadwood carried an onion to rub on the windshield if it became icy and a shovel in case they became stuck.

On this first trip, Vivien found the narrow, twisting road, the undulating hills and the colourless landscape somewhat forbidding. She felt she was "in a strange wild country and in a strange wild life." Vivien did not know that she would soon move to the Cariboo and spend the rest of

Vivien Cowan and baby Sonia, circa 1919–20. Courtesy of the Cornwall Family Archive.

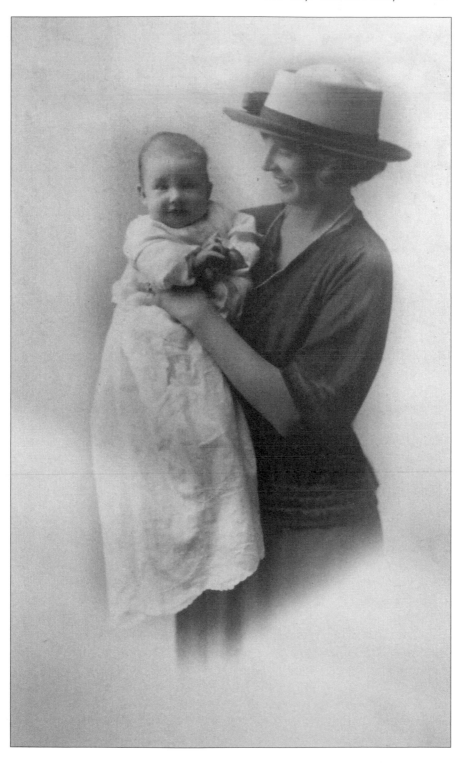

her days there. Nor did she realize that she would become a prominent innovator of the arts in the Williams Lake area.

As their journey continued, the air became cooler and pines became the predominant vegetation. They stopped at the historic Clinton Hotel (originally called Clinton House, which burned down in 1958). Vivien described the structure as "a funny little rambling wooden hotel, much added on to by lean-tos, with sagging uneven floors and low ceilings.... We were given tea and thick home-made bread, sourdough, and warmed ourselves in the minute sitting room, which was mostly linoleum floor and oil-cloth walls, with a few wooden chairs, a table and lamp, and a few straggling geraniums and begonias in tins, and ... the welcome glowing, long low stove that would take a three foot log." Refreshed, the Cowans continued northward at a whopping twenty-five miles per hour until they reached 74 Mile House, a ranch and stopping place. Although it was May, the lakes were still frozen and Vivien thought the area most "desolate." Mrs. Cunningham, the owner, gave the Cowans a warm welcome and hearty lunch. Vivien imparted that the "nice motherly person" ran the ranch with the assistance of her son and two daughters, Margaret and Rita. The latter became a jockey for Eric Johnson. (An Englishman, Johnson settled at 141 Mile Ranch and raised racehorses; later, he returned to Britain and became a Member of Parliament.)

After they departed, Vivien viewed miles of pine trees and "old derelict log cabins and outbuildings and corrals, the land having been absorbed into other ranches." When they came to the infamous and steeply graded 83 Mile Hill, slippery and muddy from spring breakup, the family had to exit the vehicle so Miller could put on chains. He then laid fir branches on the worst sections and tied a fir tree to the rear of the car to provide added weight to help with the climb and to act as a counterweight so the car would not slide off the road. Years later Vivien added wryly that the Cadillac "was definitely not like the dear modern little Volkswagen that can skip through anything."

The next hazard was the steep drive down into 100 Mile House. Even today, its four lanes can be difficult in bad weather, but in the 1920s, the hill was often slippery with a dangerous ravine on one side. Vivien defined the incline as "a long winding road with many sharp curves" and even more dangerous if one met another vehicle because one would have to let the other pass. After ten hours of travel in an open vehicle and approximately 120 miles, at 8:00 p.m. the Cowans arrived "stiff, cold and hungry" at the 105 or Highland Ranch, owned by Lord Egerton. The original home faced onto the road, and Vivien noted the building "was covered with a tin facing, painted red in imitation of bricks." The ranch was under Deadwood's care, but the local manager was an Irishman

named Pat Newman whose countenance Vivien said resembled those of the ranch's steers. The talk that accompanied their meal must have been dreary to the tired Vivien as it related to the ranch, "cattle, hay and weather." Vivien recorded that they had a "standard dessert—dried apple pie, and a huge iced cake." Without much enthusiasm, Vivien added, "Stewed prunes were always on the table, summer and winter" and were called "Cariboo strawberries."

They stayed a few days so Deadwood could check on the 105 and then went to Lord Exeter's nearby Bridge Creek Cattle Ranch (purchased through Deadwood in 1912). There, the old log structure was a sharp contrast to the opulent and ancestral Burghley House. According to Vivien,

> the floors were rough and unpainted as well as uneven and rattled as one walked. The doors were low, as were the ceilings, and the doors didn't fit. It was more sparsely furnished than most places. Nothing was painted, inside or out, and with age it had taken on a silvery sheen. It had what once had been white oilcloth on some of the walls, which seemed silvery also…. There were lots of outbuildings, barns, storerooms, root cellars—all struggling in every direction, plus corrals and mooing cows. Some cabins had dirt roofs on which tall grass grew and it was all a dull monochrome in colour.
>
> There was a general store in a dark cabin, presided over by an elderly English gentleman called Mr. Hill…. One had to stoop to enter and, as it had few windows, it was dark and mysterious. It was crowded with every conceivable thing, from harness and saddles to materials and groceries, plus the usual post office. Things hung from the ceiling and one dodged frying pans and coils of wire, etc.
>
> One day Mr. Hill said … he had something special to show me so we moved along to the dry goods counter and he proudly brought out a bolt of red flannel, "direct from England." What he expected me to do with it I don't know, but to show my appreciation of this great privilege I had to buy some.

Vivien noted that at that time nearly every ranch had a store and post office. The stores only opened when a customer appeared. Mail days were social events that brought a crowd of six or so. Ranches also doubled as hotels and restaurants for travellers as there were few such conveniences.

Continuing on their tour, the Cowans moved north until they came to 115 Mile Ranch, at the southern end of Lac La Hache and owned

by the pioneering Ogden family. Vivien observed that the Ogden ranch buildings were amongst the few that did not sit directly on the road. The Cowans then continued until they reached 150 Mile House. Vivien later learned that as they passed by, "on seeing the famous Cadillac, the word would be flashed by grape-vine, 'There goes Cowan on his first trip of the season.' He was a familiar figure to them and rather a glamorous one, as he represented big capital and important people, as well as being a great traveller."

Deadwood liked the Cariboo and when the opportunity arose to purchase a ranch near 150 Mile House, he did so. However, the family did not move immediately. In the winter of 1921, rather than travelling to England as he usually did, Deadwood decided that the family would spend the colder months on Vancouver Island. By then, they had a new vehicle, a Buick. Vivien wrote that with Mrs. Miller as nurse and Mr. Miller as chauffeur, they spent "a delightful winter" at the luxurious Brentwood Hotel (which later became a boys' school). Vivien described the facility as "more like a large English country-house with perfect servants and cuisine." Leaving Sonia with Mrs. Miller, Vivien and Deadwood spent many mornings fishing for young salmon and eating the fresh catch for dinners. Other days they would motor about, join friends for lunch, shop, take in movies and sip tea at the Empress Hotel. In that era, tea was served in what Vivien chronicled as an intimate conservatory that contained a fountain and numerous potted plants. The fountain eventually disappeared and a real conservatory was built. Nowadays, tea is served in the hotel lobby. On Saturday evenings, the Cowans attended dances in the hotel's ballroom and Vivien recounted floating "with a lovely white fox fur slung nonchalantly across my shoulders, as was the fashion." In late March, they returned home to Kamloops. They would soon relocate to the Cariboo.

The Onward Ranch

The Onward Ranch house was approximately sixteen kilometres south of Williams Lake, snuggled between the Sugar Cane Reserve[1] and St. Joseph's Mission. In 1867, Charles Boromeo Eagle bought the 1,120-acre property with another 300-acre stock ranch at Jamps' Lake. He arrived from Pennsylvania during the gold rush era and decided to settle, naming the ranch Onward as he hoped it would always progress successfully. Eagle first built a small log house along the San Jose River, which runs from Lac La Hache to Williams Lake. That structure later became a chicken house. Eagle also built a general store in order to sell goods to his employees, his First Nations neighbours and individuals travelling to and from the Chilcotin via Chimney Creek. Eagle married Annie Tatkwa from the Bonaparte Reserve and had ten children, of whom only six survived.[2] In 1886, Eagle moved his family into a large, new two-and-a-half-storey home described as "probably the finest residence in the interior" at the time. Eagle used lumber planed in his own steam-driven mill in its construction. The following description of Eagle's property appeared in the *Daily British Colonist*:

> The [ranch] lies beautifully and is well irrigated by a ditch seven miles in length, and carrying 1,000 inches of water from a permanent supply ... [and] 225,000 pounds of grain, 250,000 pounds of vegetables and 200 tons of hay are annually raised.... Mr. Eagle ... has received numerous medals in Canada and Europe, and has now an exhibit of peas and potatoes at the Colonial exhibition....
>
> A palatial residence ... the superior decorating and finishing ... [is] all done by hand. Black pine is used for the finer portions of woodwork ... and when polished and oiled ... makes an elegant finishing.... The residence is supplied with many modern conveniences.... Its cost will be in the neighborhood of $10,000.[3]

Eagle died in 1890. His son Johnny and stepson Tommy Paxton took over the ranch and founded "Eagle and Paxton, Store Merchants." They sold everything from clothing and perfume to mustard plasters, jellybeans

and harmonicas. In 1903, suffering large debts and facing foreclosure, Eagle and Paxton sold the property to John Edgar Moore of Alkali Lake. Moore reinvigorated life and work at the Onward: "Freight wagons and mule teams stopped there regularly, and dances held on the top floor of the warehouse attracted people for miles around."[4]

In 1911, Moore erected a Dutch-style barn with red walls that could hold up to one ton of hay. Side aisles at ground level housed up to forty horses, large box stalls and ample oat bins. Such barns have steep roofs that can hold significant snow loads, and they convey an imposing presence. That mode of agrarian architecture is now one of the oldest in North America. Unfortunately, aged barns are disappearing, down from six million in the 1930s to two million or so in 2012, and Dutch barns are among the rarest with fewer than six hundred still intact[5] in North America. Over a century old, the distinctive Onward barn stands as a testament to the region's agricultural history. The structure has been and continues to be the subject of many artists' interpretations including those of Sonia, A.Y. Jackson, Joseph Plaskett, Herbert Siebner, Takao Tanabe and members of the Cariboo Art Society.[6]

In 1920, Deadwood paid twenty thousand dollars for the Onward property.[7] When Vivien first viewed her new home, which had been empty for some time, she found it "lifeless" and "dilapidated." She described

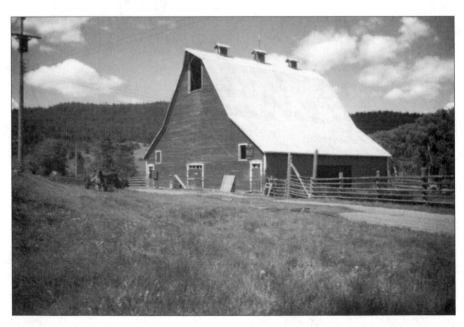

The Onward Ranch barn, date unknown. Courtesy of the Cornwall Family Archive.

the home as having "a faded raspberry coloured roof, high narrow windows and a fancy gingerbread fret-work, narrow double-decked verandah across the whole front. A lone lilac bush, tall straw-like grass and a drunken picket fence within a few feet of the house completed the dreary scene. The inside was equally forlorn, with layers of ancient peeling wallpaper, narrow, high-ceilinged rooms and tile chimneys running throughout the three storeys. No plumbing, not even a sink. A wooden sink was on the back porch with a pump in a shed. The floors were hopeless."

A positive and optimistic individual, Vivien quickly surmised that the home was structurally sound with a sturdy foundation and seven- to eight-inch-thick lumber walls covering bricks and sawdust insulation. As Vivien had previously redecorated their Kamloops home, Deadwood gave her free rein to remodel the ranch house. Vivien had a huge task ahead of her, as in her words, "The front door opened into a long passageway, painted battleship grey with a row of hooks for coats along one wall and the doors to the various rooms opening off it. The stairs came down at a steep angle, almost to the front door." There were twenty-three rooms, each with a brass number, as the building had once been a stopping house for those travelling to and from Chimney Lake.

Vivien drew upon her creativity and, with a Kamloops contactor and his six employees, transformed the structure into nine large rooms with their original ten-foot ceilings. Using Vivien's plans, they joined the two ground-level rooms and hallway into a twenty-by-thirty-foot drawing room. She altered

> the stairway halfway down, with a landing—a sort of "Juliet's balcony" overlooking the hall…. I panelled the walls in dark oak five feet high, with cream washed plaster above them and oak beams across the ceiling…. I also added a wide deep alcove with casement windows on three sides, which gave the room lots of light…. On the left of the stairs, one entered a room, narrow with one window and with an eleven-foot ceiling, completely out of proportion to it. I joined the adjoining room, which was similar, and so made a more pleasing room, which became my sitting room, and put in a lovely fireplace of the native stone, of greyish blue and pink and with French doors opening onto a wide screened verandah, another bay window with small paned casement windows, and plastered walls of a soft grey.

Vivien added casement windows to the dining room, again enhancing the light. Sonia noted that the living room was more "mannish" with

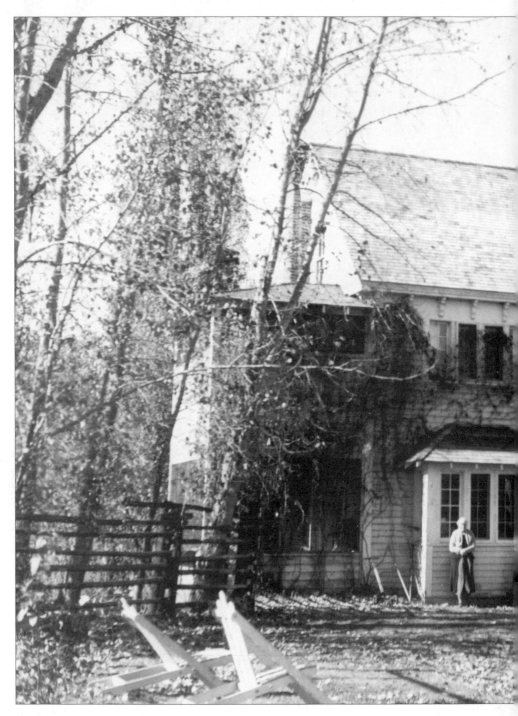

The Onward Ranch house with its porte cochère, circa 1920s to 1940s. Courtesy of the Cornwall Family Archive.

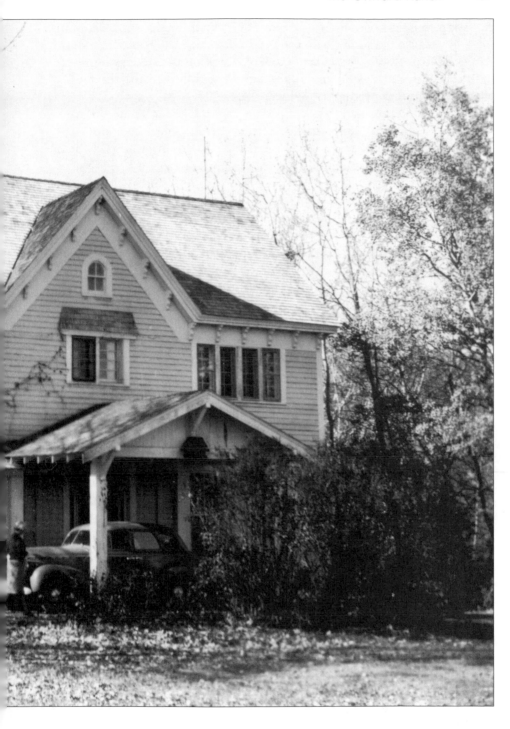

its dark panels and her father's desk in one corner. There was a piano in the hall because her father believed "all nice young ladies played the piano." Unfortunately, as Sonia lamented, she "was a bitter disappointment" musically.[8] However, Sonia's grandmother, Mrs. Tully, became the family pianist when she moved to the Onward.

The kitchen received a new floor and a large larder. There the day's milk, butter and meat were stored. A dairy behind the back door kept larger supplies of milk cool. Beside the dairy was the meat house, which held equipment such as knives, saws and chopping block and where sides of beef hung. Next to that was the icehouse, where tons of ice blocks were stored in sawdust.

The renovations included installing a new red roof, painting the exterior a cream colour, refurbishing three chimneys and replacing the veranda with a porte cochère. A porte cochère at a building's entrance allows animals or vehicles of transport to pass through. Individuals can alight and enter a building with protection from the weather. A porte cochère was often a feature of mansions of the day and is found on significant buildings such as Buckingham Palace and the White House. Vivien's use of this architectural feature was both practical and unusually elegant for a ranch house.

One of the home's five bedrooms became a bathroom, and each of the sleeping quarters received fresh wallpaper and innovative woodwork. English linens of various design curtained the windows: a Jacobean pattern in the hall, delicately shaded flowers for the drawing room. Heavier purple chenille hung in the longer windows over the French doors, and in Vivien's sitting room. She wrote that the dark Jacobean furniture and mahogany dining furniture "completed the English country-house effect." In spite of its rugged and remote setting, the five-thousand-dollar renovation (a vast sum for the day) made the house as regal and charming as Vivien herself.

Late in the summer of 1921, the Cowans moved in. The Millers came with them and settled in a nearby house. Sonia recalled that her mom always filled the home with flowers and that the colour of the blooms had to match the décor. Vivien insisted on fresh bouquets daily; therefore, from a young age, Sonia learned the art of floral design.

While Vivien concerned herself with her new abode, Deadwood concentrated on the land. Moore's grain-growing practices had depleted the ranch's soil. Deadwood replenished nutrients by growing and ploughing under legume crops and heavily fertilizing. He continued to increase the ranch's acreage and according to Vivien, in 1929, Deadwood added the 150 Mile Ranch to his holdings. Vivien explained he thereby increased the Onward to "eleven thousand acres and twenty thousand acres

of government range adjoining the 150 Mile Ranch, small in comparison to the Chilcotin ranches, but very compact and with good tame (i.e., planted) hay meadows, and also very close to transportation. D. *very* pleased as he always liked this ranch." A few months later, in September, Deadwood grazed three thousand sheep on the 150 Mile Ranch, but he did not keep sheep for long.

Near the house, Deadwood replaced several of the twelve aging log abodes with new buildings such as a blacksmith's shop. According to Vivien, Moore's sons had once had homes on the property, and Deadwood repurposed the wood from those dwellings for new structures. "One house was moved up behind our house for a dairy and later on was used as an ice-house and meat room, where half a carcass would hang. A large section of a tree was used as a chopping block." Hired help stayed in bunkhouses, and some families found accommodation in other structures. Deadwood constructed kilometres of irrigation ditches to water the arid fields. He developed a cattle business and maintained the store.

Deadwood also built a small, octagonal framework to house a Delco generator. Carole Hutchinson, who grew up on the Cotton Ranch, remembers that Deadwood later lovingly added a playhouse area above the generator for Dru.[9] Hutchinson and Dru sat through formal teas with Vivien and Mrs. Cotton and then escaped to the playhouse. Years earlier, Deadwood had provided Sonia with a playroom above the dairy and meat room. Her playhouse had bay windows on both sides and "stairs in from the back porch on one side & out to the garden on the other side. It had many shelves for my assorted collections of books, feathers, birds' eggs & toy farm animals."[10] The family spaniel, Laddie, renamed Mr. Timothy by Sonia, kept her company in the play area.

In order to supply the house with water, and for fire protection, Deadwood constructed a large wooden reservoir on log stilts. Vivien wrote, "He loved little tower-like affairs and indulged this fancy when he could. The water tower on a small knoll above the house (for gravity) was on a tall framework with a narrow walk around the huge tank. This he used for flight shooting in the autumn at twilight when the ducks flew over. The water was pumped up by a 'ram' from the San Jose stream … which ran through the ranch." According to Sonia, her father walked to the water tower every day, climbed its log stairs and enjoyed surveying the ranch from the high vantage. Years later, Sonia painted the water tower; in 1953, Joe Plaskett depicted the structure using pastel on paper.[11] Viewed from afar, Plaskett's image conveys a sombre, utilitarian presence. Sonia's oil-on-paper close-up view depicts a deteriorating structure (without its protective platform fencing) bravely standing its ground against a turbulent, menacing sky.

Vivien recounted that Deadwood loved the San Jose River and "[dammed] it up and made a pond and a little way below the bridge he had a swimming pool made by trading a horse to an Indian, to dam it up. Of course, an attractive trail led to it, which crossed and re-crossed the stream by rustic bridges, which he built and stained brown. All these were washed away by spring freshets in time, but he had fun doing it all and the children had rafts and swam and fished." Such landscaping likely rekindled Deadwood's memories of the huge American farms he had visited in his youth and the smaller one he had lost because of floods.

The Cowans built one of the area's rare homemade tennis courts of the day: priests from St. Joseph's Mission, visiting dignitaries, local enthusiasts and "tennis buffs from all over including the BC and Canadian champions, and the junior champion from Hungary"[12] played on the court. Arnold Long, who had played for Canada at Wimbledon, lived in Williams Lake and was a family friend. He often played and gave tennis lessons on the Cowan court. It was constructed of packed-down grass, so weeds were often a problem. At the best of times, Vivien struggled to maintain the court.

Living in isolation, Vivien used varying strategies to entertain her young daughter. One of Sonia's earliest recollections was of Vivien driving home: "She was the driver in our family, (most unusual in those days) from the 150 Mile House Post Office where we had gone to collect the twice-weekly mail. I could hardly see over the dashboard but managed to raise myself up enough to see the wondrous sight of all the 'fairies' that she pointed out, dancing on the snow in our headlights, a fact that some years later I pointed out to my children when they were small, and a fact which we all still remark on with joy on a clear moonlight night in winter."[13]

Prior to attending school, Sonia learned to ride, skate, swim (a lifelong pleasure) and paint. There was not a school nearby, so Vivien undertook Sonia's early education in a fun manner that developed into a lifelong love of learning. Sonia acquired basic arithmetic skills by playing card games with Vivien, particularly cribbage and then bridge. Variations on the game of fish taught Sonia French, geography and history. Sonia wrote that her mother must have spent hours designing and hand-printing those games. Vivien read to Sonia so often that Sonia soon learned to recognize words. Sonia's vocabulary and love of crossword puzzles likely came from her father. Daily, he would find an obscure word in a dictionary and for the rest of the day practise using the word in sentences. Deadwood also liked reading aloud. Sonia chronicled that he read to her "whatever book he happened to be reading at the time: biographies of Gladstone and Disraeli he particularly enjoyed; autobiographies of diplomats of the British Empire; autobiographies of well-known big game

hunters and collectors of the world. A strange combination for a child! ... Possibly, the fact that I am immensely interested in politics in an inactive way stemmed from that early reading."[14]

Sonia revelled in her freedom on the ranch but also liked accompanying her father as he travelled about inspecting the numerous ranches under his care. She estimated that during her childhood, Deadwood was responsible for over fifty thousand acres. Sonia's only discomfort on those outings was that her dad did not always pay attention to her requests to go to the bathroom, which made her "embarrassed beyond everything." Sometimes during Deadwood's inspections, his Irish temper ignited, but first he always told Sonia, "Run along now." She would only go out of his sight and often listened as her father reprimanded his help with "some real language."[15]

While he was gentle with his family, Deadwood's temper intimidated the hired men. Karen Thompson, the daughter of Orville Fletcher, retells a story passed on by her dad, one of the "150 Cowboys." Fletcher and the other hands were uneasy about asking for their pay so they could attend the Williams Lake Stampede. Finally, Fletcher plucked up his courage and approached the boss. To Fletcher's surprise, Deadwood immediately wrote a cheque. Fletcher was so thrilled he did not look at the amount. Outside with the other hands, Fletcher was chagrined to discover the men only had five dollars to share between them.[16] Either Deadwood did not have the cash, or he was ensuring that his employees would be on the job the next morning. Either way, none of the cowpokes dared approach Deadwood for more money that day.

Sonia often sat out of sight on the stairs listening to the conversations as her parents and visitors had pre-dinner drinks. She divulged in her writings that the best Scotch was only fifty cents a bottle and her parents purchased it by the case: "No wonder they always left a bit at the bottom of their glasses." A "favourite pastime" of hers was "to duck out from my hiding place under the dining-room table where I was well screened by the long white linen tablecloth and sip up the leftovers. Good for my health, I'm sure."

In 1929, Vivien was pregnant with Dru. Her widowed mother, Alice Tully, came to visit. Vivien recounted that their summer days were joyful: "We took our lunch over to the haystacks. We were laden with books, paints, toys, etc.... Laddie (our Spaniel) much excited. We spread rugs and ate our scones, etc., immediately feeling the outdoor hunger, amidst, much laughter. Sonia and I sketched and Grannie read." Sonia and her grandmother frequently performed concerts on their mouth organs during such picnics.

When Sonia was nine, the Pragnell family suggested that she join their daughter, Audrey, in Miss Beattie's private school in Kamloops.

The 150 Mile Cowboys, circa 1930–35. Left to right Unidentified, Orville Fletcher, Clarence Zirnhelt, Spencer Patenaude. Courtesy of David and Susan Zirnhelt.

When her father could not take her, Sonia rode the stagecoach to Ash-croft; from there she took a train. Almost seventy years later, Sonia wist-fully recounted that during the journey, the stagecoach driver sometimes stopped for the passengers to shoot ducks. On occasion, as she further reminisced, "[the stagecoach driver] and I would sit on the platform & wait for the old C.P.R. in the middle of the night & he would tell me stories. You can imagine how I loved it—all dark around & the Balm of Gilead leaves whispering in the breeze & the sound of the train far away.... Happy moments in one's life!"[17]

Sonia spent two years in the one-room school with eight grades and wrote she "was thrilled" at the idea of going to school and the adventure of living with her playmate, Audrey. Besides the core curriculum, Sonia also studied music, dancing, sewing and drawing. The first report home stated that Sonia was an "intelligent pupil and will make a good stu-dent."[18] Vivien was not surprised as she described Sonia as "being ready to swallow books whole!" Sonia found the school

> very well organized and very good training for one's concen-tration. While the two grades were being taught, the others were assigned work & forbidden to listen to the classes going on about them. Of course, if you were quick you listened to the class ahead of you and then thought you knew everything. If your mind wandered & you listened to Grade 2 & [the] Grade 7 class at the same time & therefore got none of your Grade 4 work done—you then got the strap and promised to do better in the future.

Curious individual that she was, Sonia undoubtedly listened to the other classes but does not seem to have ever received a strapping.

In return for free room and board, Audrey spent the summers at the Onward, an arrangement that delighted Sonia. According to Vivien, the girls only had to abide by two rules: "to be dressed for meals and on time—never keep the cook waiting!" The rest of the time, they inhabited their own realms of fantasy. Up a gulley, Sonia said she and Audrey built their own ranch complete with a corral for their horses and a "cabin." Taught to "always look after your animals first," the girls concentrated on teaching their horses circus tricks. Sonia lamented that neither the horses nor Mr. Timothy, the family dog, "saw the point of cooperating." Sonia further complained Audrey was better on a horse.

After her two years of schooling in Kamloops, Sonia became a student and boarder at Strathcona Lodge School on Vancouver Island. While she was there, her father wrote her every day and often enclosed

twenty-five cents. Sonia joked that because of the Depression, Deadwood "borrowed the money back to take me to the movies!" She found her father's letters "an extraordinary thing" as the other girls' fathers only corresponded on special occasions such as birthdays. In his letters, which he signed "Deadwood," Sonia's dad related events at the ranch, and if he had no news, "He wrote stories of his earlier life."[19] Sonia's abilities to engage listeners likely grew from her father's captivating narratives.

Sonia was the youngest in her grade eight class and recorded that she "loved every minute—all the activity, all the friends, all the learning."[20] She rejoiced that she was "taught to relate to everything globally & [studied] citizenship [and] also politics worldwide.... The more I think of it, our school was a way ahead of its time. And lots of fun!"[21] Sonia became the head girl, matriculated at sixteen and passed entrance exams to McGill University. Her desire was to study set design. She explained: "I had always loved to draw & paint and I was also a movie & theatre fan. Why not combine the two? ... I spent hours reading everything at all about theatre work."[22]

Vivien ignited Sonia's interest in painting early on, partly from self-interest. In order to have time to paint herself, Vivien set up a studio in the attic of the Onward home. There, Vivien said, she "painted endless still-lifes." To keep Sonia entertained, Vivien made her a small easel. Sonia explained Vivien kept her interested "by making a scribble on my easel & saying a mouse had painted it for me in the night. No doubt the still-lifes did me good as she was very fussy with my compositions & my interruptions of folds in background clothes, etc." When in grade school, Sonia attended Saturday morning art lessons. She discovered that the instructor's "method in watercolours was to copy old masters."[23] At Strathcona Lodge, Sonia's art teacher was the Canadian painter Lawrie Warrener. He had known and painted with members of the Group of Seven and regaled his students with stories about the iconic men. The Group's art, along with Tom Thomson's, inspired Sonia over the years. Judging by four examples of Sonia's early watercolour work, one done as early as age nine, Sonia clearly had strong technical skills. One study was of the Onward Ranch, a motif she portrayed numerous times during her career. Another was a rendering of flowers and two are classical scenes of Europe. Inscribed on the back of the depiction of a pastoral Dutch countryside is "Collection of the artist, 1929." Sonia may have written the inscription, but more likely Vivien did to strongly encourage her daughter. Many years later, Sonia honed her abilities to capture vigorous images of BC's Central Interior.

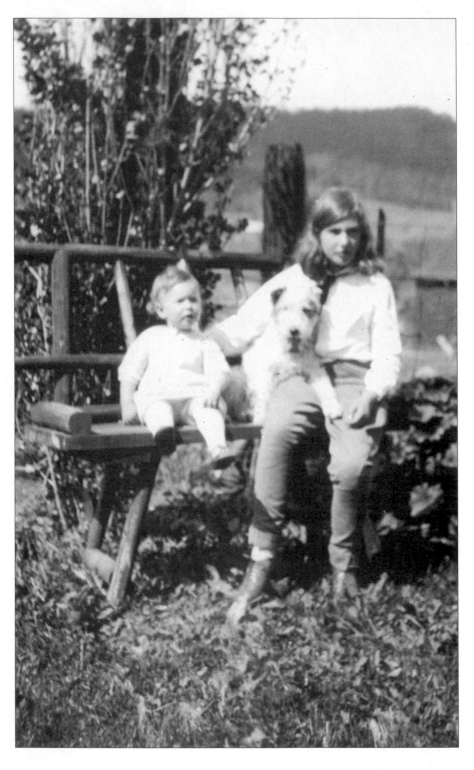

High Society and Insolvency

In 1930, Vivien gave birth to a second daughter, named Dru. Both she and Sonia grew up freely roaming among the poplar copses, the lush meadows and the thickets along the San Jose River. Their father gave them horses, and from a young age, they rode amongst the rolling hillsides and pastures. They became knowledgeable about gardening, cattle and local plants and animals. Sonia also learned how to shoot, something she did into her later years. Gophers, the bane of ranchers, were her most frequent targets. As a child, she had learned to follow cattle trails with her dad. In her adult life, Sonia often walked parts of the Onward, and later the Jones Lake Ranch, looking for painting motifs. Cattle paths often led her to those subjects.

Because of her father's various enterprises and her parents' connections, Sonia met a variety of local ranchers, cowboys, First Nations people, Catholic priests and British gentry such as Lord Willingdon (Canada's thirteenth Governor General, 1926–1931). Vivien said her visitors' book resembled Burke's Peerage as various British personages came to view the properties Deadwood had purchased or managed for them.

One such dignitary was Martin Cecil, who later became the 7th Marquess of Exeter. He befriended the Cowans and was a constant visitor. Unlike most of the affluent English investing in Canadian agricultural land, Cecil immigrated to this county, settled in the Cariboo and made significant contributions to the area.[1] His experiences reflect life in the region early in the twentieth century and highlight the many adversities ranchers endured. In 1930, Cecil was "feeling restricted by the upper-class English requirements or assumptions"[2] regarding his career choices and sailed to Canada. Although he knew nothing about cattle, Cecil hoped to improve the profits of his father's ranch at 100 Mile House (as under Deadwood the business seemed always to be losing money). Deadwood met the twenty-one-year-old Martin and his father, Lord Exeter, in Kamloops. With His Lordship in the front seat and Martin and Deadwood in the rumble seat, Bob Miller drove them to 100 Mile House in the Cowans' blue McLaughlin Buick. Martin Cecil would later relate that the bumpy

OPPOSITE: Sonia and Dru Cowan, Onward Ranch, 1930. Courtesy of the Cornwall Family Archive.

Charles Cowan and his chauffeur Bob Miller, date unknown. Courtesy of the Cornwall Family Archive.

ride had left a "strong impression ... particularly ... upon his buttocks."[3] On arrival, Martin found a town of ten or so people, a store and post office, a barn and a log structure that had been built by Syd and Frank Stephenson for blacksmithing and carpentry work.

The Bridge Creek Cattle Ranch had eight hundred head on fifteen thousand acres. After one month, Lord Exeter returned to England. Although Cecil had some help from the Cowans and neighbours, he was on his own. Martin learned to dig ditches, set up irrigation systems, hay meadows, brand, castrate and care for a large herd. His home was the old 100 Mile roadhouse known as Bridge Creek House (built by Thomas Miller). Vivien described the dwelling as a "very, very ancient log house, composed of several log houses joined or attached by [oddly] shaped rambling passages and bits and pieces added on in various directions." Though she visited numerous times over the years, Vivien admitted that she "never did learn the hang of it and it was something of a feat to find one's way.... I never penetrated the upstairs—'full of bugs' was the word about it—and I don't know where the stairs were." In 1937, the ramshackle structure burned down. Cecil humorously commented, "There was a terrible loss of life, none of it human."[4]

During his first years in the decrepit residence, Martin Cecil inhabited a small room with a wood stove that rapidly generated searing heat. As he slept during the winter, however, the sweltering temperatures would quickly plummet to below freezing. He and his father decided that a modern hotel on the site would attract customers and add to the company's profits. Without any knowledge of construction, Cecil embarked on the job of building such an establishment. His knowledge came from a book titled *Every Man His Own Builder,* various manuals on topics such as plumbing and a crash correspondence course on architecture. The wood he planed was uneven, and when he commenced roofing, the walls began to bulge. He hit upon the idea of holding them together with a cable "and spiked a couple of jackpines across the top as joists."[5] For several decades that new structure, known as the 100 Mile House Lodge, served the chapter of the Emissaries of Divine Light that Cecil helped develop.[6]

Cecil enjoyed his life in the Cariboo and for several years was the president of the Cariboo Cattlemen's Association. He showed no blueblood pretensions and worked hard. When he needed help, he often hired hands from the nearby Canim Lake Reserve because "they were good workers and knew the country. After a hard day at branding, Cecil would fetch some cold beer; although it was illegal to supply liquor to Native people, branding is thirsty work."[7] A few of Cecil's 1933 diary entries highlight a rancher's life at that time:

Thursday, July 13: Up at 06:00. Sold 55 hides to Mr. Weltmay, 48 at 4 cents per lb., 7 at 1 cent (spoilt), also 20 lbs. of horse hair at 10 cents per lb. Total $42.69. Rode up to the Highlands. Howard ploughing. Hay not very good except in meadow at head of lake. Sweet clover good…. Alfalfa no good.

Tuesday, July 18: Took lunch and rode out to Buffalo Lake…. Flies bad in the bush.

Monday, July 24: Worked with hay crew all day…. 90 degrees in the shade. Hoodoo day—barn hoist rope broke three times, broke new mower knife, broke new slings, Ben fell off his stallion. Foulis had a runaway with the mail team … smashing harness and Democrat.[8]

An article Cecil published in the British magazine *Field* further captures the seasonal changes, agricultural labour and the lure of the Cariboo:

From the moment that the spring break-up takes place to the time of the freeze-up in the fall there is no time to be wasted. The "open" seasons are all too short! The spring is so brief that one might almost say that winter jumps straight into summer, and yet there are fields to plough, crops to put in, irrigation ditches and flumes to fix, gardens to plant, calving cows to watch, and a hundred-and-one jobs all shouting for attention. Then comes the round-up for branding the calves. This may take anything from two days to two weeks, according to the number of cattle and the distance that they have drifted on the range…. There are also fences to mend, cattle to pull out of mud holes, horses to break—in fact one d---n thing after another! … When the haying is completed it is just about time to commence harvesting, and by the time the crop is cut and threshed the snow is flying and it is time for the fall round-up…. The clear days and cold nights and the superb colouring of the countryside make the fall the most beautiful season of the year…. The winter is long and cold with plenty of snow, but an abundance of sunshine…. Night succeeds day; the stars look down from a cloudless sky on a silent white world. A silence as of suspense, waiting maybe for life to come to everything and another year's work to the rancher.[9]

OPPOSITE: Sonia Cowan and Martin Cecil, circa 1930s. Courtesy of the Cornwall Family Archive.

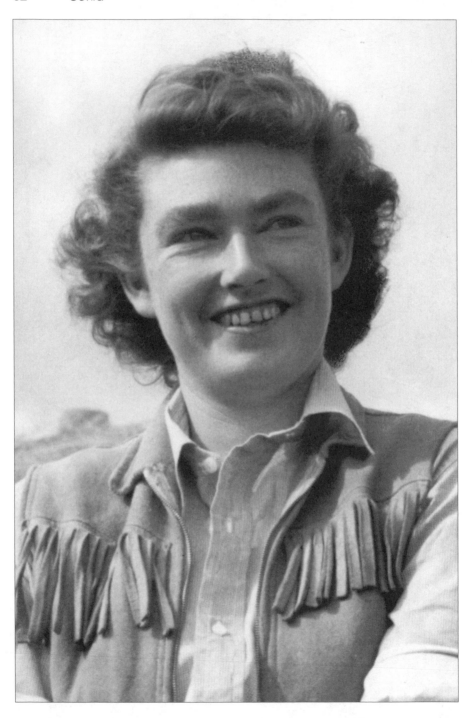

Sonia Cowan, Croton Studio (New Westminster), circa 1940s. Courtesy of the Cornwall Family Archive

The Cowans befriended Cecil and, later, his wife and child. Cecil often discussed ranching with Deadwood and obviously learned from the older, more experienced man. As he liked to draw, Cecil enjoyed conversing about art and artists with Vivien. She remembered him as "quiet but he had a very hearty laugh.... We were very fond of him. He was affectionate and kind, and used to draw pictures of animals and cowboys for our two daughters." In addition, Sonia found Cecil "very good-looking and full of fun."[10] In a letter dated July 10, 1930, Deadwood assured Lord Exeter that "Martin is OK.... We are right glad to have him.... Martin comes to us in a day or two for a little rest. He is working hard, so hard that when I last saw him he not merely had his coat off, but his shirt, and the perspiration was running down him."[11]

In 1934, Cecil married and brought his first wife (Edith Csanady de Telegd) to the Cariboo. Their son, Michael, recalls his family travelling to the Onward often when he was a youngster. He says they usually stayed overnight because "a drive from 100 Mile to Williams Lake was not for children: it was a really rough road. If you went that far, sixty miles or so, you probably wanted to stay over." He also believes that Vivien helped his mother adjust to her rugged new life: "Vivien was very kind and a good friend of the family in that way."[12] The Cecils reciprocated in various ways, and Sonia remembered that on one occasion Martin drove her to Vancouver when she was returning to school on Vancouver Island.

Vivien wrote that during their visits to the Cecils', the Cowans were always given "a tiny sitting room, more like a passageway, as it was one of the connecting links between the log buildings." The oilcloth (a waterproof fabric) on the walls had discoloured over time and as it hung over uneven boards, it "gave a wrinkled effect" that Vivien found unattractive. The room contained "a home-made table, very rough and wobbly, the ever-present hissing lamp, and two wooden kitchen chairs." Amazingly, Martin Cecil's mother, Lady Exeter, occupied the same sparse room when she visited.

Michael only has "fleeting memories of Sonia" from those days, but says that even as a boy he liked her. In later years, the two met up again, and Michael enjoyed renewing what he describes as their "very lovely contact." He "was really pleased to drive up from 100 Mile House" to visit Sonia and "really enjoyed her artwork. We talked very comfortably about just about anything.... She was fun, amusing and interested in life in a larger way and full of exploratory thought."[13] Sonia recalled that she "used to dangle Michael on my knee when he was a baby!" She believed she and Michael had "a lasting connection," partly because he had lost his mother at an early age and Sonia could relate stories about Edith. Sonia recorded that on one visit she and Michael "had a lot of laughing" over

her recollection of the time she was eating with Lord and Lady Martin Cecil in the 100 Mile House Lodge dining room. Martin "looked like any cowboy" and tourists loudly proclaimed to a server, "They heard there was a lord here somewhere—where was he?" Sonia said she and Edith had "a fit of giggles" while Martin tried "to keep a straight face."[14]

During bird-shooting season, the Cowans often hosted hunters from various locales. Other times, they forayed to the Wynn-Johnson ranch at Alkali Lake or the 105 or 100 Mile areas. Vivien described a young Sonia "trotting behind her father with a long stick, as her gun, held as he taught her, under her arm with the muzzle pointing downwards." Deadwood wished some of his hunting visitors were as careful. One year Lord Graham—who was, according to Sonia, a relative of Queen Elizabeth the Queen Mother—visited for a week. Sonia often told the story of how the nobleman "wanted to be a cowboy"; therefore, he spent time practising lassoing. However, Deadwood was not pleased when the patrician lost one of Cowan's rifles while they were out hunting.[15] After such outings, Sonia recounted, "What a joy to come back to the ranch tired from walking and all that fresh air. The ducks & geese must be sorted & counted then given to Mr. Miller to hang up carefully."

When she went to school on Vancouver Island, Sonia's parents relocated to Victoria from November to April. They rented a house and moved trunks of china, linens, clothing and at least one crate of books. Sonia remembered that the family did not move all their silver. Therefore, Vivien would hide a portion. One time she buried the remainder under the mint in the garden. Sonia was her witness, and the gardener was forbidden to dig up the mint.

The family, with at least twelve crates, boarded the train from their own Onward Station. That structure had a freight room and a waiting room. Cowan left a hired manager to look after the ranch. According to Vivien, John Zirnhelt, grandfather of the former New Democratic MLA David Zirnhelt, became the Cowans' highly trusted "cattle manger and cowboy." During the winter, he oversaw the tasks of feeding and watering the animals and making hayracks and fence posts. Vivien noted that Zirnhelt helped with the baggage and saw them off if they were taking the train. Sometimes, the family drove, as the train service was notoriously unreliable. The Cowans kept up this winter routine for eighteen years, until Deadwood's health seriously waned in 1934.

As part of Victoria's society, the family attended church on Sundays. Sonia's niece, Devereux Hodgson, divulges that Deadwood did not like sitting through the service. When Dru was small, he would whisper to Vivien that the youngster was restless and he should take her out before she made a commotion. He would then walk about outside and often

bought Dru candy.[16] Is it any wonder she fidgeted in church? Sonia may have longed to escape as well, but she was too old for Vivien to let her go. Sonia never became religious and was not a churchgoer in her adult life. She was a polite, sociable child but timid and nervous. When Sonia reached the age at which young women were formally introduced into society, she balked at being a debutante at Government House. Vivien called her a "reluctant dragon" and insisted that Sonia participate. Sonia's apprehensiveness in large groups and her reluctance to dress in what Vivien saw as "a lovely dress, evening coat, gloves and a bag" set Sonia apart from her stylish mom and younger sister.

During the early 1930s, the Cowans lived well despite the growing deprivations of the Depression. Vivien had no idea that Deadwood's enterprises were gathering more and more debt. They entertained, ordered specialized stationery and imported clothing from England. They still wintered in Victoria, renting a house or hotel rooms for three or four months. In 1934, they stayed in accommodations they often frequented during their winter sojourns, the Guest House in Oak Bay. They enjoyed two bedrooms and a sitting room with meals served in the dining room. While there, Deadwood's mounting financial stresses led to an angina attack. On the doctor's orders, the Cowans rented a house at sea level. Vivien employed a cook, and when her mother moved to Victoria, she paid for Mrs. Tully to live at the Guest House. To pass the time, Deadwood started writing his autobiography while John Zirnhelt managed the ranch's affairs.

When she was finally aware of the family's waning finances, Vivien considered removing both Sonia and Dru from their respective schools. Their headmistresses insisted that the girls stay and the tuitions be paid later. Appreciative, Vivien eventually reimbursed them. (In later years, Miss Gildea, Sonia's headmistress, spent several summers at the Onward as recompense. Ironically, the educator died in her sleep during one visit.) The Cowans remained in Victoria where they lived quietly for the next two years, but Deadwood's health worsened with heart attacks and strokes. In November 1936, after a massive stroke, he became a patient at Royal Jubilee Hospital. He remained a patient for approximately three years. Vivien quietly and doggedly endured her grief and worries over mounting living expenses and hospital bills.

Because of the lack of funds during those years, Sonia had to give up her dream of attending McGill University to study theatre set designing. A family friend suggested that with some training, Sonia could help the family recover financially. The friend recommended that Sonia enrol in courses at Sprott Shaw College. Sonia's daughter Mary Cornwall explains that although Sonia "saw it as her responsibility to get a job, the

schooling didn't last long. Mom came out in rashes. The doctor told her she had to stop."[17]

With a marriageable daughter at home, Vivien seems to have been interested in socially commendable suitors. As a result, some friction arose between the two women. Sonia complained that she "was always being shoved off to dances to meet the right boys. No matter what their families & backgrounds I knew they were not the right boys." Instead of pursuing an acceptable husband, Sonia joined Victoria's Little Theatre and the Beaux Arts, designing and painting stage sets. She also enrolled in a three-month stage design course offered in Victoria by Don May from Seattle's Cornish Theatre.

Increasingly depressed and distraught, Vivien had her mother move in, hired a maid and retained her cook. Vivien rationalized, "I probably would have had a nervous breakdown if I hadn't held on to a cook." Fortunately, the Onward and 150 Mile ranches were still intact. As he had promised, the "faithful and loyal" (as Vivien called him) John Zirnhelt was supervising the care of the cattle and the agricultural work. He and the local bank manager, Gordon Fox, were administering the payment of the hired men's wages and the cattle sales. By June 1939, with hospital and day-to-day expenses, Vivien's personal debt was approaching five thousand dollars. Her banker counselled her to return to the Cariboo where the cost of living was lower. She was reluctant to leave Deadwood, but Vivien had no other option.

While Vivien soon realized she had to cope with "the bank, the government, the Farm Loan Board, and the English clients," she was dismayed to discover that Deadwood owed ninety-two thousand dollars. Her charmed and comfortable life was over. In that era, women did not run ranches, and her banker did not believe she could repay her massive and complicated debts. He told her the only thing she could do was sell her properties and herd. Vivien lamented, "Who was I but an inexperienced woman with two children and my mother to support and no previous training in the business world? I never even paid the household bills—'charge it' was my motto." Vivien was shrewd enough to recognize that both land and beef prices were low, and she hoped to delay any sales until those prices improved. She knew that in some cases, ranchers were being forced to sell their cattle, and the repercussions were often dire. She even heard that one rancher "was left, after selling his beef, without money for groceries and went home and shot himself." Vivien asked for and received some time to consider her options, but the banker did force the immediate sale of four hundred head that spring. As she knew she would, Vivien lost money because the animals' weights were low following the rigours of winter and the prices per pound were low as well.

In dire financial straits and mourning the abandonment of Dead-wood, Vivien and her girls returned to the Onward Ranch. Within months of their departure, in August 1939, Deadwood died at age seventy-one. Vivien was forty-six, Sonia was nearly twenty and Dru was nine. The repercussions of the move would affect Sonia for the rest of her life. For the next eight years, she exchanged her artistic dreams for physical labour. While that may have embittered some, Sonia relished her ranch life and deepened her affinity to the Cariboo.

Cowboys and Quagmires

Early in the morning of June 1, 1939, John Zirnhelt met Vivien, Mrs. Tully, Sonia, Dru and their twenty-eight pieces of luggage (including plants, a radio, a typewriter and two crates of books) at the Onward train station. Farm hands took the family's belongings to the house, and Zirnhelt drove the women to the 150 Mile House Hotel and beer parlour (part of the Cowan land holdings). There they consumed what Vivien termed "a ranch breakfast. Massive amounts of bacon & all the eggs and toast you could eat. Homemade jam of course. Sonia was 'glad to be back home.'" After settling in for two days, Vivien began administering what her husband, various managers and accountants had previously overseen. Fortunately, Deadwood had often requested that Vivien accompany him on business trips around the Interior. As a result, she had some knowledge of the ranching business. On June 3, Mrs. Tully recorded in her diary, "We were amused today to see Vivien stepping about the ranch with Zirnhelt. He was so anxious for her to see everything and took her knowledge and interest as a matter of course. Together they held lengthy and technical discussions on the cattle business, a subject that at first seems as remote from her line as could be. Really she shows a flair for it."[1] Moreover, Zirnhelt's expert knowledge and management skills were a vital help.

In 1928, John and Amalia Zirnhelt left Hazelton, North Dakota, with two teenaged and two adult children (three sons and a daughter), a truck, a car and five hundred dollars. After seven years of drought, they had lost the family farm and were desperate to relocate to a better climate. Hearing about homesteading possibilities in BC, they headed for Ashcroft, where they had a relative. With "a ready made and experienced" family haying crew, they worked on the Parke Ranch and made the acquaintance of Sonia's dad while in Ashcroft. Deadwood was always in need of ranch caretakers and offered Zirnhelt a position in the Cariboo. David Zirnhelt points out that the family "spent the first winter in the old stopping house at the 134 Mile, having had to shovel out a foot of cow manure from the old place and make it liveable."[2] In 1929, John Zirnhelt started managing the 150 Mile Ranch and his family moved there. Due to the Depression, then World War II and his dedication to the Cowan family, Zirnhelt never managed to buy a ranch of his own.

His grandson David explains that John "was known as a good farmer. He built an extensive flood irrigation system to distribute water on the big field behind the 150 Store. His wheelwright and blacksmithing skills were well known and that made a small business that brought in some cash. John built a derrick hay stacker.... He built and ran a sawmill, loading logs onto the carriage by hand. His grandson John ... remembers seeing him pack a birch log out of the bush to make a sleigh runner. He was renowned for his physical strength."[3] In addition, Zirnhelt and his brother started a successful horse-training and stud-horse business.

John was a forbidding boss. David recalls a story told to him by some local cowboys. They were working in the sawmill Zirnhelt managed and "it broke down while John was away. He was out doing something on the ranch, and they didn't want to be there when he returned." They also told David that his grandfather could undo the nuts of a tractor wheel using only his powerful hands. The other astonishing anecdote about John Zirnhelt describes a day when he and some hired hands from Sugar Cane were on their way from the 150 Mile Ranch to the Onward. John had a heart attack. He was lying on the ground unconscious, and the men kicked John in the foot until he regained his senses. John then insisted that he and the crew continue on their way to the Onward.[4]

Those stories became part of the family's lore, as did an amusing tale about John's wife, Amalia. She was a frugal individual, "had to be, and kept valuable cooking ingredients like sugar under her bed to prevent family and hired hands raiding the cupboards. She used to joke about making sauerkraut in [a] stone urn with a weighted lid which she also kept under the bed, much to her husband's disgust."[5] While John was not a man with whom one trifled, Amalia could obviously hold her own.

Regularly, Zirnhelt would tell Vivien to join him when inspecting the cattle that were being fattened for a sale. She would do so and never let on how terrified she sometimes was: "I would go into the corrals with him, and cattle being very inquisitive creatures they would rush on pounding feet over to see us at close range. Not too pleasant having huge beasts breathing grain down one's neck! … I was glad that Zirnhelt was a big burly man and the fence was close by. I was always having to 'save face' by going amongst the cattle on foot, even with bulls in the corrals."

The autumn sales occurred at the Williams Lake stockyards. There Vivien would buy and sell. As she and Zirnhelt wandered between the corrals, they sometimes encountered bawling animals on the move from one holding pen to another. Vivien worried: "High fences, so no escape but Zirnhelt would say calmly: 'Oh, it's all right, they're our own.' I wasn't so sure that they recognized me in my town clothes (or otherwise)." Sonia does not seem to have shared her mother's fears, unless she encountered

bulls in the pastures. Vivien's written description and Sonia's paintings and sketches capture the "informal" and "smaller haphazard scale" in which the auctions took place. Those images are a stark contrast to modern sales, which mostly occur via the Internet. Vivien vividly depicted the event:

> One sat in an open rough grandstand, overlooking the auction ring and a carload of cattle (twenty-five head) would be pushed into the ring by cowboys. The auctioneer sat in a small tower overlooking the ring. For years, it was Matt Hassen who was very well known at all the auctions of cattle throughout British Columbia. He knew everyone and often called out remarks to the bidders. After buying a carload, small boys (runners) would take a card to the buyer to sign and this was taken to the office where volunteer workers dealt with it. It was usually late autumn when our two big sales would be on and it would often be bitterly cold, sitting on hard wooden benches for hours. Any cattle that I bought would have to be weighed and inspected by the Brand Inspector, the burly Joe Smith. I would always cope with this—Zirnhelt attending, of course. I would be wedged in the tiny [six-by-eight-foot] hut, beside the scales, with the men, while the cowboys would drive about a dozen head on to the scales and quickly shut the high gate. After getting the weights, they [the cattle] would be let out on the other end into another corral. I did the figuring by the light of a lantern on a narrow shelf, as of course it got dark early at that season and there were no windows, just an open front adjoining the scales. With snow and ice in every crevice, it could be anything from zero to ten below zero [Fahrenheit], or even colder, and only with a tiny pot-bellied stove to warm our hands by, so that we could write.... After settling up in the office it would be too dark to drive our cattle home so the riders would return the next morning, ten miles away. If I were selling beef cattle, the same procedure would take place with whichever buyer: Burns, Swift or Canada Packers, the main packers—watching their weights and brand inspection, so the little hut could be very crowded—standing room only ... an unforgettable scene.

With Zirnhelt's counsel, Vivien successfully administered the Onward and 150 Mile ranches, and eventually cleared herself of debt. That remarkable feat still astounds David Zirnhelt, who views Vivien as a "pioneer female ranch manager." He thinks that Vivien and John Zirnhelt

started buying and selling more frequently than did other ranchers in the area. Indeed, in her autobiography, Vivien wrote that during World War II profits were possible if she "bought 'feeders' (i.e., lean cattle) at the stockyards in the autumn sales to grain feed them for several months." David says that was an unusual practice for the time because most local ranchers were not growing grain, and they only began doing so in the 1950s because they had access to "cheap fertilizer that was in surplus after the war."[6] Also helpful was that Vivien could ship cattle from the Onward Station, saving her time and money. Moreover, she and John Zirnhelt were perceptive and took advantage of every possibility. Vivien described one such situation in October 1944 that she felt "was a highlight" in her agricultural experience.

> It was a fluke that I was the biggest buyer at the sale.... The cattle for sale are graded according to their being beef cattle or stockers (i.e., thin ones) and car-load lots (25 head) are put into pens, ready for the auction. The big packers: Burns, Swift, Canada Packers, etc., are at the sale to buy beef, and others come from all over the province and locally to buy stockers. I was in the latter class, of course. It just happened that this year they were *badly graded*—fat cattle ready for market in with thin ones.... When each carload came into the ring, the beef buyers wouldn't bid because of the lean ones in the lot and the ranchers wouldn't bid because the prices were too high on account of the fat ones ... so Zirnhelt and I thought, why not buy the load and sell the beef cattle and keep the feeders? This we did and bought carload after carload.... Sonia was one of the workers in the office and when the slips kept coming in with my signature for four hundred head, she thought I had gone berserk! I was way over the amount the bank had au-thorized.... I now know how gamblers feel.... I came out of the stand and a big rancher, well known as a cranky individual, came up to me and said: "Let me know if you have trouble with the bank and I'll back you." ... However, after explaining my plans they okayed my cheque. The next week we sold a hundred head of fat beef from the lot and the rest we kept to grain feed.

David Zirnhelt says,

> [Vivien] was very appreciative of my grandfather's loyalty and expertise. Before my grandfather died in '48 ... Mrs. Cowan made parcels of land available to our family ... at reasonable

prices. So, my aunt and her husband [Jack and Marcella (Zirn-
helt) McPhail] started a garage [at 150 Mile House].... My dad,
Clarence, ended up with the store property: he took over the
Cowans' mortgage and his back wages from the 150 Ranch
made up part of the payment. One of my uncles had the Heini
or Pigeon place, which was adjoining the 150. I'm not sure
of all the business transactions, but when they could help our
family, Mrs. Cowan and her family did. It was in consideration
of loyalty and help from Grandpa John. It was a nice thing.[7]

Vivien's own acuity was important to her success as well. One cold
November evening some prospective cattle buyers did not arrive at the
Onward until nine o'clock. The men were cold, hungry and exhausted.
When she heard the buyer from Swift's mutter that he was not going to
view any cattle that night, Vivien immediately seated them in front of a
roaring fire and handed each a hot toddy. She served a delicious meal of
roast beef, potatoes and gravy, Yorkshire pudding and vegetables, followed
by pie. Afterwards they went out to the barns and placed their bids. Vivien
received a good price and she prided herself that "the warm welcoming
atmosphere, two lively laughing girls chaffing them, my mother talking
so interestedly with them, all helped to turn the tide of weariness into a
pleasant time." Moreover, the buyers studied Sonia's and Vivien's paintings
and, as the men invariably had relatives who painted, they felt a kinship
with the Cowan women. Still, selling cattle was seldom easy. Besides mar-
ket demands regularly rising and dipping, there was sometimes collusion
among the buyers. In one diary entry, Mrs. Tully noted a "situation" be-
cause the buyers had agreed "amongst themselves to only offer 8¢—pro-
ducers up in arms and as a consequence they won't sell and there is no
beef on the market."[8]

One thousand head of cattle and sixty horses, including broodmares
and colts, comprised Vivien's livestock. Both ranches had a blacksmith's
shop in which Zirnhelt, "a wonderful blacksmith" (according to Vivien),
shoed horses, mended wagons and hay sleighs and made assorted parts
that were not readily available such as plough points. About thirty horses
worked during haying. Zirnhelt and his sons contracted the work and,
with the help of a few cowboys, harvested about twelve hundred tons of
hay. The men cut, raked, cocked and collected hay onto slings atop sleighs.
A pulley lifted the slings to the top of each stack, where a cowboy guided
and then unbuckled the load. Log enclosures held the piled hay until it
was needed for winter feeding. Sonia wrote that Zirnhelt had her rake
the hay with "an old fashioned dump rake. The hay was so heavy that it
would pull my right foot off the dump lever. I was always glad one had

to rest the horses in a shady spot every so often as I found it very tiring." Sonia appreciated that the horses seemed to know more about raking than she did. The teams were usually one younger, more energetic equine paired with an older, more experienced mate. Still she found, "It was pretty scary sometimes if you had a lively colt, but you relied on the steady old-timer." Her first day out, Sonia was so exhausted at lunch that she drank her tea before eating. She never did that again because in the six minutes it took Sonia to finish her drink, the food was gone and the men were napping. With the money that she made after her first hay season, Sonia treated herself to "a good pair of riding boots." The next year she bought herself a pair of chaps. As well, she used her meagre income for tobacco and movie tickets.

During the 1940s, Vivien mechanized with the purchase of a tractor and hydraulic lifter. However, she imparted that in 1939,

> everything was very run-down on the ranches, owing to the Depression and lack of labour so we had quite a time trying to restore things as best as we could under the circumstances. We had over a hundred miles of fencing to keep in good repair, which included the cross-fences for the various pastures and all the corrals on both places. The life of a fence post then was about seven years ... all log fences, of course.... These they sawed with a "Wee McGregor" saw [a forerunner of the modern chainsaw], as well as two hundred logs for firewood for us and other houses on the two ranches. The men filled our ice-house with huge squares of ice cut from our own lake at the 150.... Later on, when we were a little more affluent, I had a chance to buy a second-hand sawmill, which our men ran. This was a great help as lumber was prohibitive in price as well as scarce. The war was on and it was difficult to carry on, shorthanded as we were.

In spite of her diminished circumstances, Vivien's joie de vivre never waned. Along with Mrs. Tully, Vivien revelled in her rural environment: "Flocks of swallows building in the eaves of the big red barn. Scent of clover fills the air."[9] Visitors were always welcome and some arrived only fourteen days after the Cowans had resettled at the Onward. Mrs. Tully noted, "Saddle horses in great demand—English riding clothes and cowboy outfits clashed violently. The lawn looked more like a cross between a western movie and a scene from the 'Tatler,'" a British news cinema.

In the summer of 1940, another affliction hit the household. Dru came down with scarlet fever, which meant being quarantined. Then Dru

developed a double mastoid infection and was ill for three months. The youngster only allowed her mother to nurse her, and Vivien tended to Dru's ears every half hour. When Dru lost her hearing, Vivien set off for Kamloops with Dru on a mattress in the car's back seat and Zirnhelt driving. Fear for Dru's condition was only one of the worries during the trip. At one point, the car careened into a ditch and Vivien declared that Zirnhelt only "by the sheer strength of his hands on the wheel … got us back on the road, a miracle." Realizing that Zirnhelt could not see well at night, Vivien took over and drove until dawn. In the hospital, Dru had mastoid surgery, which was frightening enough, but Vivien fretted even more because she said that as skilled as he was, the surgeon was "somewhat of an alcoholic." Upon later seeing her daughter's bandaged head, Vivien commented that Dru had a pretty Easter bonnet. With the wit characteristic of the family, Dru replied "*Ether* bonnet you mean!"[10]

That summer Vivien's local bank manager announced that she could have no more credit. Most ranchers kept running loans, which allowed them to operate until the autumn cattle sales. Money earned at that time paid off the debts. Vivien consulted the owner of a large general store in Williams Lake, Roderick Mackenzie.[11] According to Vivien, Mackenzie loaned her five thousand dollars and "never asked for a note or any security. He hardly knew me but of course in a small community, everything is known and he knew we were carrying on in good order. I repaid him when my beef sold in the autumn…. I believe he did many kind things like this, that people did not know about, as on the surface he was known as a rather tough man to deal with in his store business." Vivien later learned that a friend of the bank manager's "hoped to get her ranch at a forced sale for one of the bank's other clients."

Vivien depended on Sonia, who she said "could turn her hand to anything, being very capable, from cooking to cowboy work, and later on to doing the tractor work…. She helped in the 'round up' each autumn, as well as at times when extra riders were needed." In those days, Sonia was up at 5:00 a.m. First, she saddled, fed and watered her horse, Romany. She then ate breakfast and was riding by 6:00. She and the cowboys rode about ten miles to the beginning of the range and then another ten to where the cattle were. The temperatures were often minus six to minus nine Celsius (twenty-one to sixteen degrees Fahrenheit), so when they stopped for their lunch of sandwiches, the crew lit a pitch tree to warm up. The cattle knew the way home, and they and the riders often returned home by 8:00 or 9:00 p.m. Some days Sonia and the hands would bring in a small number of only twenty or thirty cattle; other days, they would herd a hundred or so. After roundup came the branding of the calves and the cutting of the two-year-old steers that would be for sale.

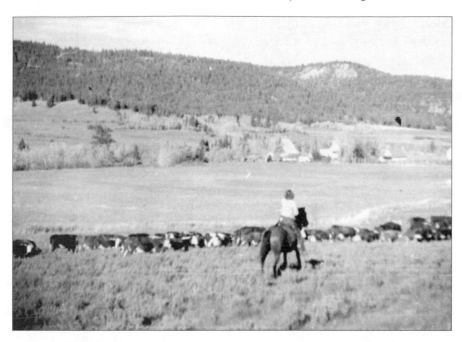

Sonia Cowan working at the Onward Ranch, circa 1940s. Courtesy of the Cornwall Family Archive.

Eventually, the family grew approximately eighty acres of grain, and Sonia was largely responsible for the necessary tractor work. Over time, she became as knowledgeable about cattle as her mother and sometimes accompanied Zirnhelt to bull sales in Kamloops. Diana French noted, "At one bull sale in Kamloops, when the committee organizing the after sale [celebratory] event realized they had no decorations, Sonia commandeered some sheets of plywood and painted appropriate background scenery on them."[12] Those panels are housed in the Museum of the Cariboo Chilcotin. Moreover, Sonia became adept at preparing food for large crowds. On days they were shipping cattle, Vivien stated they "always had a twenty pound roast in the oven." During haying and thrashing, twelve or more men could sit down to lunch. Besides cooking, Sonia often had to source the menu from the garden by digging potatoes and collecting vegetables or berries.

The annual October three-day cattle auction was a momentous occasion for the community. It was the ranchers' "annual payday," and as a result, the Williams Lake merchants had huge sales. In fact, some ranchers only paid their grocery and hardware bills once a year, after the sale. Everyone was happy, ready to socialize and attend the dance that occurred on the last evening. According to Vivien, one year, "Sonia was in charge of

cooking two hundred pounds of beef stew," complete with potatoes and onions. At the year-end stock sale, the ranchers' wives hosted a cocktail party:

> To brighten the dismal room (forty by sixty feet) Sonia would paint murals of the Cariboo country on rough paper (white sheets about four by eight feet) which lined the walls, and strips of white paper with brands as a design for the table-cloths. We would provide hearty snacks: sausage rolls, home-baked bread and buns, stuffed eggs and pies, and cakes—none of your dainty little bits of olives on crackers!
>
> The men could come in straight from the yards and get warm and have drinks from the bar ... and help themselves from the laden tables. It was a truly picturesque scene: the huge men, with their tall 'Stetson' hats, milling around greeting old friends. Later on in Sonia's painting career, she painted some large [depictions] of the scenes as she remembered them.

Winter was bleak with intense cold and snowstorms and there was less ranch work. This meant Sonia had some time to paint. How often she did so or what her subjects were is unclear. She was serious, however, and in 1947 entered a still life in oil of flowers in a vase (*Flower Piece*) in the annual, juried British Columbia Artists' Exhibition held at the Vancouver Art Gallery. The work was not accepted. Sonia might have found cold comfort in the knowledge that 270 other works of art were rejected for that exhibition (272 were displayed). If it was any consolation to Sonia, Dru also had a painting rejected (*Country of the Pointed Firs*).[13] Sonia's ambition was obvious, but she must have wondered about her artistic goals and felt much frustration at not being able to pursue her art full-time.

Joyfully, winter brought more time for socializing. Sonia and her family "livened things up" with skating on frozen lakes. Their ranch had seven small ones. Vivien recalled that after seeing who they "could collect for a party—[they would] hitch up the team to the big sleigh & make our way to a lake & build a bonfire, have some mulled wine & skate. Lovely beyond everything on a night of a full moon." On Saturday and Sunday nights, hockey games were played on outdoor rinks at various ranches. Sonia recorded in her journals, "We would hitch our team to the cutter & race along the way with sleigh bells ringing & dogs barking excitedly. The Indians from our other neighbouring ranch would race us in their sleighs & the shouting, laughing, bells & dogs made quite a commotion."

Sonia often accompanied Vivien and Zirnhelt to cattle sales. More-over, she, Vivien and Dru enjoyed participating in the annual burning

of the foliage in the irrigation ditches. Vivien described the job as "nice work in the spring air and the wood smoke from all over the valley smelt so good after the winter! We would take our lunch and work all day." The labour and returning to the ranch must have been difficult for Sonia who, like all young people, wanted to travel and pursue a career. The days were long and hard and when ploughing or haying, Sonia often worked for ten hours. She frequently fell into bed dog-tired. In her journal entry of April 30, 1944, she recounted, "Started breaking land today. The alfalfa across the track. It is very tough ploughing and leaves me exhausted at the end of the day." During ploughing season, Sonia became somewhat of a celebrity. Conductors on the Pacific Great Eastern (PGE, or the Please-Go-Easy as it was called by locals) rail line would point out the Onward Ranch. If she was ploughing or harrowing on the Ford Ferguson tractor, Sonia wrote, they would say, "'And there is Sonia' and ... everyone on the train seemed to know who Sonia was!" She was sometimes injured; for example, she once cut her knee badly while crawling under a barbed-wire fence. At the time, Williams Lake had only one doctor. Therefore, Vivien was the ranch's primary first-aid attendant. Fortunately, she had taken a St. John's Ambulance course during the Great War and could tend to minor injuries.

Sonia had an odd scare in 1943. A mentally unbalanced man telephoned the Onward and threatened her. He warned that if she did not have a horse for him when he arrived, he would chase her with a shotgun. After the police picked him up, Sonia recognized him as a hobo the local folks had dubbed "the Bluebird as he turned up every spring." A neighbour listening in on the phone contacted the police, who arrested the man an hour later. He received a one-month sentence for vagrancy. When Sonia worried what would happen upon the man's release, the police nonchalantly recommended calling them if he bothered her again. Sonia was not comforted because, as she stated, she was often alone out on the ranch or countryside and thereby far from any rapid assistance.[14] For a few years, drifters boarded or detrained at the Onward Station. But that particular man never bothered her again.

For eight years, Sonia worked as a hand alongside the men. Sonia noted that one day she had to wait for Zirnhelt to replace a broken plough point: "I filled in my time cowboying (one never knows what's next in the ranching business). Willie and I moved the cattle from the other side of the track to this side. Then we put out some strays so the morning was a busy one." To her chagrin, Zirnhelt excluded her from some activities. An old-world gentleman, he never allowed Sonia to participate in the castrating of calves, saying, "Well, you'd better go talk to Ma."[15] Decades later, Sonia observed her daughters, granddaughters and local women like

Sonia Cowan out skating, circa 1940s. Courtesy of the Cornwall Family Archive.

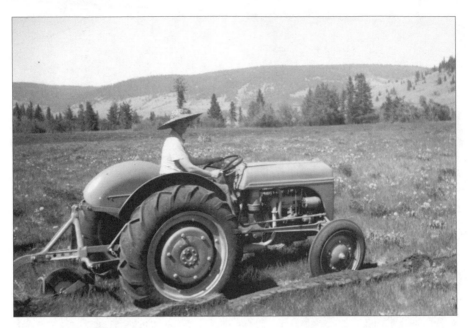

Sonia Cowan ploughing at the Onward Ranch, circa 1940s. Courtesy of the Cornwall Family Archive.

John Zirnhelt and Sonia Cowan, circa 1940s. Courtesy of the Cornwall Family Archive.

Sonia Cowan driving a bulldozer, circa 1945. Courtesy of the Cornwall Family Archive.

Pam Mahon and Carol Hilton helping with branding and castrating. Sonia chuckled to herself how times had changed and how that would shock John Zirnhelt. Sonia's other job was in the kitchen, where she often cooked for the haying and thrashing crews. As well, when Vivien had baking "binges" making puff pastry and other sweets, Sonia "objected" as she was left with a sink "piled high with pots and pans."[16] Growing several tons of potatoes and other vegetables as well as raspberries, strawberries and rhubarb kept Sonia busy. Because of that work, she developed a fondness for gardening that she retained throughout her life.

Sonia recalled that Zirnhelt gave the orders for the day: "Willie you ride today. Vince you do so & so. Sonia you plant 200 cabbages." She followed orders. The ranch garden included beets, cauliflower, carrots, lettuce, melons, onions, potatoes, radishes, tomatoes and turnips. A pump provided water from the creek, when Sonia could make it work. Early frosts sometimes ruined harvests as the land sat at approximately six hundred metres (or close to two thousand feet). What was successfully grown was stored in a large root cellar with a sod roof: included were two tons of potatoes, a ton of turnips, a ton of carrots and a half ton of beets. In a letter to the Canadian Broadcasting Corporation (CBC) radio host Peter Gzowski, Sonia noted that tomatoes were stored upside down and ripened on their vines until Christmas.[17] The cabbages kept until May.

While Sonia loved her mother, they had different temperaments, which often resulted in conflict. After long days outside, Sonia said she went home "dirty, grumpy, & exhausted." Sometimes there would be no dinner ready. Oblivious to Sonia's fatigue, her mother or grandmother would excitedly start discussing newsworthy events. Sonia would angrily retort that she did not care.

Throughout the emotional and physical demands of her life, Sonia always welcomed the understanding, silent company of dogs. After Mr. Timothy grew old and died came other canine pals: a collie named Mutt and a terrier, Nijinsky (named after the Russian ballet dancer). Nijinsky was a city-raised animal that chased cattle, horses, chickens and even groundhogs, barking continuously. Sonia marvelled that no one shot him. She, however, always indulged her pets. For example, when the below-zero temperatures set in, Nijinsky would not go out. Feeling sorry for him, Sonia dressed him in a camelhair vest of hers. Humorously, she wrote that Nijinsky did not like the ranch dogs to see him dressed for the cold. When Sonia ploughed, the two dogs followed her furrows or slept in them. She had a hard time being stern with her pets. She often gave in and took them hunting at times, even though they would scare away the game. Sonia took comfort from her canine companions and her work because, as she stated, "I loved the life and & also it removed the onus from

me as to whether I should be doing something else." That "onus" seems to have hung heavily over Sonia. In her journals, she wrote of wanting to do something worthwhile with her life. Perhaps that is why, once Sonia had time to paint, she was so prolific with and passionate about recording images of the Cariboo.

With only her mom and grandmother for company, and her younger sister (when Dru was home from school), Sonia must have yearned for people of her own age. There was a steady stream of visitors to the ranch and Sonia enjoyed the company, including Lord and Lady Exeter and their son, Michael. Some of her school friends did visit during the summer holiday months, but the rest of the time Sonia chummed with the itinerant cowboys "following the grub line,"[18] temporary workers from the Sugar Cane Reserve and the Air Force men stationed in and around 150 Mile House during World War II. Vivien said she "kept open house" for the airmen posted to the booster telephone station. Most were from Eastern Canada and lonely. They enjoyed the fresh baking, especially if accompanied by freshly whipped cream. In turn, the men invited the locals to view the many movies sent to the station. The military crew always kept the phone lines open and played any calls from other bases over a loudspeaker as the movies ran. More than once the calls of former boyfriends of Sonia's were, unbeknownst to her, listened to by the community. The local audience thought the calls were a huge joke, but Sonia was mortified.

One military fellow named Ted became seriously interested in Sonia. Several of the other service men ensured the two were never alone, and Sonia stated that was fine with her. She made a pact with the men that on Victory Day they would pile into her car and have a party. When the day arrived, she already had a date with Ted. Nevertheless, the crew jumped into Sonia's car and they headed off to a celebratory dance. Humorously, she wrote, "From under a pile of air force [men] we heard a disgruntled Ted mutter, 'Even the goddesses have feet of clay.'"[19]

Vivien was "agitated" by Sonia's friendships with the cowboys and service men because she wanted her daughter to marry someone of social standing. She bemoaned that she spent sleepless nights when Sonia was out late. Prior to her marriage, Sonia kept company with several of the local ranch hands. She became particularly friendly with Johnny McLuckie and his brother, Willie. She attended many dances with Johnny, which she described as "great fun" especially when "the dancing was fast and furious." In a journal entry from October 23, 1943, Sonia confessed that when at Rose Lake dances, "I feel very sophisticated and very wicked because I dance cheek to cheek. I wear my hair up [on] top of my head and I wear earrings. The combination makes something that everyone

out there stares at and makes whispered remarks about!!!" Another pal from those days (possibly Lloyd Keene) "used to pick his partner up and swing her around." Sonia said, "As I was no lightweight & nervous of being flung in the air it was quite a job."[20] She and Johnny McLuckie were particularly close and when she was ill on March 17, 1943, Sonia wrote in her journal, "Johnny may look in and see me. I hope so." The pair also went to movies together and visited in the community. They and Willie once went to a party together. She said, "We played Whist and then Blackjack and then had supper…. I wore my new dress and everyone admired it very much, which pleased me immensely." However, in 1943, she fell for another cowboy identified in her journal only as George. Their feelings for one another appear to have been a secret as he was married. The two were not often together, as George moved about for employment. Sonia described an evening with George:

> Johnny, Willie, Buster and I went up to the 150 to the Beer Parlour and were having a wonderful time…. I was really enjoying myself when who should walk in but George. Of course I was thrilled to see him but oh how it hurt not being able to show how I love him. We sat back to back and managed to hold hands for quite a while. He held on to me as if he were a drowning man and couldn't let go. We got quite a bit of chat in … but not enough. I can't explain how I felt but I do know it was one of the most painful moments of my life. Johnny was wonderful. When the place closed, he knew that what I wanted was to go straight home and he took me there…. He just said, "I know how you feel Sonia." It was so understanding of him I thought.

Seeing as all income was paying off debts, Sonia had no pocket money. One of the First Nations ranch hands suggested she take up trapping. Unable to secure a licence, she arranged to sell her furs through a friend from the Sugar Cane Reserve. Sonia revealed, "He was highly amused at my efforts but did teach me how to skin squirrels, muskrats, weasels, etc., and how to stretch them for the fur buyers. Squirrels brought anywhere from 3 to 10 cents each—muskrats & weasels could go as high as 1.50. This was all cigarette money to me." She said that the sale of three to five squirrel pelts bought her a package of smokes. She also liked trapping for the exercise. Sonia's weight was often an issue for her but, at that time, she was particularly conscious of her figure because of her feelings for her itinerant ranch hand.

She described her situation with George as "Desperate, desperate,

desperate because there was no solution." Another day she fretted, "I think I will go out of my mind brooding about George. This last week I have been all tense and nervous. I couldn't sit still one minute and it is simply because I can't think of anything else but George. His face keeps appearing before me. It is more than I can stand." Again her dogs, who were in her words "an essential part of my being," helped Sonia find solace. At her most anxious state over her relationship with George, Sonia and one of her dogs made their way along a creek until she found a place to cry. As she sat hugging her faithful friend, "the restful sound of the running creek would soothe mind and soul." For the rest of her life, Sonia declared that running water helped heal her "beaten spirit."

Horse riding was another stress reliever. When she could, Sonia took off on her horse, Romany, and rode for fifteen or more miles. In her journal entry of June 10, 1944, she outlined a typical ride: "First I went up to Long Lake and back through the pasture. She [Romany] was terribly excited and kept hopping up and down. Then we went around the Bunkhouse field and looked at the fence. Then I decided to go up the hill towards the wood saw. I thought I'd let her run to see what she could do and she certainly showed me. Fence posts went flying by like nothing. I practically lost my hair she went so fast." Another day she and a ranch hand (Willie) went looking for bulls and "had a gorgeous ride up along the Sugar Cane line fence to Long Lake and then through their pasture at Sugar Cane and home along the road.... I had never been in the Indians' pasture before and was surprised at how pretty it is: being all sweet clover and groves of poplars, really beautiful. It was especially pretty down along the creek, which is quite rapid and goes gurgling down through a canyon that is lush with growth. I even saw quantities of wild columbine and of course masses of great big wild roses."

In September 1944, Sonia experienced a tragedy. Her close friend Johnny McLuckie died after a kick in the stomach from a partially broken saddle horse he was trying to corral. Sonia mourned his passing for some time. In fact, she did not write in her journal until March 1945 because she said that she had lost interest in life. Her other great sadness was over her boyfriend, George. At one point, Sonia believed he was asking for a divorce, and she considered herself engaged. What happened is unknown, but she and George eventually parted. However, she took in her first dance of the year in March 1945 with Willie McLuckie (Johnny's brother) and recounted having "lots of fun." That month she also had a "beer drinking party" with friends.

Vivien was away much of that year, so Sonia had more responsibility. One unsettling event occurred when Dru, aged fourteen and bored, ran away from school. She returned to school after working one day as a chef

Sonia Cowan (left) and her mother Vivien Cowan, circa 1940s. Courtesy of the Cornwall Family Archive.

in Victoria. The summer was busy with visitors, tennis and swimming. Sonia cooed, "We had one continuous party down here & in town with my going to the dances with an escort of eight men!!!! Who says there's a shortage of men." One even presented her with a diamond ring, even though she had insisted she was not interested.

Sonia was an attractive young woman, five foot eight, with brown hair, sparkling hazel eyes and "a laugh you could hear four miles away;"[21] however, she was also shy at times and prone to nervousness. She confided in her journal that Saturdays were a nightmare of anguish as she waited to see if anyone would ask her out. Sonia often went to the movies in Williams Lake. In those days, films were on reels that would require rewinding and changing throughout the evening. For the enforced ten-minute intermission, Sonia and her pals would nip into the beer parlour for a quick beer. When the lengthy *Gone with the Wind* played, the theatre found a second projector, which Sonia noted prevented the audience from becoming "quite tight." One of Sonia's other comforts was the family radio. She and her family often listened to musical programmes well into the night. One January when the temperatures were fifty below Fahrenheit, Sonia "stayed up all night to keep the fires" in the four fireplaces going. (Vivien stayed up the next night.) During such undertakings, the radio was "a treasure" for them both. Possibly, Sonia developed her eclectic musical tastes during such evenings. Though western music was popular among the ranchers, Sonia's tastes ran from Harry Belafonte's calypso to Duke Ellington's jazz to classical, folk, and the innovative world music of Harry Aoki.[22] In a journal entry dated August 1942, Sonia recounted that after supper one evening they sat talking with John Zirnhelt while dance music played in the background. When the program ended, the Philadelphia Symphony Orchestra came on. Zirnhelt found it too highbrow and remarked, "Oh! They're just practicing ... turn it off!"

During the war years, the Rocky Mountain Rangers enlisted a reserve of ranchers and community folk to assist in defending the locality against invasion. Sonia joined the 150 Mile group. She learned to use a Sten gun (a British submachine gun) and recounted a mock skirmish with the Williams Lake group: "One night ... the 150 gang played a dirty trick & arranged the battleground would be in a local field where the cattle had just been pastured. The rival group crawling up to ambush us were completely covered in nice fresh cow manure." Sonia and Vivien were also spotters, watching for enemy planes.

Sonia sometimes felt isolated on the ranch and was often at odds with her mother and grandmother. She was certainly less concerned with social status than they were. In her journal entry on March 9, 1943, twenty-three-year-old Sonia remarked:

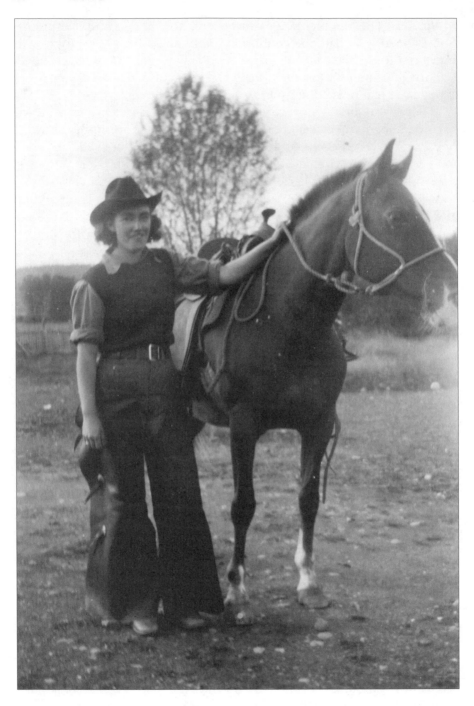

Sonia Cowan with her horse, Romany, circa 1940s. Courtesy of the Cornwall Family Archive.

We had quite a discussion at lunch today as to whether I was old or young for my age. Mother and Granny said I was young. Of course, they nearly died laughing when I said, "I didn't feel it by any manner of means." Why is it one's family can't seem to ever take you seriously or think that you have any ideas. I have got so used to this that now I just keep any ideas or thoughts that I have to myself and as a result they ask me if I am ill because I am so quiet. I really do think [about] the things that I say but usually people (family) think I am just being obstinate or contrary or something. Sometimes I think I must be a throwback because I have such completely different ideas, etc., to anyone else in the same circumstances as myself. (pardon me, "Class" I should say.)

As much as she loved her family, Sonia's differences with them, especially her mother, would vex her for most of her life. During the 1940s, a sore point between the two was whom Sonia would marry. Vivien had wealthy, upper-class men in her sights. However, Sonia had made up her mind that she loved the Cariboo and "wouldn't be happy anywhere else so the sooner everyone makes up their mind that I am going to marry an ordinary Cariboo man ... & settle down here with my ordinary & very good friends around me—the better."

Sonia had few female companions her age until nineteen-year-old Harriet Godley arrived in 1941. The two became fast friends and whenever she could, Sonia would ride alone to the 150 (eight to eleven kilometres as the crow flies) for an evening together. Harriet was living in the home of Albert Patenaude, the telegraph operator. (The house, formally the jailhouse, became the telegraph office and later the post office.) Sonia likely taught Harriet to ride,[23] and besides travelling about on horseback, the two shared interests in movies and live theatre. During her childhood, Sonia had a scrapbook filled with photographs cut from magazines of the stars of the day such as Gary Cooper, Bette Davis and Betty Grable.

Harriet eventually married Clarence Zirnhelt. According to David Zirnhelt, his mother was a talented actor who "had an opportunity to go to Hollywood, but her eyes were on London."[24] Unfortunately, due to the Depression and World War II, Harriet was forced to settle for a teaching job at the little red 150 Mile schoolhouse. In later years, Harriet taught elocution, recitation and acting to interested children and adults in the Williams Lake area and to members of the Community Club. When Harriet put on the annual Christmas school concert, Sonia painted sets for what became "major productions, even though the school only had ten students."[25]

Schoolmarms had to be pinnacles of respectability; therefore, they were not supposed to drink alcohol, smoke cigarettes or attend dances. Moreover, Harriet's brother, Harry Godley, kept a sharp eye on her activities. Despite his sternness, Sonia related that because Harry drove a truck between Vancouver and the Cariboo, she and Harriet knew "all the truck drivers as we met them in the pub with Harry."[26] David Zirnhelt adds that Sonia and his mom "liked to party and didn't give a damn about what other people thought.... We boys joked that Mom could drink us under the table any day and get up the next morning on very little sleep."[27] Prior to Harriet's marriage, the two young women snuck around to bunkhouses for card games of whist and blackjack and to community halls for dances. In the winter, that was no easy feat, as the roads were not well ploughed, and after sitting idle for hours in freezing temperatures, the cars could be difficult to start. Helping Sonia and Harriet to party discreetly was the fact that alcohol was not allowed in the halls. People imbibed in their cars, making it easier to be surreptitious but also making for chilly interludes in below-zero temperatures. The fun went on into the wee hours, and then there were often several hours of travel before arriving home from far-flung places such as Likely. Often, Sonia and Harriet would arrive home just in time to start chores and classes. Cowboys also frequented the dances. Sometimes they became so inebriated they were tied onto their horses, who safely took their unconscious cargos home.

Mary Cornwall recalls hearing a story about her parents' wintery drive home from a dance in Horsefly. "They had to get back in time for work on the ranch, and God knows how early morning it already was. They came upon a car that was stuck and blocking the road. They told whoever was in the car that they could ride with them and retrieve the car another time. They all pushed the car off the road and over the bank, so they could get by. They all got to work on time."[28]

Clarence Zirnhelt started a store at the 150 "with a barrel of gas, a box of chocolate bars and a fifty-pound bag of peanuts."[29] Clarence ran that business and the 150 Mile Motel for forty years, until he sold to Gary and Dodie Marshall. Harriet and Clarence's family grew to include five children—four boys and one girl. Part of the Zirnhelt family lore is that Sonia once spooned carrots into the ears of John, Harriet's eldest son. Apparently, she was feeding him while conversing with someone else and not paying attention. John Zirnhelt muses, "Don't know that she ever lived that down."[30]

Sonia was not yet ready for children but did yearn for a home of her own. Moreover, her enthusiasm for artistic creation continued to grow. While she could not complete more than one or two paintings a year, she sketched whenever possible.

Painters and Inspirations

A significant change for both Vivien and Sonia occurred in 1945. Feeling somewhat depressed about her ongoing financial worries, Vivien was in need of a holiday. Using a small inheritance from an aunt, she enrolled in a summer program at the Banff School of Fine Arts. There she met the Canadian portrait artist Lilias Torrance Newton and the Canadian artist Joseph Plaskett, the Russian artist Michael Werboff and the Group of Seven painters A. Y. Jackson and Lawren Harris. She also met Marmie (Margaret) Hess, a Calgary art instructor who later established the Arctic Institute of North America at the University of Calgary and who was named a Member of the Order of Canada.[1] While in Banff, Vivien gave out a general invitation to visit the Onward.

Several would accept Vivien's offer, thereby adding an eminent list of Canadian artists to the British high society who were already sojourning in the Cariboo and meeting Sonia. The first of such prestigious visitors seems to have been the portrait and landscape painter Mildred Valley Thornton. She did not meet Vivien in Banff but in the Cariboo in September 1945, when Thornton was travelling through the province. She visited the Onward briefly and painted portraits of Father Thomas from St. Joseph's Mission and "Old Annie" from Sugar Cane. Thornton is perhaps best known for completing close to three hundred portraits of First Nations people in Western Canada.[2] She travelled throughout BC for several decades but does not seem to have returned to the Onward.

Vivien told A. Y. Jackson, "You've never been to the Cariboo. You'd better come out and paint (it) and stay at our ranch." In September 1945, Sonia received a telegram from her mother, who was away, stating, "A. Y. Jackson arriving tomorrow [by bus]. Take care of him." Sonia later confided that because her former art instructor Lawrie Warrener was a friend and admirer of the Group of Seven, she considered the members gods. She therefore nervously wondered, "How do you take care of a God? I soon found he was a very easy guy to take care of." Vivien quickly returned home, and some days she sketched with Jackson. He stayed for six weeks and is the only Group of Seven member to paint numerous Cariboo landscapes. Jackson said, "I found the intimate stuff more paintable, the creeks and the little lakes, the patches of small poplar

or aspen growing in circular groups."[3] Those were often Sonia's subjects as well. Unlike Vivien, Sonia does not seem to have sketched or painted with Jackson because she was busy with ranch work, but like Vivien, Sonia would form a lasting friendship with Jackson.

In his autobiography, Jackson confessed that his "idea of ranches had been mostly derived from motion-pictures and I expected to see ... wild cowboys driving herds of cattle all over the place." Instead, he found the Onward situated in a sheltered valley and

> not a steer in sight. Inside the old frame house, in the big living room, there were shelves full of books and when I arrived ... Mrs. Tully, a bright old lady in her eighties, was playing the piano. There were paintings around by an old aunt, [Sydney] Strickland Tully. The first friends to drop in were Violet and Arnold Long; he was a surveyor who loved to go out sketching and in his spare time conducted a choir in Williams Lake. Other friends were [the English artist and critic] Roger Fry's son, Julian, who was secretary for the Beef Growers Association, and Lord Martin Cecil, who owned a ranch down the line. My ideas of the Wild West had to be quickly revised. Mrs. Cowan, herself, made me adjust my ideas of ranching. Tall and handsome, and a person of distinguished mind, she had been a widow for some years. She had two charming daughters and was head of the local art society.[4]

One day Vivien took Jackson to a cattle auction. He sat sketching, forewarned by Vivien "not to raise a finger, or he would find that he had bought a car-load of cattle!" The auctioneer, Matt Hassen, noticed Jackson and quipped, "Look at that guy, writing to his girlfriend."[5] Jackson also painted an oil of Sonia working titled *Sonia Ploughing Fields* (or *Sonia's Ploughed Fields*). The painting's whereabouts is unknown.

Jackson enjoyed the fields, forests "and the ground all bumps and hollows"[6] of the Canadian landscape and visited the Cariboo several times. Over the years, he sent gift packages of books to his Cariboo pals and their children. Mabel remembers receiving a watercolour set from him and that at Christmas, she, Mary, and Dru's children shared an assortment of interesting hardcover books. Sonia described him as a "perfect dear. A most modest little man with a great twinkle in his eyes & a lovely chuckle!!" He would roam about the ranch and area painting scenes. Those works hung on the Onward house walls until his departure. Before leaving, he would tell Vivien, Sonia and Dru to choose a piece. Sonia related, "I always picked one that would teach me something.

Not necessarily the best investment, but for me they were a learning investment." Jackson would become a major influence in Sonia's artistic development. While she was too shy to watch Jackson at work or to ask him questions, he did invite her to send him paintings for criticism. For many years, Sonia mailed works to Jackson; he sent her back comments and suggestions. Jackson emphasized having movement in one's images, and one often sees motion in her art. She said he "was very good to me. He didn't try to teach me, but ... encouraged me."

A few of the pieces Jackson commented on are identifiable but the paintings' whereabouts are not known. For example, regarding *Pause for a Chat* (1957), he wrote, "Good composition—reds very effective—background a little heavy." For *Lined Up for the Stampede* (no date), he suggested, "Not enough interest in lower half. If it had all been brighter the tints would not jump at you." About an unnamed work he warned, "Be careful—this is too slick & doesn't feel felt or expressive except in bottom half. Style is too commercial."[7] Whether Sonia reworked such studies or culled them is unknown.

Many of his other comments were more positive: "Good movement of the cattle through picture plane—nice feeling for open and negative spaces"; "good balance in colour & texture"; "good feeling for open space—colour right—suggests same quality as [David] Milne[8]—yours more elegant & sophisticated"; "lively composition worth doing on a larger size with careful studies of horses"; and "The mood's heavy—at first I didn't like this at all. But after a third viewing I feel it has a strange indefinable something."[9]

Jackson was so pleased with Sonia's development that he urged her to submit a painting to a juried Annual Winter Exhibition (December 1954) at the Art Gallery of Hamilton. He knew that her oil *Ranch Buildings* had been accepted to the 1950 non-juried B.C. Artists' Exhibition at the Vancouver Art Gallery. He considered the painting "A very able piece of work."[10] Acceptance in Hamilton was more difficult (even though Jackson was one of the judges), and Sonia must have been thrilled to have her oil *Salmon Fishers, Noon Hour* accepted. Even more exhilarating was the knowledge that her work was hanging with the likes of Molly Bobak, Jack Bush, Charles Comfort, A. Y. Jackson, Lawren Harris, Arthur Lismer, Doris McCarthy and Gordon A. Smith, to name a few. In spite of that show and the many solo and group exhibitions Sonia had in British Columbia's public and commercial galleries, she is largely unknown outside of the Cariboo region. Helen Hadden, a librarian at the Art Gallery of Hamilton, notes, "It is regrettable that Sonia Cornwall has not been included in the diverse books and catalogues dealing with Canadian women artists." Hadden believes that having Sonia's work available for study in

such publications would provide "a special regional flavour by depicting such a colourful territory of our vast country."[11] In addition, researchers and the public would broaden their understanding of the unique views and practices of female artists in this country.

In 1967, Sonia had a rare opportunity to view work by some of Canada's leading artists. While accompanying her husband, Hugh, to a Progressive Conservative Party convention in Ottawa, Sonia visited with her friends A.Y. Jackson and Davie Fulton (a lawyer and then Member of Parliament who became a Supreme Court justice and an Officer of the Order of Canada). Over a sherry in Fulton's parliamentary office, the MP indicated where he was going to hang some of Sonia's work in his collection.[12] Another highlight of that journey was having Jackson give her a personalized tour of the National Gallery. There she admired paintings by Tom Thomson and the Group of Seven. In an interview, Sonia laughingly recounted that Jackson would "stop for a long time in front of his [work] and then he'd say, 'Some old coot did those.' Then we'd go on, and I always admired Tom Thomson. I just drooled over his paintings." When they came to his *Spring Ice* (1916), Jackson commented, "'Tom did the wrong blue in there.' Then he'd come to a semi-modern painting, some of Jock Macdonald's painting to music and he'd say, 'Take it or leave it' and march on." After the tour, they went to the cafeteria. Sonia said Jackson was so deaf he did not hear the people around them excitedly noting his presence. He insisted on buying her lunch and included a huge piece of chocolate cake smothered in whipped cream: "Then he kept telling everybody serving us in the cafeteria that their cream was nothing [compared] to what he got at the Onward."[13] Sonia also received an invitation from Takao Tanabe to attend a party celebrating the completion of a mural of his in the Federation of Agriculture building, another memorable Ottawa event.

From Jackson's comments on her work, and those of others over the years, plus her own study and practice, Sonia evolved a style of her own. Colour and texture, rhythmic flow and distinctive interpretations of the Cariboo and Chilcotin became hallmarks of her work. Like Tom Thomson, who devoted himself to portraying Northern Ontario and Algonquin Lake, and Emily Carr, who dedicated herself to BC's forests and totem poles, Sonia focussed on the dry hillsides, blue-hued lakes, fleeting wildflowers, golden autumn poplars, seasonal pursuits and agricultural animals and practices of her area. Sometimes she captured the same body of water, field or copse numerous times, but her imaginative interpretations made each image fresh and energetic. She continually portrayed the mood, lighting, blazes of pigment, the fleeting moment, the struggling vegetation and the undulating life force and drama of the

locale. Throughout her life, her art boldly expressed the rugged elements of topography and lifestyles not often considered picturesque. As with Thomson and the Group of Seven, she sought to convey and define spaces by making the viewer look through screens of trees, bushes and fences. Moreover, as Sonia herself stated, her work is seldom "calm"[14] and is often marked by intense activity. Like the landscape itself, her interpretations sometimes require careful observation before that "indefinable something" that Jackson mentioned elicits a deep response.

In 1969, after a stroke, Jackson wrote Sonia (via his niece Naomi Jackson Groves) and continued his encouragement: "Hope *you are still* painting. I *like your card*."[15] The latter was likely in response to a greeting card printed with the image of one of Sonia's paintings. Although he did not write much about the Cariboo in his autobiography, *A Painter's Country*, Jackson yearned to return in his later years. He and Sonia corresponded until his death in 1974. In a 1992 letter, his niece stated that Jackson "loved it there"[16] in the Cariboo.

Lilias Torrance Newton, one of the few women who were full members of the Royal Canadian Academy, was another October 1945 visitor. A founding member of the famous Beaver Hall Group and one of Canada's prominent portrait painters of the era, Newton was the first Canadian artist to undertake portraits of Queen Elizabeth and Prince Philip. Newton painted a charming portrait of Mrs. Tully, and one of Sonia and one of Hugh.[17] Vivien recalled that with Jackson and Newton there were "terrific *art* talks."

Joe Plaskett made his first trip to the Onward in July 1946. He had just won a $1,500 Emily Carr scholarship and Jackson proclaimed that Plaskett had "a future."[18] When she could, Sonia painted with any visiting artists, learning as she went. After one session with Plaskett, Mrs. Tully found "the living room looking like an artist's studio—crammed with pictures and painting materials—one could hardly thread one's way. Joe says Sonia's flowers are *good* 'almost professional.'" Perhaps because of such encouragement, Sonia and Dru eventually decided to attend art school in Calgary.

During Jackson's 1945 visit, he, Vivien and Sonia formed the Cariboo Arts Society. The current president and membership believe their group to be one of Western Canada's longest-running art societies.[19] Vivien was the president, Jackson the honorary president and Sonia the secretary. In October 1946, the Art Society held its first exhibition in the Williams Lake high school. Jackson helped hang the work of the twenty founding members. Jackson wrote that the works in oil and watercolour reflected "local subjects, for the artist the Cariboo is a country of amazing variety: wide valleys and rolling hills, old ranches, gold mines, rivers and lakes and

dark forests."[20] The paintings by locals included those of Vivien, Sonia and Dru (who sold a painting for fifteen dollars), a study of horses and cattle by rancher Sophie Reideman and works by the more famous Jackson and Newton. Mildred Valley Thornton also exhibited a work or two (titles unknown). Mrs. Tully bragged that Lilias Torrance Newton's portrait of her was "admired as by a master hand," even though she had initially thought the portrait looked like a "poster."[21] The community's response to the society's shows has remained strong throughout its existence.

In July 1946, Vivien returned to Banff for more art lessons, taking Dru with her. Sonia must have chafed at having to stay home to run the ranch. She was gardening and doing ranch work while, according to Vivien's letters, Dru was "getting on famously with her painting." Moreover, Jock Macdonald declared, "Dru's painting showed much promise." Besides missing the lessons and not spending time with renowned painters, Sonia must have also been envious that Vivien bought Dru a white lambswool coat. Adding insult to injury, Vivien does not seem to have rewarded Sonia with something comparable.

Sonia's turn for art instruction finally came: on October 25, 1946, Sonia and Dru left for Calgary to take art courses at the Provincial Institute of Technology and Art. Dru was sixteen and Sonia was almost twenty-seven. Upon arriving in the city, the sisters rented a bedroom in a house and shared a bed. To their surprise, they found the weather colder, largely due to the winds. Sonia reflected that at home she followed her trapline, which was about two miles square, in temperatures as low as the minus thirties and had "never frozen even my nose." In Calgary, her legs froze while walking the ten blocks to classes. In addition, Sonia and Dru were dissatisfied with their art education. Most of the students were World War II veterans taking technical courses in order to learn a trade. While many of the former military were married, Sonia deplored that the school treated the students as if they were "teenagers." She complained the administration would admonish the students for "wolf whistles in the hallways or smoking in the washrooms." In some classes, she was annoyed that live models were not used. "Bored with the old fashioned classes," Sonia, Dru and a male friend, Reiss, took to skipping classes. However, they never missed Jock MacDonald's design classes or Marmie Hess's "History of Art." Carrying their paints and boards, Sonia said they would ride the streetcar out to the Bow River and "paint all day." They also "loved to go into pubs and draw people." The Calgary establishments did not allow the genders to mix, so the women hitchhiked to Okotoks (where such rules were less rigid) to sketch and socialize. They made friends with many locals who invited them to dances at Black Diamond and Turner Valley.

In an effort to live more freely and to conserve money, Sonia and Dru moved to a boarding house. With Reiss, they rented two rooms. His bedroom was on a different floor. They shared a kitchen with several other tenants and Sonia cooked for the trio. Vivien was sending them six dollars a month for rent and food. Sonia "found that if I bought a large T-bone, it went further than cheaper meat. First meal a bit of meat each. 2nd meal stew with lots of vegetables. 3rd meal soup from the bones plus vegetables." Even so, the end of the month found them scrabbling for funds and counting on refunds from returned milk bottles.

Sonia did not feel she was learning much and worried over using ranch funds. The final straw came when Dru squandered the rent money on a pair of lovely red pumps.[22] Angry and frustrated, Sonia decided to pack up, and she and Dru were back home by December 16. While Sonia's formal art education ended disappointingly, a new aspect of her life commenced with the arrival of a handsome, jocular, erudite man with a noble lineage who always wore a cowboy hat.

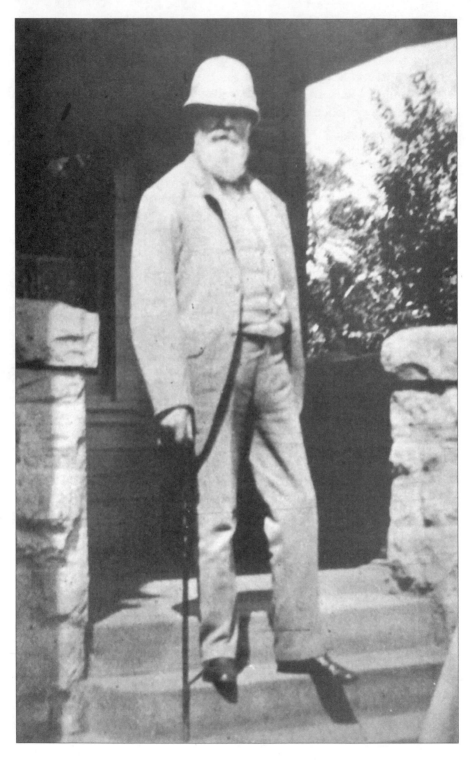

Coyotes and Sophisticated Sodbusters

Discharged from the air force, Hugh Cornwall arrived in the Cariboo in the autumn of 1945 to work in the cattle industry. Apparently, when Sonia and her approximately six-foot-two husband had their first encounter, she was annoyed with him. Hugh was making his way to the Onward when he drove through and bogged down in a mud puddle. While pulling him out, Sonia crankily asked why he did not know enough to drive on the edges rather than in the middle of the mire.[1] Patient and good-humoured, Hugh eventually won Sonia's heart.

Hugh was the great-grandson of Clement Francis Cornwall (1836–1910), an Ashcroft pioneer. Clement (a lawyer) and his brother, Henry, immigrated to Canada hoping to find adventures and riches in BC's goldfields. Landed British gentry, their heritage can be traced to Robert, Count of Mortain, the 2nd Earl of Cornwall, an ancestor of King John. Arriving in Victoria in June 1862 with letters of introduction to Governor James Douglas, they quickly heard from his legal aide, Matthew Begbie (later a famed provincial judge), that most of the big lodes had been found and there were few stakes left. However, based on Begbie's descriptions of land along the Thompson River and the building of a road to the goldfields, the brothers decided to explore north of Lytton.[2] Besides "uncommonly bad" mosquitoes, the loss of a packhorse and meeting two roaming camels that frightened the horses, the brothers enjoyed fishing and shooting grouse in the area. They found the topography "pretty" and on July 4 quickly decided to pre-empt 320 acres. With the help of hired First Nations workers, they immediately cleared land, dug irrigation ditches, put up fences, planted a garden and enjoyed catching as many as "40 capital fish"[3] a day. This was "ten years before there was any homesteading on the prairies and twenty years before the C.P.R. was built."[4]

In October, they built a house and named their place Ashcroft after their birthplace in Gloucestershire, England. They hauled in winter supplies, purchased some cattle and sixty-two horses and undertook the business of wintering horses for others. In those days, animals fended for

OPPOSITE: Clement Cornwall, date unknown. Courtesy of the Cornwall Family Archive.

themselves and in his diaries, Clement noted several cows and horses dying on the rangeland. Life was not easy for humans either. On February 8, 1863, Clement recorded, "Everything in the house freezes and one's top blanket in the morning is white with frozen breath." The next day he found his "beard and moustache so frozen together that I could only open my mouth half an inch." As Clement was new to the country and to ranching, his diary entries are amusing now but reflect the hardships he and Henry endured as they acquired experience. For example, on February 23, 1867, he reminded himself, "N.B. I THINK IT WOULD BE ALWAYS ADVISABLE TO HAVE A SUFFICIENT STOCK OF FIREWOOD HAULED IN THE EARLY PART OF THE WINTER!" On March 13, he wrote, "Be careful and take the bulls away from the cows in the spring 'til at earliest the 17th or 18th of June. It is ruin to have them calving at this time.... One lives and learns." Indeed, he did, because in 1867 Cornwall's wheat and Indian corn samples won first prizes at Western Canada's first agricultural fair in New Westminster. Moreover, his may have been "the first alfalfa seeded between the province of Ontario and the Pacific Coast."[5]

Without much work in the colder months, Clement and Henry amused themselves shooting prairie chickens and grouse and entertaining any passersby. In December 1862, they purchased another 1,800 acres; they would eventually own over 6,000 acres and run 1,500 head of cattle. In October 1863, they opened a roadhouse to accommodate the many pack trains and travellers on the Cariboo Wagon Road, which ran right by the front door.[6] Besides lodgings, Clement and Henry provided meals and sold alcohol. When one fellow "complained that he was nearly poisoned by liquor at the road house," Clement retorted, "Very odd considering that it was the best I could get in Victoria for our own consumption!"

British Columbia was not yet a province and laws were often in dispute. Some of those who worked as packers to the goldfields squatted on the Cornwalls' lands. In December 1862, Clement wrote several packers to "take notice that you are living and with your animals trespassing on my land." On some occasions, Clement described chasing other ranchers' livestock off his property and threatening the ranchers with trespassing. Horse thefts were common and sometimes men wishing to travel simply took one of the Cornwalls' horses. In July 1863, Clement went to court in Lytton and won a suit against a packer. He lamented, "A very hard matter to club any law into their heads. They are all inclined to go on their own private views of a matter."

Likewise, First Nations people were not yet living on reserves in the Colony of British Columbia, and they sometimes found it hard to

understand why range animals were not free for the taking. This led to several disputes between local Aboriginal people and ranchers. Clement settled a few such quarrels, but some of his attitudes and comments regarding those disagreements demonstrated colonialist sentiments. However, Clement and Henry appreciated the knowledge of First Nations people and hired them to work on the ranch. For many years, Jem and Harry (who was promoted to the title of master of hounds)[7] were loyal, hard-working employees. In fact, Harry stayed on for twenty-three years. Moreover, the First Nations community often offered other assistance. For example, if they encountered dead livestock, they would inform the Cornwalls.

Rattlesnakes were dangerous for both men and animals. Clement reported an extremely sick horse who he thought was suffering from snakebite. After some rest and linseed oil, the animal recovered. In August 1868, a First Nations man named Tamian was helping harvest the wheat crop when he was bitten. Clement wrote, "We got him home as soon as possible … [after Henry made Tamian's brother suck the poison from the wound] tied a ligature … and dosed him with whiskey and laudanum. He seemed in a feverish irritated state" but eventually recovered. Opium was another medicinal of the day and on February 22, 1863, Clement "sent some opium up to a Packer who was sick on the hill."

For entertainment, Clement and Henry held horse races. On October 13, 1869, Clement noted there was "a capital gathering of people from all parts" for a racing derby. Heats of differing lengths and an "Indian race" took place. The finale was a "Governor's Purse" and the last event was a hurdle race. Betting occurred and the house made well over five hundred dollars. Other entertainments included shooting tournaments and coyote hunts. Coyotes always hung about and threatened the weak or young cattle. On February 8, 1867, Clement said, "I should like immensely to have a few hounds to rattle the buggers about a bit." He soon imported dogs from England and anticipated some "sport" with them. Instead of foxhunts, the Cornwalls enjoyed coyote hunts, which were long and difficult for all. On December 19, 1868, he described one such venture in detail: "Went hunting … having viewed a coyote … the hounds settled to it and away we went at a great pace…. The hounds … went … without a semblance of a check and evidently bent on killing," chasing the animal up and down hills and through fields "and from there as straight as a crow flies 'heads up and sterns down' we went over the open for a good solid 3 or 3 ½ miles and never a sign of a check…." The coyote then went up a gulch to the top of a hill and then down but "the coyote was now sinking … and the hounds were running for blood, and sure enough although he faced the opposite hill he could

not manage it and turning along its face the hounds ran right into him and 'who whoop' for the first time sounded in B.C." Other days the wily critters would escape but not before so tiring the hounds that they were unable to walk the next day. In an 1883 letter published in *The Field*, Clement wrote that "twenty years of such fun have been worth living for."[8] Clement was irate when other ranchers attempted to poison coyotes because the poison endangered other animals, and he did not consider such a killing sporting.

On June 8, 1871, Clement married Charlotte Pemberton, the daughter of a British rector. That same year he became a member of the Canadian Senate (1871–1881); he was a Member of the Legislative Assembly (1864–1871) and the third Lieutenant-Governor of British Columbia (1881–1887), and he was a stipendiary magistrate and county court judge (1889–1907). He gave no mention of those honours in his diary, and only scant reference to his wife and six children, yet he provided detailed accounts of every dog he had ever owned and wrote extensively of his coyote hunts.

Clement's son, Fitzalan, eventually took over the Ashcroft ranch. He and his wife, Mabel (Tatlow), had nine children. Mabel was particularly frightened of slithering reptiles. She likely knew that one of Clement's daughters, Caroline, died from a rattler's attack. If her other children were anything like her son Hugh, they loved to tease. Sonia's daughter Mabel laughs at the passed-down tale of a lunch at Fitzalan's home. One of the boys had killed a snake earlier, cutting off and retaining the rattle. During the meal, the scamp shook his keepsake and, to the children's amusement, their mother "had a fit." Once Fitzalan came home, his son's punishment "was not nice."[9]

Born in 1912, Hugh Garnett Cornwall grew up in Ashcroft, becoming an avid fisher and an expert hunter and equestrian. He attended Ashcroft Elementary, St. Michaels University School in Victoria and Prince of Wales in Vancouver. He worked on the family ranch for several years. Hugh always maintained there was no money in ranching, but he enjoyed the lifestyle. Up at 5:00 a.m., he was cleaning the barn, harnessing a team, saddling a horse or feeding livestock. Breakfast was at 6:00, and by 7:00 he was back at work. Spring was calving season, summer was haying, fall was cattle roundup time and winter was for feeding and mending fences and equipment. In 1931, nineteen-year-old Hugh and a partner purchased a Wako airplane for a barnstorming and freight business. Damaged after a crash in a swamp close to Kamloops, the plane only cost them $1,500. The men did their own repairs and restoration. Hugh's partner, a former member of the Royal Air Force, taught him to fly. They built an airstrip on the Ashcroft ranch and charged five dollars for a twenty-minute ride.

Hugh explained, "At that time aircraft were enough of [a] novelty that there was always a crowd around to see you land." While not many people had money for airplane rides during the Depression, the partners kept the business until 1932 when "the plane hit a rise in the runway, caught a wing tip in the ground, and flipped several times."[10] Hugh would always complain of a stiff neck because of that crash.

For a short time, Hugh ran a Shell gas station at 12th and Kingsway in Vancouver. During World War II, he was initially an infantryman with the Seaforth Highlanders. Hugh later transferred to the RCAF and for a time trained pilots in Claresholm, Alberta. Toward the end of the war, he spent fifteen-hour days flying escort for North Atlantic convoys. Stationed in Sydney, Nova Scotia, as part of the Coastal Command, he captained a submarine-patrol plane. One night Hugh and his bomber crew picked up a foreign sonar blip. As they zeroed in, the plane's lights showed a terrorized civilian crew waving madly at them.[11]

In 1940, in an attempt to secure fair prices for their beef, the Cariboo Cattlemen's Association formed the Cariboo Marketing Agency. George Mayfield of the 141 Mile Ranch took on the job of fieldman. His job was to assess the cattle and recommend sale prices to each rancher. Mayfield successfully fought for competitive pricing because as Harry Marriott noted, "We ranchers are like a bunch of bananas. We can hang in there together, or we can be skinned off one at a time."[12] By 1945, Mayfield's health was deteriorating and a replacement was needed. According to cattleman and author Morrie Thomas, "The one person the ranchers had confidence in to do the job was Hugh Cornwall, who was still in the Air Force at the time. Many letters were written to the Minister of Agriculture asking for his support in obtaining Hugh's early release, but to no avail."[13]

Hugh's brother Ted was then the district agriculturalist in Williams Lake and encouraged Hugh to move to the Cariboo. His brother may have been concerned about Hugh as just prior to his leaving the air force, Hugh's wife, Margaret, and young daughter both died in a car accident on Vancouver Island's Malahat highway. After receiving his discharge, Hugh left Vancouver, "drove up" one evening "and started working the next morning"[14] as Mayfield's assistant. In 1946, he took over the fieldman position and quickly found that marketing cattle was not an easy task: "Hugh would gather up all the information that was available to determine what the market price should be for the cattle on that particular day. The cattle would be gathered and the buyers would draw to see who would get the first chance at the cattle. The buyer who drew the first chance would be taken aside and told what the asking price was.... He would either take them at that price or he would pass and the next

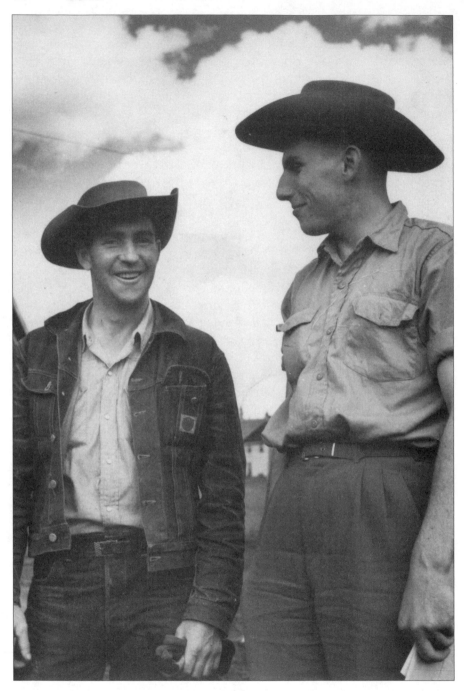

Hugh Cornwall and Norton Olson, circa mid-1950s. Photograph by the noted Canadian photographer Rosemary Gilliat (later Eaton). Courtesy of the Cole Harbour Rural Heritage Society, Nova Scotia.

buyer would get a chance and so on until the cattle were sold."[15]

Hugh helped found the first flying club in Williams Lake, and the members purchased a plane. Telephones were still few in number and service was unreliable. Therefore, the fieldman drove long distances over poor roads or rode for hours or days on horseback. In order to improve communication, Hugh used the club's "puddle jumper"[16] in the fall to assist the ranchers by looking for their stray cattle on the ranges. As well, he "would sometimes fly over the larger ranches and drop a message to let the rancher know when to sell his cattle to prevent a glut of cattle on the market."[17] In order to alert the rancher to the incoming message, Hugh rolled the aircraft's wings up and down. On at least one occasion, Sonia accompanied Hugh in his Piper Cub. She said her first experience of the waggling manoeuvre "scared the wits"[18] out of her. Unfortunately, someone eventually crashed the plane, which the club did not replace.

When the B.C. Livestock Co-op took over responsibility for the fieldman, they retained Hugh in the position. His office was in the basement of the Lakewood Hotel. The telephone company was next door. Long distance calls were often slow to connect. Hugh frequently tired of waiting for the call and thus headed down into the stockyards. This would infuriate the operator. To Hugh's amusement, one time when he walked past the telephone office after placing a call, the operator spotted him, ran out and shouted, "Get back into your office and stay there until this call comes through."[19]

In spite of his playfulness, Hugh worked fervently to help ranchers protect and improve their industry. He became "a leader in expanding the boundaries of the cattlemen's associations to represent the needs of the ranching industry throughout the whole province."[20] In recognition of his more than five decades of contributions, Hugh was inducted into the B.C. Cowboy Hall of Fame in 2005. He proved to be as well respected and principled as his grandfather Clement. Hugh also proved to be an incredibly supportive and fun-loving husband.

Untitled (Self-Portrait), 1993, greyscale copy of original colour pastel on paper. Sonia Cornwall Family Collection. Photo by Harvey Chometsky.

Gallery

Untitled (Indoor Rodeo), 1993, oil on board. Sonia Cornwall Family Collection. Photo by Harvey Chometsky.

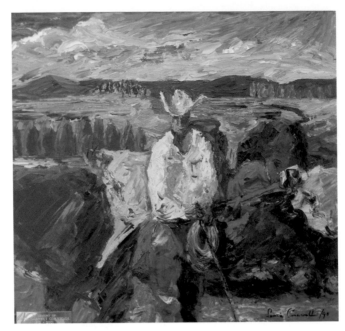

Hugh Cornwall, 1998, oil on board. Collection of the Museum of the Cariboo Chilcotin. Photo by John Miller.

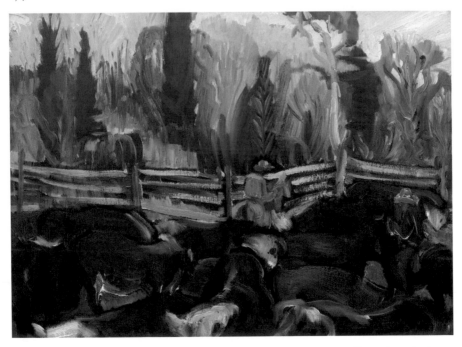

Working Cattle, 1971, oil on board. Collection of the Penticton Art Gallery. Photo by Lisa Anderson.

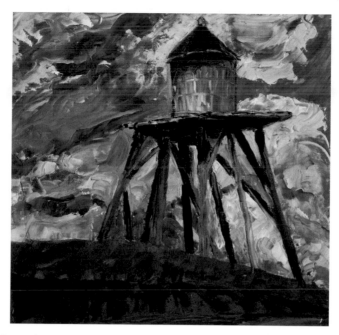

Untitled (Onward Watertower), 1963, oil on paper. Sonia Cornwall Family Collection. Photo by Harvey Chometsky.

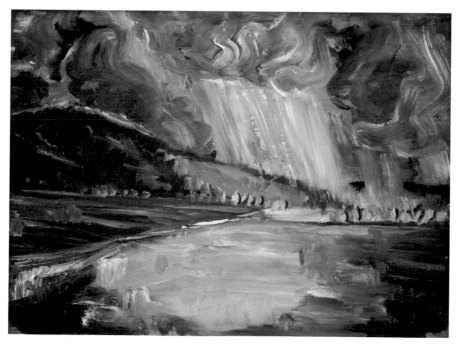

Storm, 1965, oil on board. Sonia Cornwall Family Collection. Photo by Harvey Chometsky.

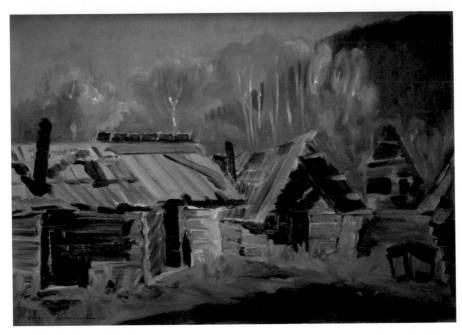

Quesnel Forks, 1967, oil on board. Collection of the Cariboo Art Society. Photo by Harvey Chometsky.

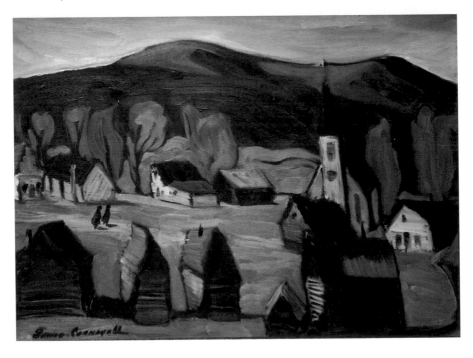

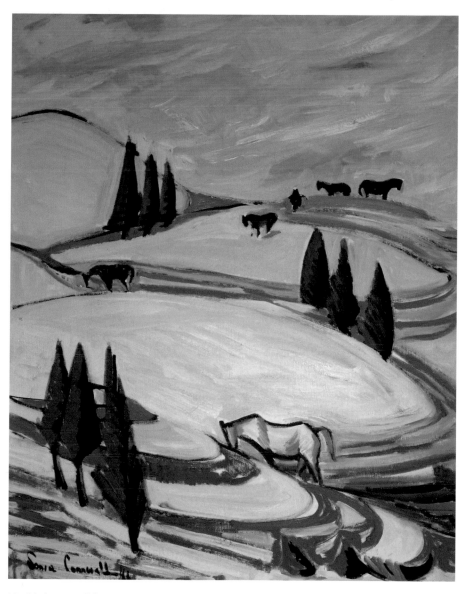

Untitled (Beautiful BC Horses), 1966, oil on board. Sonia Cornwall Family Collection. Photo by Harvey Chometsky.

BOTTOM OPPOSITE: *Untitled (Sugar Cane Village)*, n.d., oil on board. Zirnhelt Family Collection. Photo by Harvey Chometsky.

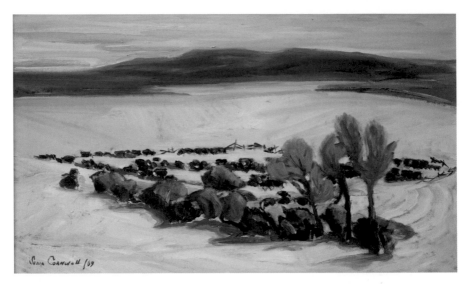

Cattle on the Feed Grounds, 1969, oil on masonite. Collection of the Kamloops Art Gallery.

Spring Floods, Cariboo, 1974, oil on board. BC Art Collection. Photo by Jacquelyn Bortolussi, (Open Space).

Storm Coming, 1992, oil on board. Westbridge Fine Art. Photo by Harvey Chometsky.

Big Stuff, 1973, oil on board. Sonia Cornwall Family Collection. Photo by Harvey Chometsky.

The Onward Barn, 1955, oil on board. Sonia Cornwall Family Collection. Photo by Harvey Chometsky.

OPPOSITE BOTTOM: *The Onward Barn,* 1969, oil on canvas. Private Collection. Photo by Lisa Anderson.

Untitled (Anahim Lake Stampede Grounds), circa 1958, oil on board. Sonia Cornwall Family Collection. Photo by Harvey Chometsky.

Untitled (Anahim Lake Stampede), n.d., mixed media. Private Collection. Photo by Harvey Chometsky.

Untitled (First Nations Camp), 1967, oil on plywood. Private Collection. Photo by Harvey Chometsky.

Steer Wrestling, 1958, oil on board. Sonia Cornwall Family Collection. Photo by Harvey Chometsky.

Untitled (Playing), 1964, oil on masonite. Private Collection. Photo by Harvey Chometsky.

Untitled (Cariboo Still Life), 1975, oil on board. Collection of John and Yvonne Zirnhelt. Photo by James Hung (Wonder Bridal Studio).

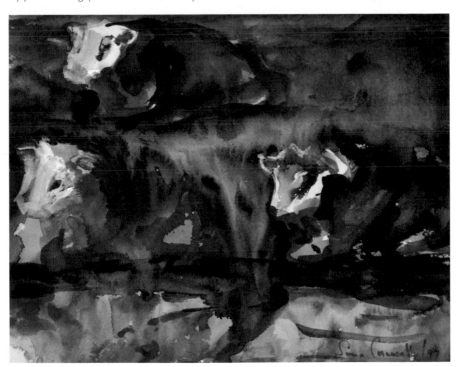

Untitled (Cattle), 1997, watercolour. Private Collection. Photo by Harvey Chometsky.

OPPOSITE BOTTOM: *Cattle Melee*, 1972, oil on board. Private Collection John and Yvonne Zirnhelt.. Photo by Dave Abbott.

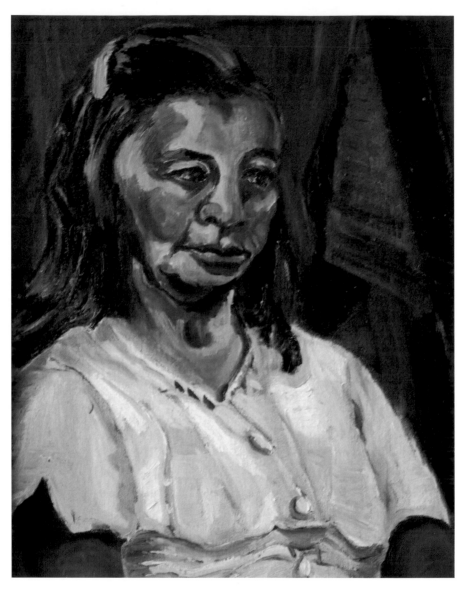

Anastasia Sandy, n.d., oil on board. Westbridge Fine Art. Photo by Harvey Chometsky.

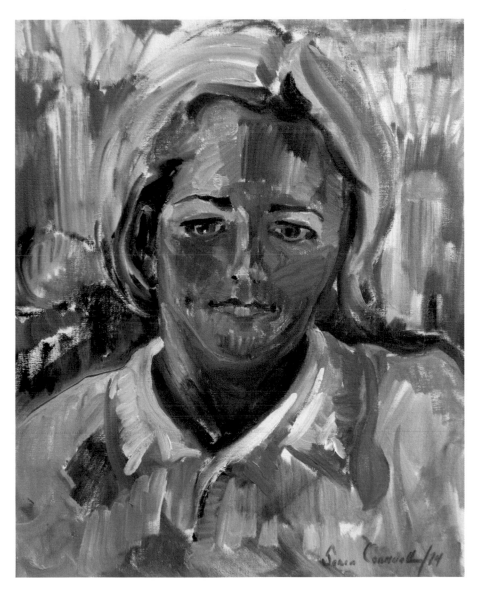

Portrait of Jane Shaak, 1974, oil on canvas. Private Collection. Photo by Jane Shaak.

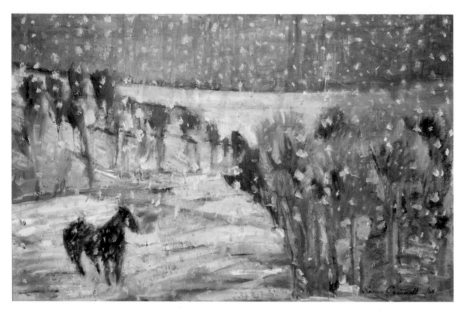

Johnny, 1966, oil on canvas. Private Collection. Photo by Harvey Chometsky.

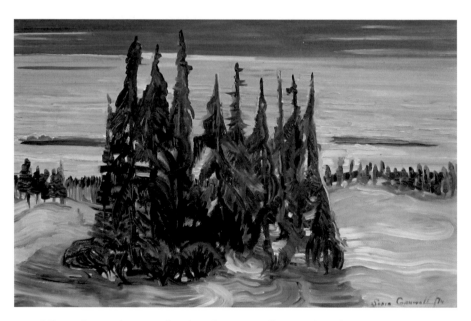

Snowdrifts on the Ranch, 1974, oil on board. Private Collection. Photo by Nicholas Westbridge.

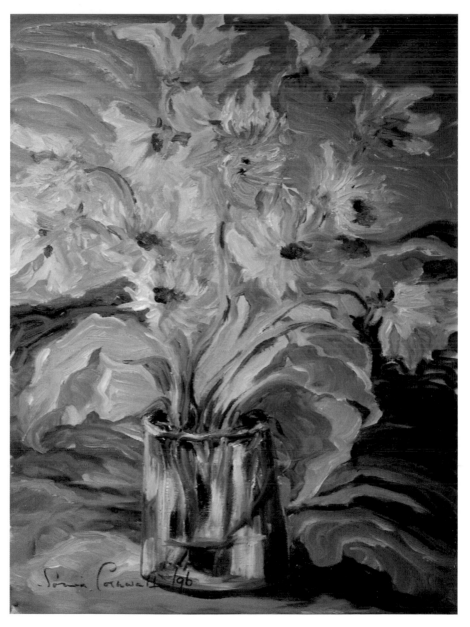

Untitled (Sunflowers), 1996, oil on canvas. Collection of Lilla Tipton. Photo by Harvey Chometsky.

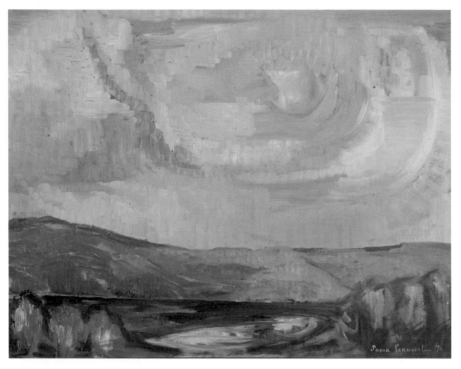

Ring Around the Sun, 1970, oil on masonite. Private Collection. Photo by Harvey Chometsky.

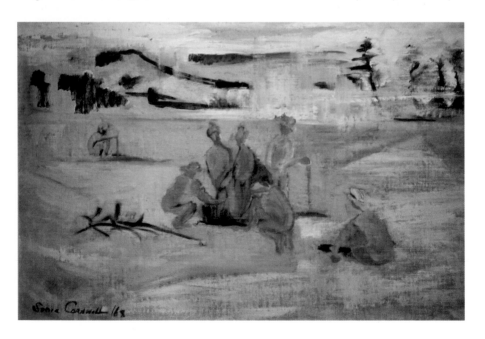

Winter Sports, 1968, oil on canvasboard. Private Collection. Photo by Harvey Chometsky.

Untitled (Sugar Cane Church), 1972, oil on board. Sonia Cornwvall Family Collection. Photo by Harvey Chometsky.

Salmon Fishers, Noon Hour, circa 1954, oil on board. Private Collection. Photo by Harvey Chometsky.

Untitled (Cariboo Landscape), n.d., oil on board. Private Collection. Photo by Kirk Salloum.

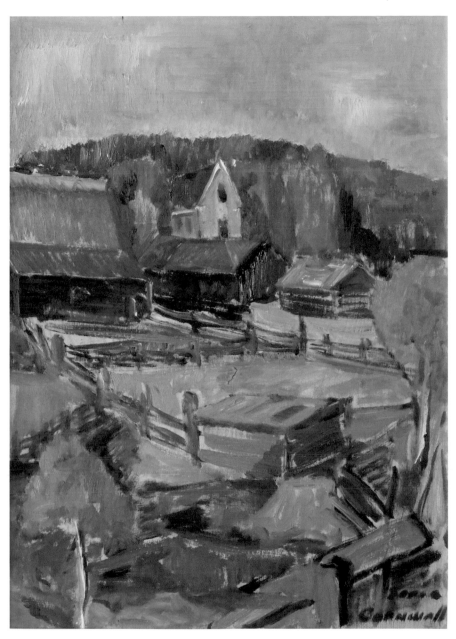

Untitled (Onward Ranch), n.d., oil on board. Private Collection. Photo by Kirk Salloum.

OPPOSITE PAGE: *Cold War*, 1958, oil on board. Private Collection. Photo by Harvey Chometsky.

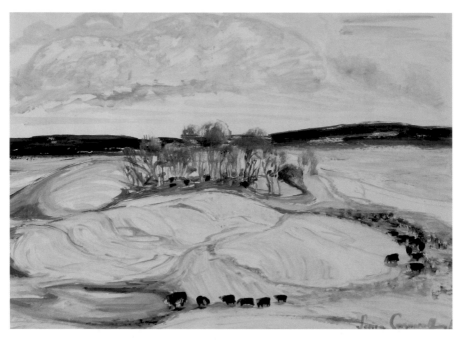

Last Snowdrifts of Spring, 1976, mixed media on paper. Private Collection. Photo by Nicholas Westbridge.

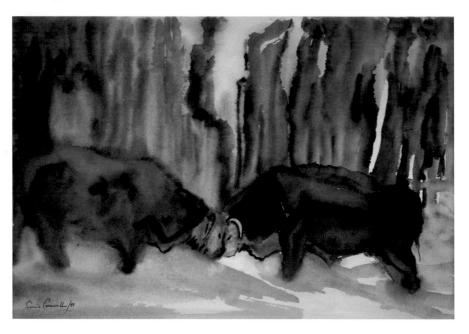

Test of Power, 1988, watercolour. Private Collection. Photo by Harvey Chometsky.

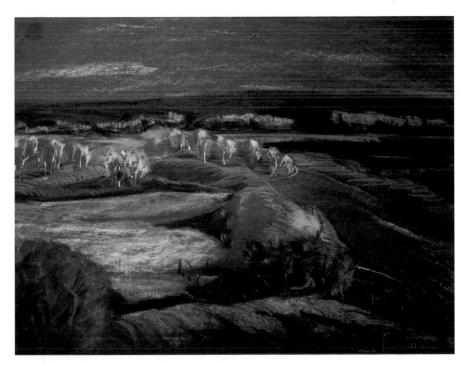

Untitled (Sunny Fields), 1979, pastel on coloured paper. Zirnhelt Family Collection. Photo by Harvey Chometsky.

Melting Ice, 1994, watercolour. Sonia Cornwall Family Collection. Photo by Harvey Chometsky.

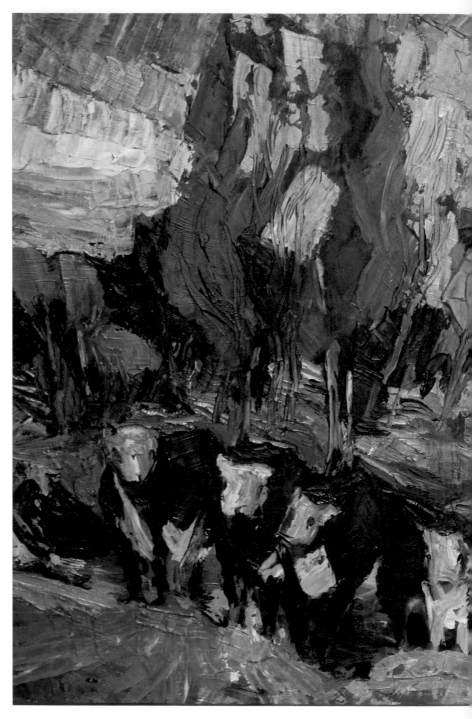

Cattle in a Gully, 1996, oil on board. Westbridge Fine Art Photo by Harvey Chometsky.

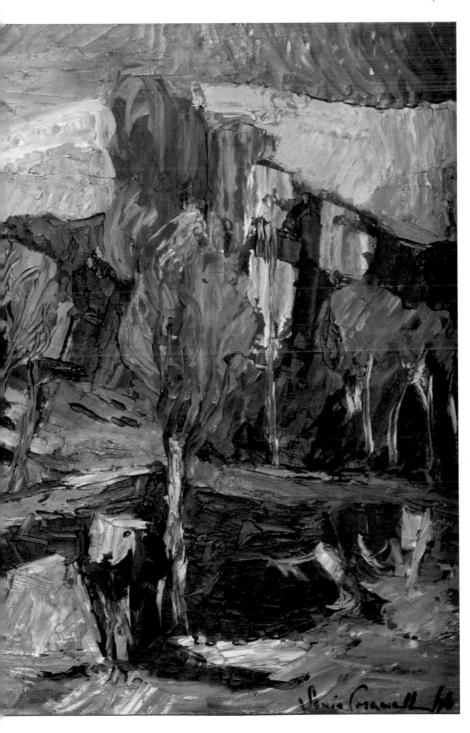

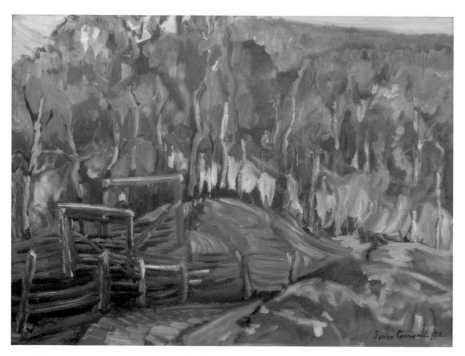

Corrals, 1972, oil on masonite. Collection of Station House Gallery. Photo by Brandon Hoffmann.

Untitled (Road and Trees), 2003, mixed media. Sonia Cornwall Family Collection. Photo by Harvey Chometsky.

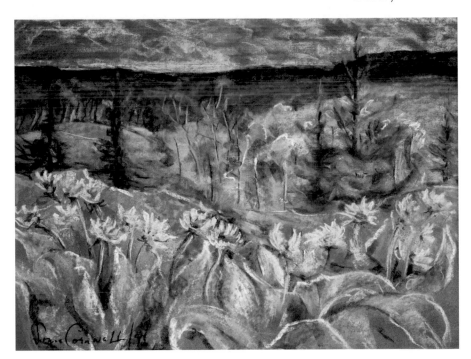

Sunflowers Overlooking the Valley, 1991, pastel on paper. Collection of Esther Chometsky. Photo by Harvey Chometsky.

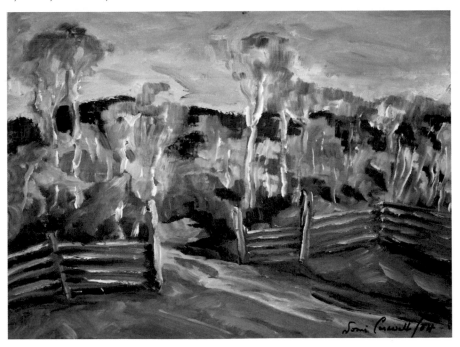

Our Gateway, 2004, oil on board. Westbridge Fine Art. Photo by Harvey Chometsky

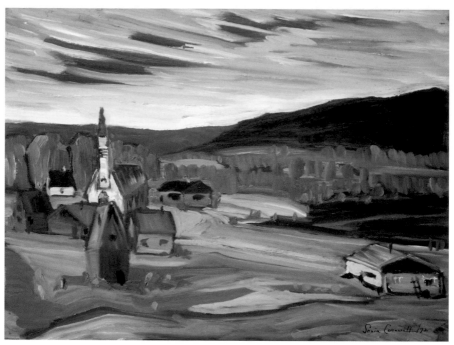

Edge of the Village (Sugar Cane), 1972, oil on panel. Private Collection. Photo by Harvey Chometsky.

Indian Camps at Dusk, 1972, oil on panel. Private Collection. Photo by Harvey Chometsky.

Calm, 2000, oil on board. Private Collection. Photo by Dallas Kempfle Photography.

Untitled (Onward Barn), n.d., oil on board. Private Collection. Photo by Harvey Chometsky.

Chilcotin Rodeo Dance, 1991, oil on board. Private Collection. Photo by Harvey Chometsky.

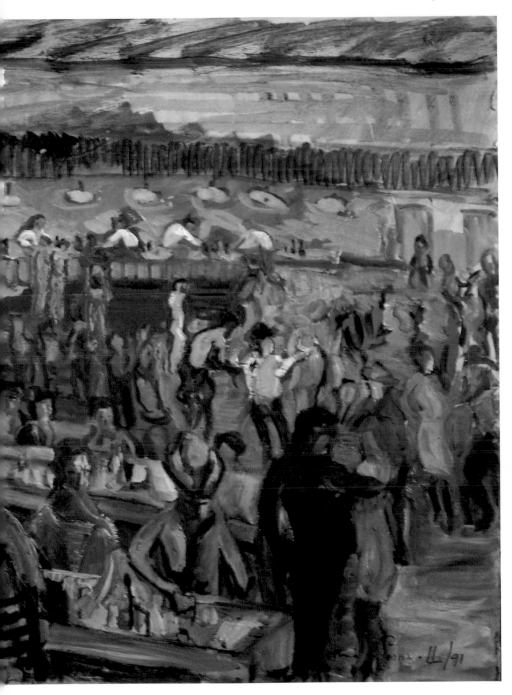

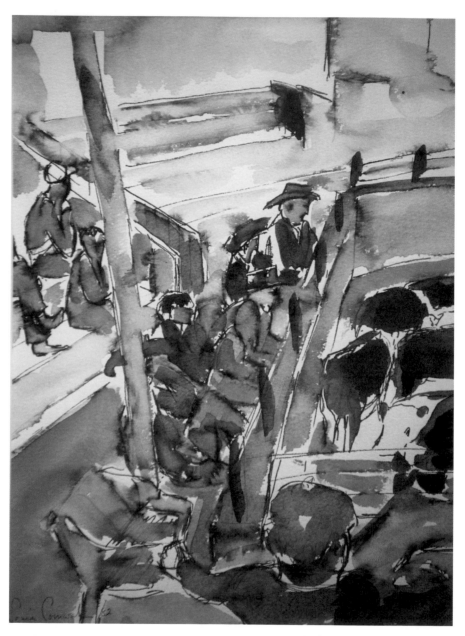

Untitled (Williams Lake Cattle Sale), 1982, mixed media on paper. Private Collection. Photo by Harvey Chometsky.

Marriage and Children

While Sonia deemed Hugh Cornwall "very good looking," he did not win her heart immediately. She may have still been romantically involved with the ever-absent George. In addition, she initially disdained her mother's approval of Hugh's prominent family background. Hugh, however, seemed attracted to Sonia. In fact, one night he and Willie McLuckie arrived simultaneously at Sonia's door—both hoping to escort her to a local dance. She did not choose one over the other and went to the dance hall by herself.[1] Hugh then formally invited her on a date to another dance. Prior to the evening, he became ill with a cold. Hugh asked if they could just visit at his place. Sonia did not like missing a favourite activity and "dancing every dance." She was prepared to be bored but, to her surprise, found she "really enjoyed talking" with Hugh. He was witty and a tease, and they both enjoyed a hearty laugh. In addition, they had ranching backgrounds in common and Sonia had joined Hugh's Flying Club (she never seems to have learned to operate a plane). They spent more and more time together, and one evening Hugh invited Sonia to his house for dinner. She declared the dinner "was so good that I said this is the man for me!" They married in May 1947 and Sonia always grumbled, "I can't say he's done much cooking since then."

Sonia had one disaster prior to her nuptials. While she was out searching for balsamroot blooms (her beloved sunflowers) for her wedding, her car caught on fire. She then had no way for her, Vivien and Mrs. Tully to travel to town for the ceremony. She phoned Alex Ray at the "town garage," and he lent her a demonstration car for the occasion. He and Robin Blair not only delivered the vehicle, but they also instructed Sonia on how to drive the new automatic Buick. Sonia laughed that she "sailed into town in the newest car in town!"[2]

After the wedding, Mr. and Mrs. Cornwall toured ranching country in Alberta, Idaho, Montana and Washington, attending various rodeos. For that trip, Hugh purchased a second-hand Ford, as his 1932 Chevrolet (named Esmeralda) was unreliable. Sonia complained that the new vehicle lacked personality. She much preferred the idiosyncratic Chevy with a front passenger seat that she said would suddenly flip "backward leaving the poor inhabitant lying flat & struggling to regain position. If it rained the passenger pulled a rope working the windshield wipers." While the

Ford did not provide playful diversions, the couple still had adventures. One of the most memorable occurred one evening in eastern Washington when they motored out to view the landscape. Snuggling in the front seat, they had two drinks while "talking and romancing." Suddenly, the earth seemed to be alive and undulating. Sonia was sure they had not had enough alcohol to blur their vision. To her and Hugh's amazement, what they observed were hundreds of jackrabbits "the same colour as the earth & sage!" foraging at dusk.[3]

For the first while, the newlyweds lived in Hugh's log home on the shores of Williams Lake. There they had what Sonia called "a very busy life" because Hugh was in charge of the local stockyards and always talking to cattle buyers. He often invited Sonia on his trips to various ranches. Sonia usually went because she insisted, "Not for me the wifely remark, 'I'm washing clothes or cooking or cleaning.' Those chores could be done another day." While the couple had no running water or electricity, they entertained regularly and in Sonia's words "were very happy."

One time some of Hugh's family and friends were visiting, and they decided to go duck hunting. Hugh and Sonia left the family with some other hunters near a narrow point on the waterway. Then Hugh stationed her on a point while he moved closer to scare the birds into the air. His instructions were, "Whatever you do, don't let them fly back this way." Following a shot by Hugh, the geese flew over Sonia. She then "shot & turned them back as instructed." She also killed a goose and started back to join the others. The going was not easy as the area was swampy and her bird was heavy. Being a newlywed, she expected Hugh to come and help her. "But no—I walked and walked almost two miles over rough ground & the goose got heavier & heavier. I came within hearing distance of the rest of the party and heard all kinds of things such as 'I just missed'—'I saw feathers fly' & then I strode in with my goose. You could have heard a pin drop. I was the only one with a bird & I a mere female. Then Hugh said, 'Why didn't you get one with the other barrel?'" This hunt created a funny and unforgettable anecdote. Two of the hunters were brothers and both were physicians. One practised in Williams Lake and the other in Quesnel. When Sonia was pregnant with her first child, her doctor, the brother in Williams Lake, said that if he were away, his brother would tend to her needs. When she went into labour, Sonia's physician was absent. When the Quesnel doctor received a call to attend, Sonia says he mischievously replied, "That's the girl that shot the goose. She can have her own baby."

The doctor's petulance proved to be the least of Sonia's concerns. Her labour started during a minus-forty cold spell. While driving to the Williams Lake Hospital, Hugh spotted a deer near the road. He told

Four generations at the Onward Ranch. Left to right: Alice Tully, Mabel Cornwall, Vivien Cowan, Mary Cornwall, and Sonia Cornwall, 1956, and photographed by Lady Lake during a visit to the Onward Ranch. Courtesy of the Cornwall Family Archive.

Sonia he wanted to go back and get his gun. In her penetrating voice, Sonia boomed, "No way!" Moreover, Sonia bemoaned, "Everything in the hospital froze up—nurses spent their time bringing [the patients] hot water bottles!"[4] In spite of the cold, Mabel (named after Hugh's mother) arrived on December 1, 1950. Five years later (January 25, 1955), a second daughter, Mary, joined the family.

When John Zirnhelt died in 1948, Vivien asked Hugh to take over as her ranch manager. Not wanting to rush Mrs. Zirnhelt out of her house, Sonia and Hugh temporarily moved to a two-room cabin at the 150 Mile Ranch for the summer months. Expecting dry, sunny weather, the Cornwalls planned to keep extra chairs and other belongings outside. However, the season was an unusually rainy one. Sonia recorded, "Absolutely everything had to be in a twenty by twelve foot space.... We managed and indeed still had visitors jammed into corners or sitting on the floor." When they finally moved into the house, Sonia was kept busy preparing three meals a day for thirteen hungry men made "cranky" by the wet weather. The large wood stove on which she cooked came with the house. Though it made her kitchens swelter, Sonia kept that stove for the rest of her life.

Sonia noted that another initial problem they encountered was that Hugh was "continuously challenged by old employees testing the new guy." For example, Zirnhelt had hired a local man from Sugar Cane to build a fence. The first section was fine, but the part built under Hugh's management was not adequate. Hugh paid but refused to hire the man again. One day the fellow asked why Hugh would no longer give him work. After Hugh explained, the former employee answered, "We got to try you out." He then told Hugh if a better fence were needed, he would build a better one. To add to the Cornwalls' frustrations, the 150 Ranch was for sale and prospective buyers, usually accompanied by friends, relatives and pets, would arrive. As well, they often required feeding. Luckily, Dru was available to help.

As they so often did when faced with adversity, the family found humour in the situation. That Halloween, Mrs. Tully facetiously dressed as a wealthy and elegant possible buyer similar to an American woman who had viewed the property; Vivien was a big-stomached, cigar-smoking real estate agent; and, Dru was a dapper Canadian realtor sporting a polka-dotted bow tie. On their way to Sonia and Hugh's, their car ran out of gas. Dru set off walking but Vivien and Mrs. Tully remained with the vehicle. Ironically, locals did not stop to assist the costumed women because they assumed the Texan and the refined socialite were merely parked. As Sonia wrote, "The joke backfired."

In 1950, the 150 Mile Ranch sold to Huston Dunaway, helping to pay off more of Vivien's debts. The next year, Vivien decided a trip to England and Africa was in order. Twenty-year-old Dru accompanied her, partly as a companion and partly because Vivien wished to remove Dru from her interest in a Chilcotin trucker, Wilf Hodgson. In England, Vivien fulfilled her long-held dream when she and Dru met King George. Vivien apparently lost all thoughts of financial considerations as the two travelled through Europe and on to Lord Egerton's estate in Kenya. One day the bank manager spoke with Hugh because Vivien had put the ranch's accounts into overdraft. Mabel and Mary Cornwall say that Vivien's spending on that holiday was a hardship for Sonia and Hugh. They add that Hugh felt Vivien was often inconsiderate of Sonia. Ironically, Dru cut the trip short, returned home and married the much older Hodgson in spite of her mother's disapproval.

Ranch help was always required. Willie Crosina (currently a director with the Williams Lake Stampede Association) hired on as a hand and worked for Hugh from winter 1949 to spring 1950. Crosina's brother Jimmy was a hand at the Onward at the time. Crosina earned approximately $125 a month plus room and board. For a short time, his youngest brother, Omar, joined him at the 150 Mile Ranch. Their parents had lived

in the Williams Lake area but had relocated to a logging camp near Midway. For some reason, Omar ran away. Only twelve years old, he made his way from the Lower Mainland (where his parents had been visiting) to the Cariboo and spent the winter at the Cornwalls' 150 Mile Ranch. The boy then boarded with his other brother, Roy, in Williams Lake in order to be closer to a school.[5] Like many folks of the time, Hugh and Sonia would not accept money for Omar's keep.

Crosina recalls his employment at the 150 Mile Ranch with fondness and says that both Hugh and Sonia were "great people" and he is happy "to have been able to call them friends." He remembers an amusing incident regarding a grain salesman who, to everyone's annoyance, "always showed up around mealtime." One day when Crosina and Hugh were going in for lunch, Crosina noticed the salesman coming up the road. Hugh responded that he would "get rid" of the bothersome fellow within five minutes. With the plan in place, Sonia and Crosina hid out in Willie's room, which was just behind the kitchen. Remembering Hugh's boast, Crosina set his alarm clock to ring in five minutes. When the salesman heard the chime, he asked Hugh what had caused the sound. Hugh replied, "That's just my wife and the hired man in the bedroom." The salesman made a quick departure, and that story was a shared joke for many years afterwards.

Crosina remembers that on Boxing Day 1949, the weather turned bitterly cold, and until Groundhog Day the temperatures were anywhere from forty-five to sixty degrees below zero Fahrenheit. He and Hugh were feeding six or seven hundred head. According to Crosina, "The calves were sold as yearlings or older so you had the calves to feed and the mothers and the in-betweens." He figures they fed about a tonne per hundred head per day. Most of the hay was kept in nearby fields and stackyards. Using pitchforks, they piled the hay onto horse-pulled sleighs, and then forked it onto a feeding area. Crosina says, "You dressed for the cold but the workin' kept you warm." The hay in the barn, which was usually of better quality, was reserved for milk cows, workhorses and saddle horses.

Although physically harder, Crosina believes life was more fun back then. In particular, he recalls the camaraderie of haying. Small competitions enlivened the long workdays. "We each had a team and a sloop that we loaded hay on. If you were the first man out, you were supposed to be the first in and you didn't let anybody pass you. If that happened, you wouldn't be well thought of. You had to keep coming in, in your proper place, and never get behind. That was a matter of pride. Somebody passed you, he figured he was a better man than you." Crosina explains that haystacks had rounded tops so water would run off. He stresses, "A good

Feeding cattle, Onward Ranch, circa 1940s–50s. Courtesy of the Cornwall Family Archive.

stacker was your key man. You didn't want to leave loose spots because that would mean that the rain would settle there, and then you'd have a spoiled spot. Then you might be choppin' it out with an axe in the winter when it froze."

Men from the Sugar Cane Reserve usually formed the bulk of the haying crews. Crosina recalls that Morris Bates worked for his dad for years. Morris's nephew, Louis Bates, worked at the 150 with Crosina, as did Charlie Twan, Joe Bob and Sammy and Willie Peters. Crosina says the First Nations people were "easy to work with. You could joke and laugh with them but they always worked hard. They were usually easier to work with than with some of the white people because they seemed happier. They got to be part of the family." Sonia's job was to cook lunch for crews that ranged from ten to twenty-five men. As Sonia probably already knew the haying crews, interacting with them would have made the work seem less onerous.

Hugh was the ranch supervisor but Crosina says easygoing Hugh "couldn't get after people." As well, Hugh would do a task himself before making someone else undertake the job. Crosina found it often fell to him to "make sure the guys did their jobs. I think I wasn't too popular at times." Besides haying and rounding up cattle for branding or for sales,

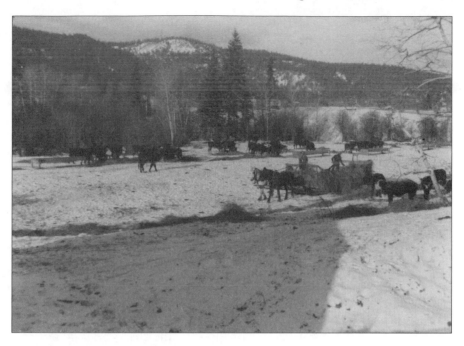

Stacking hay at the Onward Ranch or 150 Mile Ranch, circa 1940s–50s. Courtesy of the Cornwall Family Archive.

the chores could include cutting and hauling wood, mending fences and cleaning stalls. Crosina left the ranch to help his aunt Lil (Crosina) at the 153 Mile Store for a short while; he then married and eventually became the bookkeeper for the Cariboo Cattlemen's Association.

With Hugh running the ranches, Sonia spent less time working with the cowhands. She started devoting more time to painting and completed at least two representations of the 150 Mile Ranch. Those depictions are more realistic than much of her later work. In *150 Barns,* two characteristics of Sonia's style are evident: the mundane aspects of the scene are alleviated by tilted or lopsided structures, and the clothes drying on the outdoor line highlight a woman's presence or sensibility. In a 1996 painting, Sonia whimsically portrayed a line of laundry, including some large knickers, flapping above a cowboy (possibly Hugh) making his way from the barn. The scene is vibrant with bold colours and movement. The whereabouts of *Washing Day, Onward Ranch* is unknown.[6]

The sale of the 150 Mile Ranch meant Sonia and her family needed a new home. Initially, they built a small house at the Onward and relocated there. A few years later, they moved into Vivien's large home. A moveable, accordion-style wall divider separated them from what became Vivien's smaller quarters. On special occasions, the divider would open

to make the dining room larger. Mary recalls that when the family dined together, Vivien expected everyone to dress formally for dinner. She and Mabel had to wait until everyone had finished eating and then the girls could ask to be excused. Mary explains that after they left the Onward, Sonia upheld some of Vivien's English traditions, but they no longer had to dress for dinner. Sonia did set a nice table and Mary adds, "You never brought a jar of something to the table." Moreover, though fiercely independent, Sonia believed that serving drinks was a man's job. During her early twenties, Mabel remembers being angry at what she viewed as her mom's old-fashioned ways. For example, at one gathering when guests filled the house, Mary volunteered to refill Sonia's drink. Her mother refused the offer. Mary explains, "She never said, 'Men do that,' but she would say, 'No, John (or Hugh or another male) will do that.' To her, that was man's work."

Sonia was modest, matter-of-fact and respectful to everyone. Mabel notes that all types of people went "through our home. If they had something to say, something to offer, Mom was interested. She was a curious person. She was not judgemental. That endeared her to people. For example, kids growing their hair long during the Beatles generation didn't bother her in the slightest." Mabel does lament that her mother's tolerance did not always extend to her daughters. "She could be set in her ways. I remember that I could not wear black clothing or tight skirts. Black was for funerals or older people; tight skirts were wonderful on others, but not us." Nor was Sonia a person who smothered her children in affection or doted on them. Mabel says that Sonia took it for granted that the girls knew she loved them, and they did.

With young children to care for and ranch duties to perform, Sonia painted when she could. For extra help when needed, the Cornwalls hired Mrs. Josephine Bob, from the Sugar Cane (or T'exelc) community. Her duties were to help Sonia with cooking, cleaning and child minding. Both Mabel and Mary relate that they thought Mrs. Bob was "wonderful," and Sonia described her as "a marvellous babysitter for both girls." However, Mabel says that when they were small, Mrs. Bob "scared the bejesus out of us." Mary adds, "To me she was the biggest, scariest person because she didn't take any guff. We were little and Mrs. Bob looked huge to us. Then you get older and you realize she's four feet tall. She just had a presence." Mrs. Bob, along with her daughter and two grandchildren, attended Mary's wedding to Ken Borkowski. According to Sonia, Mrs. Bob kept saying, "Our little Mary, our little Mary." Mabel and Mary stress that Mrs. Bob was considered a friend and "a part of the family," not a servant. She would tease Sonia and give her a hard time. For example, if geese needed cleaning Mrs. Bob would joke, "Oh, the boys got some geese we

need to pluck. Sonia, you know I don't like that." Over her sixteen years of employment, Mrs. Bob always playfully interacted with Sonia. Mary recalls that Mrs. Bob would jest about cleaning jobs she said she did not like; however, she always did them thoroughly.

Mabel and Mary grew up much as Sonia and Dru had, with freedom to roam in the outdoors. In those years, there were more bushes and trees by the San Jose River and in summer, the area was perfect for building forts and playing games. The girls would leave the house after breakfast with a packed lunch, and their only rule was to be home in time to wash up before supper. During the winter, they could play in the snow and skate on frozen potholes. There were numerous springs on the rolling hills of the property. One particularly frigid winter, a rivulet that flowed down from a hillside froze and provided a fast, downhill skating surface. Sometimes, friends, neighbours or families would pile onto the huge sleigh Hugh used for hauling hay. David Zirnhelt remembers himself and others bumping along behind on sleds towed by the sleigh. Some would fall off onto the snow and then run to catch up.[7] Finally, a large bonfire would warm all before they headed back to the house. Alcoholic drinks usually provided extra heat for the adults.

Sometimes Mary and Mabel played on the gravel roadway that runs through the Sugar Cane Reserve, past the Onward and on to what was Saint Joseph's Mission before circling back to Highway 97. Land for the Mission was first pre-empted in 1860. Six years later, twenty-five-year-old Father James Maria McGuckin (Oblate of St. Joseph) and missionary François Jayol chose a site along the San Jose River for a school and farm that would feed those at the facility and produce income. Initially, both Indigenous and Caucasian children attended. In 1886, St. Joseph's became an Indian residential school. Until Williams Lake officially became a town, the Oblates recorded births, deaths and marriages. St. Joseph's Cemetery, the oldest in the area of Williams Lake, has graves of early settlers including several members of the Isnardy and Felker families, and Mr. Eagle (who first ranched the Onward property), his wife and four of their children. Moreover, buried at the cemetery are Secwepemc ancestors such as Bob Joe and Chief William Williams, ranch hands such as Johnnie McLuckie and Oblate Father F.M. Thomas.[8] Tragically, some First Nations children suffered emotional, physical and sexual abuse at the Mission; several even died and were interred in the graveyard. In 1957, the school burned down and the Oblates retired from teaching to become counsellors, social workers and recreation facilitators. In 1964, the Oblates purchased the Onward Ranch and the priests used the house for their residence. By 1967, First Nations children were integrating into the schools of the Cariboo-Chilcotin School District. In 2015, only a few

buildings remain along with the cemetery, and the property now belongs to the Sugar Cane community.

Mary says they had to watch out for the Oblate priests driving at high speeds "in their little Volkswagen bugs. I guess someone was looking after the priests because they sure weren't looking after themselves." Mabel adds, "If you ever saw a cloud of dust, you'd get off the road shouting, 'The priests are coming. The priests are coming.' They didn't slow down for kids or cows." John Miller, Mabel's husband, jests that the Oblates "knew they were going to heaven, but you didn't."[9] Although St. Joseph's became a residential school for First Nations students, both Mabel and Mary completed grade one at the institution. Afterwards, they took their elementary grades at the 150 Mile School. Like Sonia's, their high school education occurred at Strathcona Lodge. In spite of being away for large portions of each year, they both learned to ride and participated in many ranch activities. They also played tennis on the courts Vivien had built at the Onward. When a pool was built at the Mission, the Cornwall family swam in it during the summer months.

While the Cornwalls befriended several of the Oblates, Sonia took exception to the negative effects they had on the local First Nations people. That response came through in a painting of the Sugar Cane Catholic church that was different from Sonia's regular style. While her other depictions of village churches are more rustic, this one is abstruse.[10] She discussed the painting with a friend, William Matthews, who hastily compiled notes as Sonia spoke. He recorded, "What appears abstract and gothic with almost floating forms on a red background is one of Sonia's few social statements on the effect of the white man's religion on the Native peoples, specifically those on the Sugar Cane Reserve.... She said, 'The church superimposed itself on other people.... The Indians had their own culture.... The church ... did a lot of damage.' That really bugged her.... The painting expresses her frustration and anger. It was a condemnation of the Catholic church."[11] Moreover, Sonia wrote Matthews that in looking over depictions of "village churches—some Catholic & some Anglican, they seem to show the stagnation, barrenness & above all the domination"[12] of one culture over another. In her art, Sonia always sought to portray genuine responses to her life and surroundings.

Art and Artists

Over the years, Sonia befriended and communicated with numerous artists. Her mother met Joseph Plaskett in Banff in 1945; like A.Y. Jackson, Plaskett became a frequent visitor and friend to the family. In his autobiography, *A Speaking Likeness*, Plaskett wrote that he travelled to 150 Mile House via "the winding Cariboo road bordered by snake fences and corrals, to find haven at the Onward Ranch … where the hospitality was legendary…. For decades I kept coming back to this land, my passion for place unsated."[1] He sometimes brought artists Jim Willer and Takao Tanabe with him. In the Cariboo, they had fresh vistas for their palettes; Vivien and Sonia provided delicious meals served on bone china atop white tablecloths. Mary recalls one luncheon in particular when she was about ten years of age. As she began to clear the table, Plaskett, who during his career painted many dining tables, told her to stop because he and those in attendance (Tanabe and Willer were also there) were going to capture the dining scene. He often thought, "The flower, fruit or table napkin is alive, begging me to make its presence felt."[2] The adults had a great time portraying the once inviting table now transformed with its dishevelled leavings, but poor Mary could only moan and wonder what she would do for the afternoon as she waited for them to finish. Years later, Mary attended an exhibition of Plaskett's work and saw a triptych of Vivien's dining table. While Mary often considered the visiting artists "different," she says, "It was an experience listening to them laughing and arguing and commenting on each other's stuff." The fun the artists had at the Onward, and Vivien's panache, is clear in this example from her writings: she came home one day to find that the formerly bearded Plaskett, Tanabe and Willer had shaved. She gaily responded that if she had known, she would have joined in by dyeing her hair red.

Takao Tanabe did not become a regular visitor, but his portrayal of a side of the red Onward barn became one of Sonia's favourites and always hung in her home. In the piece, the structure seems to be rising or moving upwards. Sonia enjoyed that sense of the building soaring because as a child she had often lain in the grass staring up the side of the building, imaging that the structure was flying.[3]

During her mother's lifetime and after Vivien's death, Sonia kept in touch with Plaskett. He eventually settled in Europe, returning to Canada for yearly exhibitions in Vancouver and Victoria galleries where

his work sold well. Plaskett died in 2014, having had a major influence on contemporary art in Canada, particularly West Coast modernism.⁴ His busy schedule often precluded visits to the Cariboo. In 1962, he wrote Sonia, "I'd love to hop the PGE & see you right this minute. It would do me no end of good to be out in [the] country as spring pops—but my movements are, alas, restricted."⁵ On February 6, 1987, he wrote, "How sad I am that it is such a long time since I've visited the Cariboo." In June 1990, after Vivien died, Plaskett recalled, "All those extraordinary times we spent together.... My youth and all the early stages of my career seem bound up with the Onward Ranch." Throughout his life, Plaskett kept in touch with Sonia, Dru and their children. When possible, they attended his exhibitions. In 1994, Plaskett and his partner and fellow artist, Mario Doucet, did travel to the Cariboo. They stayed with Sonia and Hugh, with whom they again enjoyed "bountiful hospitality," and he "got a charge out of seeing that beloved landscape again."⁶

Sonia and Plaskett corresponded until her death in 2006. In those letters, they would both describe their lives and art. In addition, Plaskett sometimes provided critiques of Sonia's work. For example, on December 3, 2003, he commented on *Dance of the Poplars*, telling her, "It is beautiful. In reproduction, everything seems right in tune to nature and to your observation of it. It works perfectly on an abstract level too. Bravo." On December 15, 2004, he mentioned that in spite of increasing deafness and age, he was "painting non-stop all & every day. It is wonderful that, if inspired, I can paint with as much energy as ever." As encouraging as those words were to Sonia, who at eighty-five was suffering from her own age-related debilities, his further statement was equally uplifting: "You seem just as vigorous at painting as I." A year later, Plaskett wrote Sonia that after a day of painting he was often too fatigued to communicate with "the medium of words." He apologized because their "friendship is of vital importance, binding a rich past to the tangible present." He concluded, "Your painting gets better & better."⁷

Plaskett often worked with pastels and Sonia followed his lead. She enjoyed the crayons for sketching and completed vibrant pieces in that medium. Like Plaskett, she rarely sought to make social comment in her art. She did, however, capture historic scenes. In fact, years later when she was going through pieces she had stored in her studio, she was surprised to realize their historic value. Her portrayals of Indigenous peoples' encampments, early rodeos, stock auctions and various villages (now altered or abandoned) are of increasing significance. Political or didactic messages were mostly left to others. She surely agreed with Plaskett, who believed that "a painting does not always have to *mean*. It is quite enough that it *be*."⁸ Therefore, like him, Sonia delighted in the inspirations of her surroundings.

Indeed, Plaskett admired Sonia for focussing her work on her environ-
ment. Sonia struggled to convey personal interpretations of her environ-
ment and eventually "found her brushstroke."[9]

On some occasions, Plaskett sent work for inclusion in the annual
Cariboo Art Society exhibition. Both Vivien and Sonia invited contribu-
tions from artists outside the area as a source of inspiration and education
for the members and the community.[10] As well, numerous artists travelled
to the Onward or Williams Lake to give lectures on art or workshops.
Some of those visits came about because the Cariboo Art Society invited
the artists, and some came through Extension Department programs de-
veloped by the University of British Columbia.

After the war, and as the Canadian economy began to prosper, the
arts started to flourish in the province. In 1946, artist Bertram C. Binning
lectured throughout the Interior and reported going to "teas, luncheons,
church dinners (god bless them) … but generally speaking the artists
have kept too much inside their own groups … with the result that art is
considered merely in its avocation or hobby form or in other words the
outside interest is not serious enough that the artist can ask for … cultural
or civic centres, substantial support, etc. However, let me assure you, all
this has changed now.… Better start planning a Branch of the Extension
Dept. up here right away!"[11] That trip only took Binning through the
Okanagan and Kootenays, but UBC was soon sending artists throughout
the province. In 1947, a fine arts committee decided that a Department
of Fine Arts should be instituted at UBC. Extension programs on campus
included concerts, dance and drama classes, public speaking clubs, writing
programs and visual arts courses on architecture, painting, photography
and weaving, among others. As the department grew on campus, more
off-campus programs became available. In conjunction with the Feder-
ation of Canadian Artists (BC Region) and the Vancouver Art Gallery,
the Extension Department started a travelling art exhibitions program.
Three times a year, forty or so paintings hung in various communities for
a week or two. Moreover, books on art, architecture and crafts, filmstrips
and lanternslides on art and a projector were available for loan.

By 1947, artists such as W.P. Weston started journeying throughout the
province lecturing and giving courses to art clubs and other groups. One
of the successful classes he and others taught was Painting for Pleasure. As
Binning had enthusiastically predicted, "Come snow & ice 'culture' gets
through."[12] The classes were welcomed and successful. Unfortunately, by
1949 Weston's health and that of his wife prevented him from travelling.
Binning made "one or two trips" but a more permanent instructor was
required. Gordon Shrum, then director of UBC's Extension Department
(also a physics professor and, in 1965, the first chancellor of Simon Fraser

University), wrote the superintendent of education and suggested hiring any local "housewife who is a competent artist."[13] Surprisingly, and quite a contrast to a homemaker, Shrum also mentioned that Group of Seven member Frederick Varley, known for his drinking and unconventional ways, might be available. In another letter, Shrum pointed out that the university could not finance a full-time instructor. He understood that "people in the rural areas are as much interested in modern art as those in the larger urban areas. However, a person going out on a job of this nature does have to have some understanding and appreciation of the point of view of the rural folk."[14] They found such an individual in Clifford Robinson (1917–1992), who became the supervisor of arts and handicrafts.

Robinson undertook the Extension Department's first travelling Painting for Pleasure summer classes. The reaction was positive. For example, in 1949 the secretary of the Prince George Art Society wrote the Minister of Education that the success of the course "was due to the instructor, Mr. Cliff Robinson ... and his unfailing encouragement of each at his particular stage of development.... Courses such as this ... are a wonderful thing for outlying places like Prince George." Two years later the secretary of the Prince Rupert Art Club told the director of UBC's Extension Department that besides learning to paint from Robinson, "We got something that's rather hard to express. I don't know whether it's getting out of a rut and deciding to learn, or just getting more in touch with the outside world.... We were in worse than a rut.... We knew nothing of composition before. One of the school teachers taking the course who has taught art in one of the public schools for at least 15 years said, 'Rhythm—I never heard of it before.'"[15] Robinson eventually added batik and woodcuts to his classes.

When she met Robinson, Sonia became interested in batik, linocuts and woodcuts. As usual, she focussed her work on images of her home and ranching. In notes she kept, she indicated that she felt quite unschooled when she met Robinson: "That was when I didn't even understand painting terms such as 'cool it.'" He and the other presenters stayed with Sonia and Hugh, and she noted that through the travellers, "my art learning extended beyond the actual lecture."[16]

In 1952, however, Robinson was feeling the strain of the work. He suggested being hired for an eight-month period, four months of which would be for rural instruction and the rest for painting and exhibitions of his own work. The university declined. By 1954, Robinson had resigned and become the first director of CBC TV in Vancouver. Robinson recommended that UBC increase the new supervisor's salary, hire more personnel and provide more materials. UBC's records are incomplete; therefore, Robinson's replacement is unknown. The university's annual

reports for 1951–1952 and 1952–1953 indicate that despite "remarkable interest," the need for more instructors was acute and the wait-list for workshops in many communities was years long. In 1961, Herbert Siebner is recorded as teaching eight painting workshops and John Reeve as teaching pottery in four towns. Don Jarvis gave a workshop in Chilliwack.[17] The arts extension program seems to have sputtered to an end by 1968, the victim of underfunding. Furthermore, some programs, such as pottery, were considered too expensive to run.

Robinson kept in touch with Sonia for a time and his letters indicate that he sent batiks, paintings and relief work (at which he excelled) for Cariboo Art Society exhibitions and sales. While Sonia learned some techniques from him, the Cariboo must have likewise inspired Robinson. In an undated letter, he discussed sending her a bull's image in batik on silk satin. As well, he gave her instructions for matting two drawings and warned, "Don't show them [unmatted], because it'll be like appearing on the street with trousers but no shirt or shoes."[18]

Information on Molly Lamb Bobak's trip throughout BC is recorded in UBC's 1959–1960 annual report.[19] In the Cariboo, she gave three drawing and painting workshops. From those sessions, Sonia increased her knowledge of composition and was encouraged to practise methods used by well-known artists. Bobak did not sleep at the ranch, preferring to take a Williams Lake hotel room from which she could watch the goings-on of the town.

Bobak had never been to the Cariboo and travelled there in 1960 via the PGE. She particularly enjoyed her train ride. "I was sitting in the coach and the guy that came around with an enamel pot of coffee,

A sketch by Molly Bobak in Sonia Cornwall's Guest Book, 1960. Courtesy of the Cornwall Family Archive and printed with permission from Anny Scoones.

giving everyone free coffee said, 'Mr. Duchene would welcome you in the cab'.... He was the engineer. So, I went up and sat in the cab with him. We went over trestles; I can remember it to this day. It was exciting."[20]

Bobak and Sonia kept in touch over the years. In 2012, Bobak described Sonia as "that wonderful woman from the Cariboo." She further stated, "How nice those people [Sonia and Hugh] were."[21] Sonia frequently reproduced images of her paintings on note cards. Bobak reacted to one such image (title unknown) by exclaiming, "It was a beautiful surprise to get your strong woodcut and wonderful note—we both [she and her husband Bruno] do love the wild flowers—I remember the spring earth around Ashcroft—full of tumbling blooms—wow!"[22]

When corresponding, Sonia always discussed the everyday details of her life. She must have described a moment when Hugh picked her a bouquet of balsamroot blooms because on June 24, 1991, Bobak responded, "What a lovely image of Hugh riding in from the cattle with flowers for you!" On September 22, 2001, Bobak noted that a watercolour of Sonia's "looks full of ... what counts—vision & energy." Earlier, on December 27, 1996, Bobak wrote, "It would be great fun to meet you two once more." Sonia had sent a Christmas/New Year message on a greeting card bearing the image of one of her paintings. Bobak extolled, "I *love* your Mexican painting (so did Bruno). You have remembered the hot colour." That type of communication with other artists remained vital to Sonia throughout her life.

As well, during her years as vice-president and then president of the Cariboo Art Society, Sonia wrote that she "went on the theory that we ask any famous artist to give us a show, luring them with how paintable the Cariboo was and free bed and board. None that we asked said no."[23] Sonia felt showing works by artists from outside the region and having workshops was critical. Without new inspirations and techniques, she worried that the work of the local artists would all look the same.[24] She met several artists via such invitations including Sybil Andrews, Peter Aspell, Jack Hardman, Herbert Siebner and Zeljko Kujundzic. Unfortunately, there seem to be no detailed records of Sonia's meeting with Andrews. Sonia's *Untitled (Beautiful BC Horses)* suggests Andrews' influence. In "May or June 1964," Sonia's mother noted in her diary that fourteen people were taking a workshop with Aspell. Every night for a week, they spent three hours listening to his lectures on modern art and painted abstracts. He told them, "It was the best workshop he had ever conducted & the only group with a 'professional' attitude." From Aspell, Sonia learned to use strong pigments, mix her own oil paints and work in an Expressionist style.[25] Kujundzic instructed her on using a palette knife and "to be big and bold"[26] with her oil paintings.

An international award-winning artist, Kujundzic was of Turkish ancestry but born in Yugoslavia in 1920. He was a professional artist and author when he and his family immigrated to Canada in 1958. They first settled in Cranbrook, BC, and the next year they moved to Nelson, where Kujundzic taught at the Summer School of the Arts. In 1960, Kujundzic was instrumental in founding the Kootenay School of the Arts and was its director until 1964. Bill Horne, an artist from Wells, BC, describes Kujundzic as having been bearded, long-haired and often in sandals, long before hippies adopted that look. According to Horne, a further example of Kujundzic's unconventionality is that he painted a mural of nudes on the front of the house (a former Methodist church) Kujundzic's family later inhabited in Kelowna.[27] Vivien came to know Kujundzic well as she spent two years (1960–1962) studying at the school. Although she is included in an archival photograph of graduates, she never completed a degree at the institution.[28] With a sense of noblesse oblige, Vivien decided that the children from Sugar Cane might enjoy pottery making, and they might use their products as a source of income. Vivien asked Kujundzic to help in 1964, and he was happy to provide instruction. Vivien asked the now noted Williams Lake naturalist and potter Anna Roberts to work as Kujundzic's assistant. Roberts agreed, and she also helped transport young people from the Sugar Cane Reserve to the Onward Ranch where Vivien had a small kiln (that she later donated to the Sugar Cane community). Roberts found that the students "did quite interesting work."[29] Pottery was not a traditional endeavour for the T'exelc community, but Hazel Alexis, Francis and Peter Alphonse, Joseph Thomas and Amy, Helen and Vivian Sandy were among those who learned the craft.[30]

Helen Sandy, now a maker of pine-needle jewellery and an eminent T'exelc photographer, relates that because Sugar Cane is approximately fourteen kilometres from town, the children of her day were somewhat isolated. After the completion of their chores, their summer months "were absolutely free." Therefore, pottery and art workshops were interesting diversions that she enjoyed. Furthermore, Sandy explains that people like Vivien, educator Liz Robertson and Sonia "wanted to motivate us to do something we were gonna be good at…. Once we had that first taste of success, then the drive to continue producing great works of art would continue." Sandy says that once the students worked successfully with pencil crayons, they were encouraged to try painting, pottery and jewellery making. She found as the work became "a little bit harder, a little bit more intense," the children's creativity developed. She adds that Vivien, Sonia and Kujundzic "inspired you to think about art. What arts were offered in the schools was minimal. Quite a number of our people are very, very visual,

so textbook learning is very difficult.... Vivien and Sonia were there to show us the various mediums we could use.... They're very, very well respected in this community ... because of their contribution not only to the First Nations community but in all the ... community in Williams Lake.... There was no prejudice in them."While some members of her community view them as having had paternalistic attitudes, Sandy believes that Vivien, Sonia and Kujundzic "were welcomed in our community because they appreciated us as a people."[31] Years later, in March 1999, Sonia viewed an exhibition of Helen Sandy's prints and deemed them "awfully good."[32]

Herbert Siebner, a member of the Royal Canadian Academy, had an important influence on Sonia. She met him in 1962 when he travelled throughout the province giving workshops under the auspices of UBC's Extension Department. From him she learned to paint using various methods and stated, "Much of what I learned from him I practice today."[33] Siebner's work reflected an abstract expressionist tradition to which he added archetypal symbolism executed with bold colours and prominent brushstrokes. A German émigré, he, his wife, Hannelore, and their daughter, Angela, arrived in BC in 1954. He was soon recognized as part of Victoria's avant-garde. In 1971, he, Maxwell Bates and several others created the Limners, a collective of artists who held group shows throughout BC and Canada. Siebner insisted, "Work is a mistake from which I learn."[34] That comment would have resonated with Sonia, who often struggled with the challenges of painting and who always sought to learn more.

Exuberant and charismatic, Siebner liked to challenge perceptions and attitudes. Author Robin Skelton recalled that Siebner sometimes chose to "wear one of his large collection of peculiar hats, and sometimes ... a mask."At parties, Siebner "would address some unprepared academic with the question 'Are you honest?' ... and he would frequently express his feeling that there was too much fakery in the world by removing his clothing.... It got to be that we never thought a party involving Herbert was a success unless he had made this symbolic assertion."[35] Sonia and Hugh attended one soiree at which Siebner had wrapped a nude model in cellophane. That many of the guests were uncomfortable and did not know how to react or where to look bemused Sonia.

Sonia was not as outgoing or as formidable a personality as Siebner, but both sought to reflect the universality of the ordinary world in inimitable and unique ways. Of Sonia's work, Siebner wrote that he liked "to see her work reflecting so much honesty from her earthy surroundings." He expounded that she "painted with joy and love and gave back joy and love. Sonia is a natural artist with the charms of a child to bring back (to) us such treasures found around her home—her cattle and her red barn right here in B.C."[36]

Sonia met the "charming, but also mercurial"[37] printmaker and sculptor Jack Hardman through two Cariboo workshops: one printmaking and one oil painting (dates unknown). Sonia appreciated that "he encouraged [her] greatly and arranged a show for [her] in The Little Gallery, New Westminster, where Joe Plaskett occasionally showed."[38] Hardman wrote Sonia that he had "heard from others about how much they liked it. I am pleased."[39] Sonia sometimes sent paintings to Hardman for criticism. In a letter dated March 14, 1962, he commented on each of the works (those pieces are not extant in the Cornwall archive). He did not like all the images but told Sonia there "are three or four very good ones—this I would consider a high percentage." Furthermore, he wrote he had submitted her name for inclusion in the B.C. Society of Artists annual exhibition. While he warned her to "be prepared for rejection," Hardman encouraged her to submit "the oils you have done of the cattle" because he considered them "most expressive." Moreover, he felt that the show was important for Sonia because "how else will people see your work." Unfortunately, Sonia was not accepted; in an undated letter, Hardman stated that her acceptance was "short by one vote." That made him "furious," especially as in his view, "there were some that were elected that I am sure couldn't draw a tree—just smears & blotches. I feel it [the rejection] personally and am sorry."

In the same letter, Hardman said he "immensely" liked a watercolour Sonia had done of the Onward house and buildings: "When you make a moving plane in your picture it really works—be careful of presenting a static quality." She seems to have added Hardman's advice to that of A.Y. Jackson and in 2001 told CBUT reporter Peter Clemente, "Very few of my paintings are serene."[40] Movement, joyful or disquieting, is an element in much of her work. In an undated message, Hardman asked if he could have a painting because he thought her watercolours "rather special & would like very much to have one." In a letter from February 5, 1965, he stressed that he was "simply avaricious" about one and had "to have it even if I have to steal or buy it." On January 12, 1972, Hardman commented on the reproduction on her Christmas card saying it "indicates a perceptive growth."

The two artists shared a distaste for phoniness and were both mischievous. For example, in a letter dated only March 24, Hardman enclosed thirty dollars (probably for a painting) and said Sonia was "such a sweetie but please you must not be so kind—hell I love you for it and on the other hand want to give you a good smack on the butt (Freudian eh wot?). Thanks so much." Another time while visiting Sonia and Hugh at Jones Lake, Hardman teased Sonia about her weak hip. To get even, after her hip replacement surgery she mailed him a hipbone from a cow with the note, "Here's my old hip." He found the gesture so funny he hung the bone on his porch.[41]

In 1953, Hardman married the poet Marya Fiamengo (they divorced in 1966). In 1957, their son Dmitri was born. In March or April 1964, Hardman took his seven-year-old boy with him to the Onward. Dmitri recalls "long horseback rides, witnessing the birth of a calf and being struck by the fact that the Cornwalls bought booze by the case."[42] On April 8, 1964, Hardman wrote Sonia to thank her for the kindness she and Hugh had shown Dmitri. Hardman described how upon their arrival home, "Dmitri rushed around the neighbourhood telling about his adventures at the ranch. We both had a most marvellous vacation.... Marya finds Dmitri much changed in one week, more articulate and independent." Hardman too had benefitted and told Sonia, "I came back refreshed and ready to plunge right in—already. I have one large sculpture underway and have even had the courage to colour one sculpture a soft cinnabar colour—could this be the influence of the Onward?" Some years later, after a visit to Jones Lake, Hardman wrote Sonia (in an undated letter) that he liked the new ranch "immensely" and found it "very beautiful." He added, "The country gets a hold on you—I can understand why the landscape is a dominant theme. Everything here seems overly lush."

Sonia and Hardman discussed art and artists in their letters. On February 22, 1966, Hardman disclosed that he had begun "to hate painting with a deep loathe" because he had recently viewed

> so much crap.... I can't take fad or non-art—the idea that "the media is the message" is just too slick for me.... I would go to openings after several drinks & then would sober up as soon as I was confronted by the work & then I would run out.... So ... I am painting ... in the fad or vogue or whatever you call it—just to see if there is any substance. Well my dear it is all very sick decoration but art NO! ... I don't think the galleries will be satisfied until somebody has live models copulating in a huge wooden box frame, preferably the artist I suppose.

In her writings, Sonia noted how vital contacts with other artists were to her as they helped her to keep in touch "with the outside world." She also learned "there are no rules in art, as every artist has a different set of dos and don'ts." She freely studied and explored as her style evolved. Sometime in the early 1960s, Sonia sold a painting and used the money to travel by bus to the Portland Museum. There, she viewed the paintings of Charles Price, who depicted the West but, as she explained, "the more agricultural side of it & ... very abstract. I idealized his work." By the 1960s, Sonia became less involved in ranch work and devoted herself to her painting anew. Scenes of cattle and ranch life became prominent motifs.

Ranch Vignettes

With advances in the country's media, Canadians were becoming more interested in documentaries about the cattle industry (among others). The National Film Board was in the Williams Lake area in October 1944, and the film crew found their way to the Onward Ranch. There, Sonia helped round up three hundred head for the production crew. They filmed Sonia riding Romany.[1] In 1958 and 1959, the award-winning film and production specialist Peter Elkington filmed two black-and-white documentaries on the Cariboo-Chilcotin beef industry. The first was *Cattle at the Crossroads*, aka *Crisis in the Cattle Industry* (which aired on CBUT on February 4, 1960). For that movie, Elkington interviewed individuals such as John Wade of the Chilco Ranch and livestock inspector Heck Ford. The focus of the second, *The Lazy Cross*, aka *Cattle Drive Cariboo* (which aired on the CBC, February 18, 1960), was the foreman of the Alkali Lake Ranch, Bill Twan, and the branding of that ranch's two thousand head.[2] Elkington met Hugh, who, through his connections with Cariboo beef suppliers, suggested the ranches Elkington should visit. The producer immediately befriended the Cornwalls. His first wife, Dorothy, says Elkington had never before been to the Cariboo and "all that incredible space just blew his mind. He came to Canada from England after a horrendous [and traumatizing] World War II experience in Burma. He found himself in that landscape and its vast skies. The Onward Ranch and Sonia and Hugh became a refuge for him."[3]

Elkington was comfortable riding horses and helping on the ranch. Dorothy says, "Peter became a real cowboy when he was with Hugh." She laughs that for one trip Elkington "borrowed" a cowboy hat from the CBC props room. Dust had been glued or sprayed on the stetson to make it look used. After several trips, real grime replaced the artificial dirt. One day he went out to a corral to watch Hugh and some hired hands working. Seven-year-old Mabel was perched on the fence watching. He asked her what was happening and "she nonchalantly said, 'They are cutting a colt ... so it won't have babies.'"[4] Elkington was impressed by Mabel's matter-of-fact attitude to castration. Furthermore, he liked that Mary and Mabel had responsibilities and animals of their own to tend. Smitten by the Cornwalls' lifestyle, Elkington later brought Dorothy and their eldest daughter, Kim, for a visit.

On her initial visit, Dorothy did not know what to expect when she arrived. First, they had tea with Vivien and then settled in at Sonia and Hugh's. Dorothy recalls that the collection of paintings Sonia had from artists such as A.Y. Jackson who had visited the Onward

> was just incredible. I guess I had felt the Cornwalls would be culturally isolated.... But there were books piled everywhere. They had an account with Foyle's, a bookstore in London, England. They had newspapers like the *Times of London* and the *Manchester Guardian*. They were both completely up-to-date with what was happening. It was an eye-opener and delightful. I remember Sonia telling me she was reading Henry Miller's *Wisdom of the Heart*. That was the first time I had heard about that book. I got a copy and still have it. She was also waiting for a book of Henry Miller's that was a translation of the writings of the Indian spiritual leader Krishnamurti. Hugh was reading and inspired by Teilhard de Chardin's *Phenomenon of Man*. I can still see the animation in his face as he was discussing the book. Both books have to do with man seeking a greater consciousness and the understanding that comes from within: that seemed to be such a new idea and so exciting at the time. Hugh and Sonia were on that cusp of awareness of what was new and intriguing. I only saw them a few times but their impact was such that I could never forget it. I find myself using words like decency when I think of Sonia and Hugh.

Dorothy discovered Sonia was a great cook and in particular recalls eating her Armenian Cake: "When I first saw it, I thought it was a flop, but it was absolutely delicious. It has a brown-sugar base, then a cake part with cinnamon and nuts on top. I got her recipe and for decades now people I know in the Guelph and Kitchener areas of Ontario have been making it. They all call it Sonia Cornwall's Armenian Cake."

Dorothy never objected when her husband asked to travel to visit the Cornwalls. She only refused his request once: "Hugh had phoned to say he had broken an arm, and he wanted Peter's help on the ranch. I was pregnant with our second daughter, Caitlin, who was due any time. I had just been in hospital for ten days, Kim was three and we were moving house the following week. Peter said, 'Please, I must go. Hugh needs me.' It was the only time I denied him going to the Cariboo."

Based on his experiences, Elkington wrote three short stories set in the Cariboo (all unpublished).[5] His narratives convey the rugged life-style and vistas that became subjects of Sonia's brushes. For instance, in

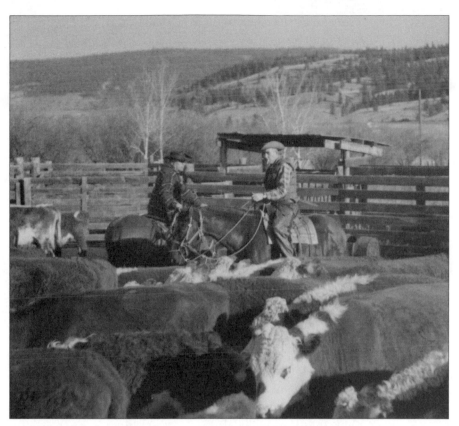

Peter Elkington and Hugh Cornwall working at the Onward Ranch, circa 1950s–60s. Courtesy of the Cornwall Family Archive.

"Tomorrow the Killers" he wrote, "How often the routine task becomes an adventure ... [and] the commonplace became particular.... Through the mists, huddled clumps of alder would suddenly appear and pass like withered sentinels." In "To the Barn," the Onward Ranch comes to life:

> As I walked down the dirt road from the house through the alfalfa field, I could feel the departing chill of a heavy over-night dew clinging to me. Over to the right, the western ridge was lightly bathed in sloping sunlight, lifting the sombre jack-pines from their winter drabness into the meadow greens of spring.... Alongside the shop, a yellow side-rake with its round wheels, extending rake points and high-arched supports, offers a curious study in form.

Elkington's words are an apt description of Sonia's study *The Onward Barn* (1955).

Cattle have always been vital to agrarian economies, whether raised for meat or dairy products or as beasts of burden. Depending upon their breed, cattle can weigh anywhere from 600 to 2,500 pounds (and bulls up to 3,300 pounds). Furthermore, bovines are part of the mythology of several peoples and to Buddhists and Hindus, they symbolize holiness and patience. Bulls often symbolize strength or passion. Cattle have frequently been part of various peoples' religious beliefs and have inspired art throughout the ages. One of the prominent examples is the wall paintings in the Lascaux Caves, France. The German expressionist Franz Marc and Canadian artist Joe Fafard are just two examples of artists who have celebrated farm animals in painting and sculpture. Indeed, Sonia's depictions of blue horses and bulls may be a reference to Marc's renditions of blue-hued equines. For Marc, animals represented rebirth and blue symbolized sublime realities.

Sonia lived with cows and bulls. She found them beautiful, complex, essential, fascinating beings that she enjoyed portraying. Her images acquaint urban dwellers with farm life and the characteristics of cattle. In her work, the powerful beasts sometimes seem to dance, threaten, fight or play. Viewers come to know their awkward, lumpy bodies and their curious dispositions. Frequently emphasized in her work is the cattle's dependence on humans. Images such as a herd scattered around strewn hay are more than bucolic representations: they convey the beauty found in simple, everyday rural vistas. Sonia's oil *Storm Coming* strikingly depicts cattle heading home to shelter from a roiling purple sky presaging a tempest. Many of her other pieces depict work on a ranch: particularly herding, rounding up or separating cattle.

Like Sonia's images, Elkington's "Balm of Gilead" represents in writing the bygone practices and day-to-day routines and emergencies on a 1960s ranch. This excerpt gives an intimate glimpse of Hugh and Sonia's world:

> Joe, Willie and I were leaning on the tractor in the cool shade of a Lombardy poplar, talking and smoking a cigarette before heading home for the day, when we saw Hugh riding towards us. The ranch owner was making good time, too. He'd been out for another check on the heifer herd about a mile away. There's nearly always one of us riding out to check them during calving time.

> "I'm going to need some help," he called. "A fallen calf bed.... Pete, you'd better come with me." ... We were concerned about the heifer, not only because of the urge in a man to help ailing creatures, but for a very practical reason as well:

a heifer and calf represent about $250.00 to a cattleman.... A calf bed is the apt range term for the uterus. Sometimes, after throwing her calf, a heifer will continue to bear down and the natural muscular contractions proceed unnaturally. The result is that she turns the entire womb inside out and it falls, trailing to the ground. If the new mother is to be saved, the uterus must be put back.

With gentle ease, Hugh encouraged her towards me. It wasn't necessary to direct the thin-legged, wobbly calf because he was never far from her heels. She stopped close to the open gate, head down and feet apart, her instinct suspicious and un-decided towards me.

"Ho-o—cow," I called softly, and motioned my horse for-ward a step. This made up her mind for her, and she moved through the gate dragging and scraping her inverted womb over the rough ground. I was appalled to think a living creature could absorb so much pain and not cry out.

I followed them into the stack-yard and closed the gate. My job now was to toss a rope over her head and pass it through to Hugh who was waiting outside by one of the fence corner posts. This was no hand-raised cow of the southern domestic herds and accustomed to man on foot; she was instead, a wild creature of the range, easily frightened and panicked even with her present pain.

Hugh took the rope and snubbed her head down until it almost touched the ground; a few wraps around the post and then through the fence rail back to me. I then ran the rope from her head, along her heaving sides just below the bulge of the rib cage, under the trailing uterus and fastened it tightly around the fence rail. She was now pinned against the fence and unable to sit down, which she would surely try when we started to work.

We then took off our jackets, rolled our sleeves up as high as possible and washed our hands and arms thoroughly in the disinfectant.

While I went to get the calf, Hugh started to wash and clean the uterus.... Hugh and I took turns ... in the cleansing. During one of the periods of waiting, I raised up to wipe my brow with my forearm and to look around. Up on the slope

where we had first sighted the heifer, I could see other creatures in their search for a place to settle and drop their own calves. There were two down already, throwing back their heads in the throes of labour, and a sign of possible trouble. (We'd have to check them both when we had finished here.) The sun was still quite high and very warm; swallows were darting in search of food for their own young; far away on the still air, I could hear the P.G.E. passenger car, which would shortly pass us by with its curious tourists and rewarding northern people. Behind us, past the willows and Balm of Gilead gracing the banks of the stream, I could see the barn in the distance. The smoke from the house chimney seemed to grow straight out of the treetops. Supper would wait a long time for us this day....

The grey uterus is covered with "buttons." They are muscular supports, which cover the lining of the uterus walls to help lift the calf and pass it through to the world.... Each "button" must be thoroughly cleaned ... before the main work begins—replacing the uterus; and that, is an arduous two-man job.... It wasn't long before our wrists and shoulders cried out for relief from the strain, but a glance at the silent cow, white-eyed and exhausted, but above all—silent—put discomfort to shame. We worked on for more than an hour, and then, it was done.

We had exchanged few words with each other during our work, with the exception of requests for help or to curse the heat and sweat rolling into our eyes. The strain of physical exertion was intense but the conflict of this with the desire not to cause more pain to an animal already overburdened with it, was greater; so we took it out on that blessed sun.

Now for the problem of how to keep the uterus in place with muscle spasms still working against us.... It probably sounds ludicrous to you, having to use a milk bottle ... to make this task ... effective. Here's what to do. After disinfecting the bottle, a peeled willow stick is placed through the neck of the bottle until it butts up against the bottom. When a retaining notch has been cut in the projecting limb, the bottle and stick are inserted. By tying a cord from the notch to her tail, the exhausted heifer is unable to push out the bottle, which will keep her alive. It may not be the most sophisticated treatment, but it's highly efficient when you're miles from anywhere and the need is now.

This done, our work was finished. We untied her. Slowly she sank with tired relief to the ground close to the new life she had worked so hard to achieve.... We collected the bucket, coiled our ropes and mounted up. The heifer and calf would stay in the stack-yard for two or three days, easily reached by us, and free from harm.

A final, quiet ride around the heifer pasture to check our maternity ward, revealed only the fulfillment of our charges. The two heifers I'd seen earlier from the stack-yard would need to be checked again later tonight; otherwise, all was well and peaceful and as it should be.

We turned our impatient horses for home. Suddenly I felt very tired, and very glad to be here and to be a part of it all.

Some years later, Elkington and Dorothy separated, and he married the Canadian actor Sharon Acker. She, too, visited the Cornwalls but at their home on Jones Lake Ranch. Like most other visitors, Acker remembers that Sonia and Hugh

> were incredibly hospitable, warm, generous and full of joy and humour. Sonia got a kick out of me because I was always in the kitchen and I used rubber gloves. I always hung my gloves to make sure they would dry. Later, after we were home, a photograph arrived in the mail. It was of my rubber gloves hanging over the sink in Sonia's kitchen. She called it, 'Sharon's Still Life.' That is still a family joke. She was so magnanimous: she just became a part of you within minutes of meeting her.[6]

Later, Elkington's broadcast and production work took him to other provinces. He left the CBC in 1962 and worked as a freelancer before becoming a film producer for the BC Department of Highways in 1963. After a particularly gruelling schedule while filming his award-winning documentary *Rogers Pass*, Elkington was overcome by exhaustion and stress and exclaimed, "Take me to Jones Lake!"[7] He took sanctuary there for four or five days before returning to work.[8] After he died in 2001, Elkinton's ashes were taken to Jones Lake Ranch. In a small ceremony, Sonia's granddaughter Natalie rode about the ranch spreading the ashes over the landscape Elkington so enjoyed. When Sonia had a 2001 exhibition at Westbridge Fine Art (Vancouver), Acker flew across the country to attend. She says the trip was a pilgrimage that she "needed to do" for herself and Elkington.

Acker "loved Sonia's art." On one visit, she and Elkington photographed a number of Sonia's paintings. They took the prints to several Toronto galleries, hoping to find Sonia a representative in that city. Acker emphasizes, "Sonia painted life—the Cariboo. Her joy was all over her canvases. She sent me a little watercolour of a couple of cows. It is so enchanting, so sparse and lively at the same time. She sent me a pastel of sunflowers and the sunshine just leaps off the wall and dapples the room. We thought it ridiculous that her work was unknown in Ontario. However, when we met with Toronto gallery owners, they had 'attitude.'" Acker then contacted Robert and Signe McMichael about purchasing some of Sonia's work for the McMichael Gallery. Acker recounts that the McMichaels were at that time in dispute with the curatorial staff that showed no interest in Sonia's work. Hence, that institution declined an acquisition. Acker still thinks a collection of Sonia's paintings "would be perfect" for the McMichael.

Acker made one last trip to the Cariboo. While she was there, some hunters arrived at the ranch house. Acker does not approve of hunting, and Sonia warned her that the hunters would be arriving with their kill. She also cautioned that the men were boisterous. Acker decided to avoid the company. However, when they arrived, they had not yet killed an animal. One of the boys with the men went out by himself on the ranch property and shot a deer. The men went out to help the youth clean and cut up the animal. As was their custom, the hunters presented Sonia with the liver and the heart. The next day, after the men had departed, Sonia asked Acker what they should have for dinner. Acker replied, "I think we should eat that deer liver." Acker remembers Sonia's surprise. Acker explained, "'I think it's time to honour that deer that was taken on your property.' So, she and I ate the liver. The remembrance of that event is a treasure for me because I grew up in that moment. I came to a different understanding and appreciation of life."

One day while Acker was visiting, Sonia gave her a sketchpad and a piece of charcoal with the instruction, "Go and do a sketch for me." Acker wandered out into a field and sat down. She sighted a gopher and did a fast sketch. Then, she saw a cow looking at her through the fence. "I did a sketch of the cow: just the head, face—the expression. When Sonia looked at it she said, 'I know exactly which cow that is.' That was the biggest compliment she could have given me. It just thrilled me. The way she said it was so loving and with such delight. I miss her terribly. She was larger than life. Her paintings had a magic that drew you in."

Anxiously Extending

During the 1950s, raising her daughters and helping Hugh on the ranch filled Sonia's life. She still had little time to herself but she worked out a regimen that gave her some freedom. Sonia emphasized that as soon as Hugh and the kids were out the door, she would ignore the housework because "you can do that anytime in your sleep."[1] She then spent an hour or two painting or studying art. According to David Zirnhelt, his mother "admired Sonia's ability to let the housework go and take time to paint." With raising five children and helping her husband, Clarence, with his "boom and bust" business ventures, Harriet did not "have the same level of fulfillment" as Sonia, nor could she "keep on with her love of literature and art" to the same extent. Zirnhelt adds, "My mother was determined that she wasn't gonna raise any cowboys and that her children would get an education. That's where she spent her time." However, Harriet had "a lot of respect for what Sonia was able to do" and that she pursued her vocation "right to the end."[2] While Sonia might not have won any housekeeping awards, she ably managed her home life and ranching duties; moreover, she did not raise any buckaroos, as Mabel became an accountant and Mary a teacher. Sonia could no longer contain her zeal, and producing art became an integral part of her family and community life.

According to Sonia, one person who greatly encouraged that fervour was the award-winning author and playwright Gwen Pharis Ringwood. In 1953, her husband, Dr. John Brian Ringwood, accepted a surgeon's position in Williams Lake. They became close friends with Sonia, Dru and Vivien. Like the Cornwalls, the Ringwoods had intriguing visitors. Sonia said, "Whenever we had interesting friends, we'd ask the Ringwoods out to meet them and vice versa. So, I met a lot of people through her and also she encouraged me—kept buying [my] paintings and really liking them and insisted I paint. She was pretty forceful. She was the kind of woman that can draw you out—things you didn't know you had in you. Very encouraging. So that sort of helped me keep up my discipline. She was tremendous." Sonia wrote that the images Ringwood purchased "were good ones. Looking back, she picked the ones that I would have picked. She painted herself, latterly—very different types of painting—imaginative, very interesting."[3]

While Ringwood's work (over sixty plays, a novel and several short stories) often reflects survival in a stark environment, Devereux Hodgson recalls that her mother, Dru, and Ringwood sometimes wrote

and produced minor, less serious productions. Some may have been short skits put on with the Williams Lake Players Club during informal coffee-houses. As social commentary was vital to Ringwood's work, there was usually much within those skits. Sonia often painted sets for Ringwood's productions. For *The Road Runs North*, produced in Williams Lake for the BC 1967 centenary, Sonia's sets were reminiscent of various mountain plateaus. According to Sonia's daughters, with Hugh's help their mother would make small dioramas at home to perfect her stage designs. Hugh then built the wooden sets, and Sonia painted them. Her art depicted life in rural Western Canada, and Ringwood's plays became "metaphors"[4] of the same. The two appear to have shared a similar belief in the dignity and mystery of all life and the Canadian landscape. In her poem "The Road," published in the *Williams Lake Tribune* and encircled by a design of Sonia's, Ringwood shared sentiments similar to those conveyed in Sonia's images of bovines: "The soft stare of cattle holds some / enveloping strangeness / Bland, benign, that eases the heart."[5]

Sonia found more time for art when, in 1960, British citizens Pam and Hugh Mahon and their two eldest children moved to the Onward. They came through a CPR immigration program: in return for working on a farm for one year, the Mahons received reimbursement for their train travel to any Canadian destination. Their employers would provide accommodation and a salary. Pam says she and Hugh were frustrated in England because they could not afford to buy a farm and no one would rent to them. When offered a job in the Interior of BC, they accepted. Pam laughs, "We couldn't even find Williams Lake on a map." They were working for a British cattle breeder who knew Ted Cornwall, Hugh's brother. Ted was a CPR agent at the time and the Englishman said Ted "was a very nice fellow and, if his brother is anything like him,"[6] they would be okay. On that encouragement, and the promise of $175 a month, plus lodging, the Mahons took the job.

They rode the PGE from Vancouver and arrived at the Onward Station around 6:00 p.m. one day in June 1960. Hugh and Sonia had no idea the Mahon family were on their way until Hugh Mahon sent a cable from Vancouver. Upon arrival at the Onward Station, the train crew unreasonably refused to let the Mahons off because Hugh was late and no one was there to meet the newcomers. Apparently, the winter before, a man detrained somewhere along the line and later died in a snowbank. Pam says the ranch buildings were visible, and she and her husband insisted they would be fine. The rail crew finally relented. The Mahons received a warm welcome from Sonia and Hugh. Pam emphasizes that the Cornwalls "were so good to us ... we ended [up] more than just working for them," and they became lifelong friends.

Not having had time to prepare, the Cornwalls put the Mahons and their children up at the 150 Motel for the night. The next day, after the old bunkhouse had been thoroughly cleaned, the Mahons moved in. They had no furniture, so Sonia and Hugh gave them some. Pam recalls that Williams Lake had a second-hand store but no furniture stores. Besides, they had no money for furniture. Pam explains, "We made do. We sat on packing trunks and packing cases for a while." Their new locale and lifestyle were a shock as there was no indoor bathroom and only a cold-water tap. However, Pam says the worst part of their adventure "was the mosquitoes. They hit soon after we got there, and we weren't used to them. We suffered. There were a lot of mosquitoes down there; no screens on the windows. It was a little chilly in that house—no insulation. We had three stoves (downstairs) going in the winter. We lived there for seven years."

Pam remembers that she and her family faced many adjustments: for example, they were astounded that the Williams Lake sidewalks were still made of wood. As well, when people came for coffee, Pam made café au lait: "It was the only coffee I knew: half milk, half coffee. You heated it in a pan…. And I didn't know how to cook steaks. I put them in the oven. They came out like bits of cardboard." Pam had to learn quickly as one of her first tasks was to prepare the ranch hands their midday meal. She recalls that Sonia wanted more time to paint, so having Pam cook freed Sonia from that task. Pam "had never cooked for a bunch of men before." Most were from the Sugar Cane Reserve. Sonia advised, "Just give them meat and potatoes and some sort of dessert. But no meat on Fridays 'cause they're all Catholics." Pam remembers, "So they used to get macaroni and cheese, if we didn't have any fish. You couldn't buy fish in Williams Lake then. Salad was all right when you had some. Sonia paid me a dollar a day for every guy, but they weren't there all year round."

Hugh Mahon says that Hugh Cornwall was "so easy" and a "quiet fellow." On the ranch, "there was always the struggle of equipment and money, but we just carried on." Mahon remembers one day when they were working "at the far end [of the ranch] where the trains go round the bluff and it was getting pretty hot. Hugh [Cornwall] said, 'Let's have a rest.' Coming from England, you didn't do that sort of thing. Basically, he was really kind and thoughtful."[7] Pam adds that sometimes Cornwall was "too kind for his own good." She relates a story about him:

[He was] buying traps for somebody to trap beaver and Hugh [Cornwall] never saw any beavers or any money for the traps. He wasn't that great a businessman—because he was just so easy to get along with. I remember one fellow who's gone now, but he used to come to the grain store and buy a couple

of sacks of grain for his stud. He'd give me a cheque 'cause I was looking after the grain store.... The next time he came I said, "That cheque bounced." He said, "I'll make it good this time." Well, it got worse and worse; finally, Hugh went up to his place and got two lambs [in lieu of payment]. Hugh tethered them on the lawn, and the next morning they were gone. He figured the guy came ... and took them.

Mabel and Mary recall that incident well. As young girls, they were thrilled at having two lambs. Because of their excitement, their dad tethered the sheep on the lawn so the jubilant girls would go to sleep with the prospect of seeing their lambs first thing in the morning. If Hugh Cornwall suspected that the farmer had pinched the animals, he never let on. The girls believed that either an animal, such as a coyote, killed the lambs or the animals simply managed to get free of their restraints.

Hugh Cornwall was a fun-loving man who was always teasing. Pam says he would tell the children that Ashcroft had chocolate houses and banana trees: "I remember the first time we went through Ashcroft: my kids were quite disappointed they didn't see any of those things." He purported to be a graduate of the University of Ashcroft. He also told children he was a French professor and, as proof, at meals would ask them to "*Passez la beurre*" [butter].

The Mahons remember "wonderful" parties at the Cornwalls' with dancing and many people. Sonia's friend Ellinore Milner adds that well over a hundred people attended the Cornwall Boxing Day open house: "Sonia always cooked a huge roast of spiced beef, the old English recipe. You soaked it in spices for two or three weeks before you cooked it." In addition, Sonia served freshly baked bread and a large fruitcake that her son-in-law John iced with homemade marzipan. Milner describes the meal as "a feast—simple but wonderful."[8]

Pirjo Raits, a former reporter for the *Williams Lake Tribune*, attended some of the Boxing Day parties. She says that when people came in the front door, they removed their boots, which formed a huge pile. After one celebration, she struggled to get into her new and expensive black Santana boots. She finally realized they did not fit, and hers were gone. Raits assumed someone had imbibed a little too much alcohol and the mistake would be sorted out.[9] When no one owned up to the error, Aaron Drake published "Foul Deed A Foot: Williams Lake's unsolved mystery" in the *Williams Lake Advocate*, adding to the fame of the Cornwalls' seasonal fete. In the article, Raits described herself as "Shoeless in Seattle," and offered "to make a prisoner exchange" as "only then can the heeling begin."[10] The bootlegged footwear never turned up.

Besides their annual Boxing Day festivities, the Cornwalls held year-ly pig roasts every January. That event started because of an amusing en-counter Gwen Ringwood had in 1957 while shopping in Williams Lake. According to Vivien, prior to Christmas 1957, Ringwood went to the butcher shop where she saw a "suckling pig displayed, complete with cranberry eyes and an apple in its mouth. She turned to an Irish priest standing by, and said as she went out: 'What would one do if that were sent to one?' After she left, the priest bought the pig and sent it to her.... She said that every time she opened her freezer it leered at her, in an un-canny way. The problem was how to cook it as no ordinary oven would take it." The solution was Sonia's large wood-burning stove. Vivien fur-ther detailed in her unpublished manuscript that prior to the feast, the guests rode in cars or a hayrack (with children being towed behind on toboggans) out to Long Lake. Upon their return, the revellers toasted the hog with steins of ale and Hugh, a former member of the Highland Regiment, "piped" the hog "high around the table." Vivien noted that those present were "happy and full of ... good food and happy laughter."

The Cornwalls also hosted an annual duck hunt every September. After their morning shoot, Hugh and his pals feasted on Sonia's hearty lunches: "often freshly baked corn bread and baked beans, along with some liquid refreshment."[11] Moreover, Hugh and Sonia had branding bashes each spring and winter tobogganing parties. Pam Mahon de-scribes one tobogganing outing held "about the third week in January because Mary, Dru, and our daughters had birthdays around that time. It was a big toboggan party. We'd find a place on the ranch with a nice hill. Hugh [Cornwall] would take out a sleigh or tractor and make a tobog-gan run. We'd have a huge fire and food and hot wine." The Cornwalls also had skating outings: Pam says, "If there wasn't too much snow, that was the best skating. Sometimes we went all the way up to Cummins Lake, which is towards the 150 and shovelled a bit of snow off the ice." After the Cornwalls moved to Jones Lake, they kept having the parties. Pam explains, "There were several little potholes or sloughs around there and we cleared snow off them. We skated, had a big fire—lots of fun. I remember one guy falling through the ice in one of those potholes. He thought he had to swim out, so there he was lying on the ice, swimming with his arms, trying to get out. When he kicked, he touched bottom. He realized the water was only up to his knees. We all had a good laugh about that."

The Mahons had only been at the Onward a few weeks when the annual Williams Lake Stampede opened. Hugh Mahon recalls Hugh Corn-wall telling him they had the day off to go to the Stampede parade. "I said, 'What do we do the next day? Hugh said, 'You go to the Stampede.'

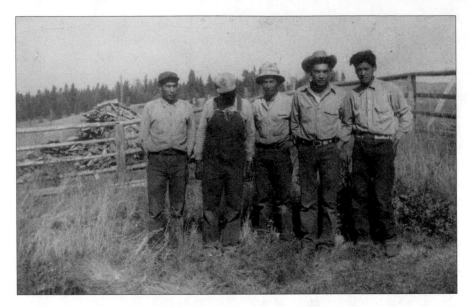

Some of the Sugar Cane hands who worked at the Onward and 150 Mile ranches. Left to right: Jimmie Sandy, Tommy Wycotte, Andrew Gilbert, Tommy Wycotte Jr. and Robert Gilbert, 1949. Courtesy of the Cornwall Family Archive.

I asked, 'What do you want me to do the next day?' He said, 'Go to the Stampede.' I went home and said, 'I just got three days off and we've only been here three weeks.' That was summer, so it was okay."

Hugh Mahon worked with many men from the Sugar Cane Reserve who hired on to fence, clean ditches and harvest hay. He worked with Joe Bob, Lawrence and Robert Gilbert, Sammy Peters and George and Tommy Wycotte. Mahon says First Nations men liked the seasonal employment and "they did a good job." Mahon and Robert Gilbert "were the first ones to set up [the Onward Ranch's] new irrigation system." Furthermore, Mahon "ploughed up the whole forty-acre flat and seeded it with alfalfa.... The first year we were there was the first year they had square bales. [Before that], they had only put up loose hay. I think the biggest horsepower tractor was 40 horsepower."

The Stampede was an experience for the Mahons. They enjoyed the novelty of watching a cowboy rolling his smokes with the aid of a fence post. They recall that after one Stampede parade, Sonia volunteered to drive the BX Stagecoach. Bolstered by a few drinks, Sonia wrote that she "drove down in front of the grandstand on the track & picked up tourists to give them a ride around the track! (At that point Hugh & the kids left me & went to the 'rides!') I went right around the track, brought the tourists safely back, picked up the family & we

A winter party at Onward Ranch, circa 1950s. On the far left and standing on the sleigh is Patrick Ringwood; on the ground holding a child is Barney Ringwood; Sonia Cornwall is sitting holding her daughter, Mary, and the child standing on Sonia's left is her other daughter, Mabel; the man on the right wearing a hat is Clarence Zirnhelt; others are unidentified. Courtesy of the Cornwall Family Archive.

headed home. By this time, we had Hughie Atwood & Ann Irwin with us & all the way home tourists stopped & took our pictures at which I posed…. Hugh was mortified."[12] Another time, the Mahons wakened to boisterous noises "coming along the road. Soon the BX Stagecoach came with a team and Hugh driving. Sonia, Dru, her husband Wilfred and others were just a whooping and hollering. We thought this is different. The team belonged to the Onward and, after the parade, they brought the stagecoach back to the ranch. Anne Stevenson later kept it at their place for years." The historic conveyance eventually went on permanent display at the Red Coach Inn in 100 Mile House.

When Prime Minister Pierre Elliott Trudeau travelled through Williams Lake in August 1970, his popularity or "Trudeaumania" was high. Over one thousand people turned out to see him, and Dorothy Jeff, representing the First Nations peoples of the Cariboo and Chilcotin, gave Trudeau a moose-skin jacket. He wore the jacket on several occasions and it became an iconic item. The folks in Williams Lake put on a

special event for Trudeau, the Rockin "T" Rodeo, which was a miniature stampede. The prime minister was to ride to the function in the old BX Stagecoach driven by Bill Garrow of 100 Mile House. Hugh Mahon was supervising the stagecoach's parade through town and into the stampede grounds. Mahon's jaw dropped when he saw that Trudeau had taken the reins from Garrow as the old coach made its way down the steep incline to the grounds. Pam Mahon laughs, "Down the hill they went. Trudeau's white running shoes were up on the board in front, where it should have been cowboy boots." That evening at the western-style barbeque for Trudeau, Hugh Mahon asked Trudeau how he had enjoyed the rodeo. The prime minister only quipped, "Were you there?" To the same query from a *Williams Lake Advocate* reporter, Trudeau gave a more politically correct response, claiming the event was "a dream come true."[13]

Aside from the reprieve of such cultural events, the Mahons were working hard and looking for ways to increase their income. In order to assist them, Hugh Cornwall said they could keep animals other than cattle as a way to earn more money. They decided on chickens and obtained about two hundred laying hens. Every Friday for many years, the Mahons delivered eggs in Williams Lake. Pam says the Cornwalls ordered a few dozen every week. Instead of money, Pam often kept a running tab until she could take a painting in exchange for the eggs.

The financial well-being of the Onward was always a concern. Eventually the property was divided in two, with 2,500 acres becoming Jones Lake Ranch. In 1964, the family sold the Onward Ranch section of their holdings to the Oblates at St. Joseph's Mission. The Mahons were looking to relocate and Hugh Cornwall sold them a seventeen-acre parcel near 147 Mile. There the Mahons built a house and undertook a new venture—the honey business. Hugh Mahon's interest in bees began after an earlier incident at the Onward. A commercial beekeeper had hives on the ranch, and one morning Vivien awoke to find the insects in her boudoir. A swarm had escaped from one of the hives and had installed itself in one of Vivien's bedroom walls. Hugh Cornwall was allergic to bee venom, so Mahon took on their removal. With a lace curtain wrapped about his head, Mahon punched a hole in the wall and deftly removed the queen.[14] In 1967, Mahon began the 147 Apiaries and by 1975 had over two hundred hives. Although a bear once destroyed twenty hives, the business did well. In 1981, the Mahons moved to the Bunting Lake area. There they raised sheep and cattle, and Mahon increased his hives to 320. He retired from honey production in 1998 and became a honey packer until his retirement in 2001.

Eventually, Pam started painting with Sonia, who persuaded Pam to join the Cariboo Art Society. Pam had not painted since her schooldays, and she remembers Sonia being

so encouraging and helpful.... She'd give you critiques, but she was very cautious about saying too much. I'd say, "I can't get this right," and she'd say, "Try this, or that." I never got the feeling that she was telling me what to do.... She'd praise, lots of praise, but not really critique.... I remember going through the back streets of Williams Lake to sketch with her and some other art club members. She said you go into the lanes and you get a totally different view of buildings (structures, shadows and light) than when you go down on the main street. It was fascinating.

Ellinore Milner also met Sonia through the Art Society, and they, too, became close friends. She often painted with Sonia and Pam. Before Milner moved away from the Cariboo, she says they

> were a threesome for many years.... Our kids were in school, so we could ... enjoy the day. We'd get into one or the other's cars, and we'd coast around just off the highway and look for suitable spots ... to sit down and paint or draw.... We had a standing joke because one time ... we were all craning our necks looking for the right spot. Finally, one of us said, "Who's driving?" We tried to go out in the mornings because the light would be lovely.... Those humpy Cariboo hills are amazing [to paint] and [so are] the sloughs.... When we started, we were very focussed. There would be no chitchat.... By noon, the colours weren't that wonderful or the shadows changed.... It was time ... for lunch and a good shot of gin each. It was absolute fun. We always had a great time.

Pam Mahon stresses, "Sonia was by far the most serious.... She was instrumental" in bringing in "the really good teachers" who gave workshops in the area. Moreover, Sonia often instigated projects such as decorating a van for the Art Society's entry in one or more of the stampede parades. One time, she won a proposal to complete a mural for the Williams Lake Tourist Information Centre. She designed a cowboy sitting on a hill with his horse standing nearby. The piece was approximately eight feet by twelve feet and made up of black, grey and white pebbles glued onto three plywood panels. Once attached to the side of the Information Centre, the commission became a disaster. The sun heated the linoleum cement the artists used and, according to Ellinore Milner, the piece "slumped."

Local high school teacher Quint Robertson came to the rescue with the suggestion of redoing the triptych using fibreglass to hold the pebbles. Donning masks, the women set to work in Milner's backyard.

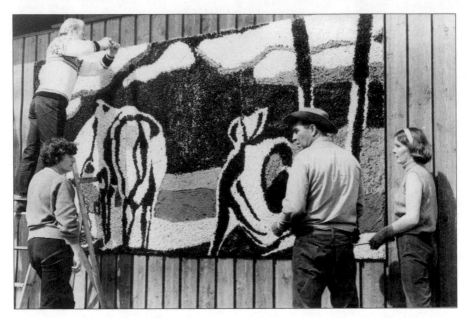

Erecting the mosaic mural created by Sonia Cornwall, Pam Mahon and Ellinore Milner, circa early 1970s. Left to right: Hugh Mahon, Sonia Cornwall, Hugh Cornwall, and Pam Mahon. Photograph by Ellinore Milner and courtesy of the Museum of the Cariboo Chilcotin.

She chuckles that the artists "became foolish with the fumes and were staggering around, and the neighbours were watching." Later, the mural was donated to the Museum of the Cariboo and Chilcotin. However, when the facility moved to a new building, the mural disappeared. Fortunately, the Museum does house other murals Sonia painted.[15]

Pam Mahon recounts that Sonia "loved talking about art. If you went to the house at Jones Lake, usually the first thing you did was look through the window over the kitchen sink down into the studio to see what was new.... [Then] you'd go down and have a look, ask her about what she'd been doing.... She was very modest about her work. She gave many pieces away.... She was always surprised if people wanted her to have a show somewhere outside of Williams Lake.... Sonia knew what she wanted [to achieve], although she was perfectly willing to say that the work didn't come out like she wanted. Then she'd start over." Sonia would burn the ones she felt weren't successful. Her family says Sonia would prop paintings on the piano, other furniture or the floor to study if the piece needed further work. Her granddaughter Natalie remembers Sonia sitting in her chair in the corner, "and she'd just stare at a painting. Then she'd pick it up, put it on the easel and do just a few touches. Then she'd put the painting back, sit there"[16] and study the piece some more. Ellinore Milner

laughs that after Sonia read how Henry Miller would try to sneak up on paintings as if seeing them for the first time in order to analyze his work, she did the same (as did Milner).[17] In a letter to Harvey Chometsky dated February 4, 1998, Sonia confessed, "[I took] a sneak look at my last painting & decided I had two options—burn or go for broke! So I took my palette knife & went for it. It is at least alive now ... and I had a lot of fun."

Sonia had an extensive library of art books that she studied carefully and frequently. Her journals contain notes on the philosophies and practices of artists such as Paul Cézanne, Paul Gauguin, Henry Miller, Arthur Lismer, Pablo Picasso, Diego Rivera, Georges Rouault and Tom Thomson. In an untitled, undated rough draft of a talk Sonia gave to an art club, she recommended that the group "extend themselves." She counselled that the members had to concentrate on their interests and practise new methods in depicting those motifs. Using herself as an example, she stated that she was "interested in cattle & ranching—landscape, etc. I don't just want to make pretty ranch scenes. I want to study & think out the spirit of ranching & try to express it." She continually experimented as she attempted to convey what fascinated her about the Cariboo and the Chilcotin. From Emily Carr's writings, Sonia said she learned to always carry a notebook "and carefully ask myself your [Carr's] questions. What attracted you to this subject? Why do you want to paint it? What is its core, the thing you are trying to express?"[18] Sonia sought to answer those queries with the simplest forms.

In 1963, Sonia sent a crate of paintings to Colin Graham, the director of the Art Gallery of Greater Victoria. She could not attend art school, but she happily acquired knowledge by accepting comments on her work. On December 11, Graham congratulated Sonia "on getting as far as you have considering the limited opportunities open to you in your somewhat isolated situation." He stated she was "basically an Expressionist—that is, one who paints with intuitive spontaneity, putting the expression of emotion before consideration of form." While he felt some images were not successful, he found others such as *Sudden Storm* and *Poplars in Spring* were "powerful in expression, rich in colour, and have a strong unified mood. They show ... a genuinely creative ability to handle form and colour." He recommended that Sonia continue painting for pleasure or "make a serious drive toward professionalism with all the risks and sacrifices that usually entails."[19] She boldly chose to do so. Graham must have felt Sonia succeeded because in later years, the Art Gallery of Greater Victoria carried her work in its art rental program, as did the Burnaby Art Gallery Association and the Prince George Art Gallery.[20]

Even with ongoing success, Sonia struggled to refine her creative expression. In 1967 she wrote, "For some time now I've felt as if I were

just about to put my brush to what I want to do. I keep seeing large expanses of Cariboo colours somehow combined to make forms—Cariboo forms—soft rolling rhythms? angular rhythms? ... It's just on the other side of a misty curtain...." Four years later, she asked herself, "What's so fascinating about Cariboo—rhythm, pattern, space, colour, sky, air, atmosphere, mood—simplify all in one.... Should I just feel out colour into form?" In August 1981 Sonia lamented, "I'm still struggling to know how to paint—if anything, more puzzled than years ago.... For years I have been telling students ... look-look-look & then paint." She followed her own advice and related how she completed a commission by looking "for a week" and then "all of a sudden was ready" to portray what she considered "the spirit" of her subject.

Besides working on her techniques, Sonia began exhibiting her work in earnest. Records indicate that her paintings hung in malls (including Woodward's in Kamloops and the Boitanio Mall in Williams Lake) and libraries in various parts of the province and Alberta. As well, in 1967, she had an exhibition at the Little Gallery in New Westminster that had "a steady stream of visitors."[21] In her journal entry of February 1967, Sonia stated that she alternated "between being overly anxious to know what people say and telling myself what does it matter.... I paint the only way I know how and I have to paint so." Her style gained recognition when *Beautiful British Columbia* (winter 1967) featured Sonia's depiction of horses on a snowy hillside. Sometime between 1963 and 1968, a selection of her watercolours was displayed at the entrance to the BC Government Library.[22] She also sent work to various art organizations such as the Summerland Art Club. For a time, two now-defunct Vancouver establishments carried her work: the Alex Fraser Gallery and the de Vooght Gallery. Sonia was pleased when the BC government purchased her oil painting *Spring Floods, Cariboo* (1974) for inclusion in the Provincial Art Collection (now the BC Art Collection). Works in that assemblage were exhibited throughout BC from 1974 to 1980.[23] In addition, Sonia had numerous shows at the Station House Gallery in Williams Lake (which she co-founded in 1981). She also had a solo exhibition at the Prince George Art Gallery in 1992. Such events played havoc with Sonia's nerves as she vacillated between exhilaration and fear of the critics' remarks. Furthermore, one of her diary entries illustrates Sonia's surprise at positive reactions to her work. She was late for the opening of a solo exhibition at the Station House Gallery. When she walked in, those in attendance broke into applause. Sonia turned and looked behind her, wondering who was being lauded.[24] Such humility was common for her.

Over the years, Pam Mahon witnessed the changes in Sonia's work: "her yellow became more brilliant. Some of her other colours changed a

bit, too. When I was first painting with her, she was still kind of painting like the Group of Seven. A. Y. Jackson had been a big influence. She evolved. She went beyond those influences. She went a little bit more into abstract. Most people were going for acrylics later on, which she didn't like.... Her paintings were of spring, fall and winter.... She had to paint every day." Sonia did not paint in the summer for several reasons: she found there was too much green, the lighting was stronger and harsher and she reserved summers for family, visitors and swimming. Winters were cold and bleak, and as Sonia became older, she found the snow more confining and depressing. Even so, she painted numerous frozen landscapes.

The other thing that took Sonia from her work was her children. Pam says,

> Sonia devoted herself to being a mom although it wasn't very natural to her. When Mabel was a baby, she cried a lot. Hugh would load Mabel up in the car and take her for a drive and that would settle her down. Sonia found it hard being a parent, but she did an excellent job.... I think she had been a bundle of nerves when she was younger, and almost had nervous breakdowns at times. Things just got too much for her. She had trouble coping with Mabel [when she was little]. Mabel was in perpetual movement. Mary was different. She was calm and placid, but I remember Mabel waltzing around the kitchen at age nine or ten and placing the scissors into the electrical socket. There were quite a lot of sparks. She didn't get much of a shock and Sonia responded, "Only Mabel would think of doing that."

Her daughters' impressions of their mother often delighted Sonia. Ellinore Milner recounts the time that Mary was asked if Sonia could send a batch of cookies for a school fundraising event. Mary responded, "Oh, no, my mom doesn't do anything useful like that. She's an artist." Milner laughs, "Sonia loved that story." Pam Mahon remembers Sonia saying, "We've had so many late night sessions because kids want to talk and you have to listen. No matter how tired you are, you have to listen to them." Mahon considers Sonia "an excellent mom." While her family was of prime importance, Sonia found ways to integrate her creativity into daily life. Her freedom to do so increased when the family moved to Jones Lake Ranch.

Jones Lake Ranch

After the Cornwalls sold the Onward Ranch in 1964, they retained occupancy until 1965. Sonia and Hugh hired the architect T.W.P. Thompson to design them a modernist and functional three-bedroom home. The family lived in a tent near the building site for several months while the house was in its final stages of construction. In the kitchen, over her sink, Sonia had an opening installed so that she could look down into the room she had built specifically for a studio, which was 12½ by 17½ feet. From that window, she gazed at the work of artist friends and scenes on which she was working. As at the Onward, numerous artists visited the Jones Lake Ranch.

In July 1968, the Vancouver Art Gallery (VAG) undertook a project to bring art to the far-flung reaches of the province. After filling a rented truck with twenty-seven Emily Carr paintings and drawings, assistant curator Jim Shearer drove to numerous small BC towns. The reception to "Carrs on Wheels" was "extremely warm and appreciative."[1] In September, Ted Lindberg (who had a career as an art consultant, curator/director and author) undertook the northern itinerary with two-day stops in Williams Lake, Quesnel, Prince George, Vanderhoof, Smithers, Hazelton, Terrace and Prince Rupert. According to Vancouver Art Gallery records, Lindberg "showed almost superhuman stamina, lecturing to groups of as many as 200 school-children at a time, from ten in the morning to ten at night."[2] The attendance in Williams Lake in 1968 was a whopping 820 visitors.

That travelling exhibition was such a hit that the outreach program continued. In 1969, Lindberg toured paintings from such now famous artists as Maxwell Bates, Bertram C. Binning, Lionel LeMoine Fitzgerald, Lawren Harris, A.Y. Jackson, Arthur Lismer, David Milne, Toni Onley, Tom Thomson and Frederick Varley, to name some. Sonia and Ellinore Milner assisted in setting up the exhibition at the Williams Lake Elementary School. That year attendance reached 1,025. Records at the VAG indicate that "the burden of driving ... in all kinds of road and weather conditions, toward all kinds of deadlines, can never be overlooked. Unpacking, hanging, dismantling and packing a full-scale exhibition 60 times requires unflagging patience and time."[3]

When Lindberg first met Sonia, he was incensed, as at her invitation he had bumped and bounced his cargo of precious Emily Carr paintings over her wintry three-kilometre Jones Lake Ranch driveway

in February. Sonia wrote that their "road was awful & he arrived abso-
lutely furious with me."[4] Her response was to offer Lindberg a Scotch,
and they immediately became friends. Lindberg and his first wife, Norah,
sometimes visited in ensuing years; often they corresponded. Like others,
Lindberg commented on the paintings Sonia reproduced onto note cards.
In 1997, he told Sonia, "I was so pleased to read your letter, look at the
new reproduction of a painting (Onward never looked so good).... You
are some kind of a paragon in your role as ranch-wife, mother, hostess
to stray artists and intellectuals, and dogged ever-flourishing professional
painter—despite everything which might have mitigated against that. I
am *awed* by your immense *perspicuousness*. (how's *that for a 75-cent word?*)"[5]
In 2001, Lindberg stated:

> The challenge of rendering ... remote ranch country—this
> strange ocean of hills and grasslands, tree-brakes and bench-
> es—with its immense weather, its isolated towns and ranches,
> its working cattle and horses, would daunt an artist less attuned
> to the consciousness of a place where the land and the cycles
> of nature are paramount. Through sheer persistence and ex-
> perimentation ... she has become its chronicler, capturing in
> her paintings something of the rancher's fierce independence
> as well as the practices and rigours of what may be a passing
> way of life....
>
> Cornwall is a legitimately modernist painter. She has suc-
> cessfully internalized the analytical and reductivist lessons of early
> moderns, such as the Group of Seven and Emily Carr. She is cog-
> nizant of the spiritual and expressionistic imperatives as ancient
> as those evinced by the Lascaux cave paintings, and of the lyrical
> and colour-expressive liberties taken by the Blue Rider[6] painters
> of more recent times. The unsentimentality of her themes and
> subjects simply preclude that which is merely decorative or pic-
> turesque. Her compositions reflect real life and experience, no
> matter how unkempt or unlikely: wild-eyed, behemoth Here-
> fords; a banner-like clothesline above a muddy barnyard; a haunt-
> ing eagle-sentinelled lake; a dwarfed homestead all but lost in
> the deep mouth of a mountain trench.... Her painting is tough,
> directly stated ... [and] in later decades it revels in the depth and
> painterly lustre made possible with the impastoed oil medium.[7]

Later, other VAG staff found their way to Williams Lake with trav-
elling exhibitions. One extension animateur (gallery guide) was a young
woman named Ina Lee, who Sonia felt was "becoming quite a painter."[8]

Jones Lake Ranch house viewed from the back. Pen and ink sketch by Sonia Cornwall, circa 1970s to 1981. Courtesy of Ellinore Milner, who received this image reproduced on a note card from Sonia Cornwall in October 1981.

The two developed a long, close friendship over a period of nearly thirty years. Lee's sister Mary says that in spite of their age differences, Sonia and Lee "had a real connection."[9] In fact, Sonia often described Lee as her "adopted" or "extra daughter," explaining that she had been through all of Lee's "trials & tribulations with her."[10] Lee was a struggling artist who later taught art in China and Prince Edward Island as well at several BC colleges, but she never secured a full-time position. In her own words, Lee often had difficulty keeping "the chicken in the pot,"[11] and she was without a lasting romantic partner for much of her adult life. Lee's friend Virginia (Ginny) Evans, then an English instructor at the University of British Columbia, believes Jones Lake Ranch became a "refuge" for Lee where she could "talk endlessly about life and art, occasionally enjoy the companionship of Sonia in painting, eat hearty meals, and share cigarettes, tons of coffee and the daily cocktail-hour Scotches. Sonia was something of a mentor to Ina."[12]

Sometimes Lee and Sonia's dog, Joey, wandered the ranch, to "wherever our noses took us."[13] As Lee's letters indicate, the landscape and solitude were restorative for her. Moreover, according to Evans, "The occasions on which Ina and Sonia painted the Cariboo together were

inspiring for the younger artist. But Sonia was also a model to Ina as a woman who lived close to the earth and the reality of daily life.... The problems of female artists and the frustrations of not having enough time to paint were often topics of discussion between Sonia and Ina. It was talk therapy for Ina and sometimes she would tell me, 'We didn't do much painting. It was more talk and Scotch.'" Mary Cornwall says her mom "was like a psychologist," and several individuals came to the ranch "to get things back together."

Sonia Cornwall and her Cordova 10 wood stove at Jones Lake Ranch, date unknown. Courtesy of the Museum of the Cariboo Chilcotin.

Lee made many "precious"[14] visits to Jones Lake Ranch. Evans accompanied Lee on two occasions, twenty-two years apart. On the first occasion, Evans recalls Sonia cooking breakfast for eight to ten people every morning and baking bread on her wood stove. The kitchen "was not a fancy kitchen and it was not big. Sonia had a pile of pans by the side of the stove blackened around the right spots.... She was like a dancer in there. It was stunning to watch." At the end of each day, Hugh came home with three or four ranch hands and Evans remembers everyone partaking of "a small smash or two of Scotch. For Hugh it was always a 'small smash' or 'another small smash.'"

Lee and Evans went to the Williams Lake Stampede with the Cornwalls. Evans "had no interest in attending, tried to get out of it, and felt a strong aversion to that type of activity. They assured me it would be okay. I found it ghastly, but I did learn that quarter horses are extraordinarily interesting beasts and their training is very unusual. The Cornwalls would listen to rodeo reports over the radio the way we might track tennis or golf scores, and they would know the players. The whole family was involved." Whenever possible, the Cornwalls attended rodeos. In his younger years, Hugh competed for fun while Sonia captured images of the events. Like most ranch children, their daughters and granddaughters were in 4-H and were skilled riders; Mary's daughter Christie became a Williams Lake Stampede Princess in 2001.

An incident with underclothing exemplifies Sonia's sense of fun. Evans had washed and hung some panties and chuckles that Sonia "had no hesitation in coming upstairs with the bikini underwear in her hands and proclaiming loudly that she had no idea what such a skimpy piece of

clothing might be. To her mind, it was not underwear. She was just taking the piss out of me."

On Evans's later visit, she recalls Sonia was in her mid-eighties and could not "cook meals for company. Ina had volunteered to do the cooking for the three of us, but Ina in the kitchen was something of a hazard. After one breakfast fiasco, I mentioned the pancake griddle in the pile of pans by the wood stove … with its four shiny circles surrounded by black. Sonia virtually leapt from her chair, and in no time the two of us were serving up pancakes."

Evans found that "although having spent her life far from the big cities, Sonia was unusually urbane, delightful, fun and endlessly interesting." Furthermore, Evans was struck by the ways in which Sonia captured her "domestic landscape and the flavour of the Cariboo. She was not an ideas painter. She was not painting the idea of the place; she was painting the feeling of the place. As Ina's friend, I feel fortunate in having met this remarkable lady and in having visited her home."

Another VAG extension animateur was Eileen Truscott, who went on to become an art historian at Okanagan University College. Like others, she stayed at the Jones Lake Ranch and thought Hugh and Sonia were "most wonderful people." Truscott "loved" Sonia's work and viewed her style as a spirited evolution of Canadian impressionism. Therefore, Truscott applied to guest-curate an exhibition of Sonia's work at the Kelowna Art Gallery. In 2000, Truscott and a friend arrived to select paintings. They slept outside in a van and were surprised when "in the middle of the night, some cows came and were rubbing up against the van. My friend said, 'This is like Canada's *Out of Africa*—the Karen Blixen experience.' I thought that's exactly what it is."[15]

Truscott wanted to show Sonia's work because "much of Sonia Cornwall's early life intersected with the very romantic era of the opening of the west, and the transition from European cultural traditions to the beginnings of a particularly Canadian art history."[16] From July 8 to August 27, 2000, *Cariboo Ranch Scenes* displayed forty of the eighty-year-old artist's watercolours and oils that were "a powerful visual testimony to the hard work and a way of life that is fast disappearing from ranches today."[17] Truscott wrote that Sonia's paintings further affirmed "her love of life and her energy and talent to capture this love in her work."[18] Moreover, a review of the exhibition in the *Okanagan Sunday* lauded Sonia's "strong, swirling strokes [that] have documented rustic farm buildings, grazing cattle, horse auctions and other rural scenes." The reviewer picked out a painting of Hugh's horse, Johnny, as one of the best works. "A sheet of wet, white blobs is laid almost like wallpaper over the muted landscape. It is a silent testimony to the power of nature,

the endurance of animals and, one suspects, the humans who care for them."[19]

Among the visitors to Sonia's Kelowna exhibition were author Lily Hoy Price and her sister Lona Joe, daughters of the photographer C.D. Hoy (1883–1973). He emigrated from China to British Columbia in the early part of the twentieth century and went to Barkerville in 1909. With nothing to do there during the winter, he taught himself photography and began capturing images of the gold miners. He later settled in Quesnel, where he became a storekeeper and raised twelve children (the first nine were girls). His more than 1,500 black-and-white portraits, taken between 1909 and 1920, of First Nations individuals, Chinese workers and Caucasians who lived around Quesnel are compelling images of bygone times in a remote area. Art historian Faith Moosang describes the photographs as "beautifully rendered." She says that Hoy's work is "the largest extant and publicly accessible record of Interior Native people in the whole of British Columbia. The same is true of his photographs of Chinese miners, shopkeepers, farmers and freight-carriers, whose continuing viability in Canada was cut short by imposition of the Exclusion Act, which banned immigration from China from 1923 until 1947. If it were not for Hoy and his camera, these people would have been excluded from the photographic record, and would be largely invisible to our cultural memory."[20] Sonia likewise recorded and preserved Cariboo images, and the reactions of Lily Hoy Price and Lona Joe reflect her success. When they saw Sonia's work, they recognized and related to the Cariboo scenes they had enjoyed as children. In the guest book, Lona wrote, "The cattle I can smell! The rawness of the scene is so earthy." Lily commented, "Just love *Storm Coming*."[21] After reading such comments, Sonia said she "was extremely flattered," because if ranchers and people from rural locales "like ranch paintings, especially mine, it is indeed a compliment as they always say what they think!"[22]

Much of Sonia's work documents a former era, and those depictions are now an important part of the province's art and cultural history. Some images she had purposefully hidden for decades under her studio table because she "thought they might be historic." Therefore, she wanted to ensure they remained unsold. Those works included a 1955 series of stampede sketches and variously dated oils of Sugar Cane and other First Nations reserves. When she reviewed those depictions in 1997, Sonia was astonished at "what huge changes there have been."[23] For example, her painting *Indian Camps at Dusk* (1972) depicts a Bennett buggy: a car frame covered with canvas and pulled by horses. The vehicle moved local First Nations individuals to rodeos or other encampments. Sonia told her friend William Matthews that the painting

captured one of the last times that mode of transport was used locally.[24] Perhaps that is why her depiction conveys a deep sense of wistfulness and looming obscurity.

Sonia developed a circle of friends with whom she painted. One was Jane Shaak, who moved to Williams Lake in 1971 when her husband worked at Gibraltar Mines. At first, Shaak was "pretty miserable" in her new locale, but then she joined the Cariboo Art Society. She recalls that the group met weekly. Shaak took over Ellinore Milner's spot (she had relocated to Vancouver Island) and every Tuesday, she, Sonia and Pam Mahon would get together for a painting outing and then lunch. Shaak says,

> We'd always bring a fancy lunch and have it with wine or gin and, man, we'd have a good time. Sonia was a very intense individual, very passionate. She was interested in helping people and she was encouraging, fun and very earthy. She was absolutely driven with her work. We did oils, watercolours, lots of drawing, and we did some studies of people and still life. It was a very enriching experience for me. One time I did a sketch of her and she did one of me. We traded because she wanted the sketch. Then I got the portrait she did of me.[25]

The green hues and introspective depiction of the subject convey a compelling image.

When her husband transferred to the larger centre of Prince George, Shaak could not find another art group that was as dedicated or creative. For a time, she worked at the Prince George Art Gallery (now Two Rivers Gallery). That work developed Shaak's interest in working at the Okanagan School of the Arts, where she is now the executive director. Shaak says her connection to the arts through Sonia "is very much in the fabric of my life." Her memories of Sonia and others in the Cariboo are of "authentic people that loved the outdoors, nature, the open space and interpreting that." Shaak emphasizes that Sonia "deserves recognition and appreciation."[26]

Well-known locally, Sonia had numerous exhibitions at the Station House Gallery. Susan Lacourciere moved to Williams Lake in 1977 and began volunteering at the gallery in 1990. She became exhibition coordinator in 1993 and recalls organizing several Cornwall shows:

> Nobody knew cows like Sonia. They were wonderful in every attitude and pose. She knew ... their stance, shape and outline, even from a distance, even in very small paintings. She was an exceptional painter. Her colours were her own and special because they reflected the colours of the Cariboo and ranch life.

Not everyone liked her work, but the more you looked, the more you appreciated the work. Sonia caught a mood, a time of year, or what a day might feel like in the Cariboo. You look at her work and you say, "That's the Cariboo." There's such a feeling about them. Nobody else came close to representing the Cariboo as prolifically as she did. She really focussed on ranch life. It was her first love as a subject. She once said, "You'd think I'd get tired of cows," but she didn't. She was always seeing something new or different when she was working on a picture. She'd say the light was like this this morning, and you could see that light and the colours. She brought you into the pictures. She painted in an Impressionist style. I have one of her pastels. She used large sweeping strokes in the vertical shapes of the aspen grove that the cows are lying in. She succeeded in capturing the light and shadow and the feeling of the weight of the cows lying in the pasture. I don't think an artist like Sonia comes along every day. She deserves to be better known. She specialized in the Cariboo and she should be recognized as a significant British Columbia artist.[27]

Lacourciere became a member of the Cariboo Art Society, and the group often went to the Jones Lake Ranch. They would go into Sonia's studio, where there were "hundreds of paintings stacked against the wall or [on the] floor, and she always had one or two on the go. She painted every day. She was incredibly prolific." Lacourciere further enjoyed those trips because Sonia was "a lovely person with a great sense of humour. She didn't mince words; she was genuine." The group would be inspired by what they saw and by Sonia's discussions. "Her knowledge of painting, artists and Impressionists was amazing. She was always reading art books: she had piles of them, and she'd read every single one many times. She was always sharing painting techniques and her knowledge. She was quite a storyteller, too. She had stories about ranch life, her travels and the artists she knew and had known." Lacourciere appreciated "the warm chaos of books, paintings, and ranch paraphernalia" and "the coziness" that filled the house. Lacourciere says, "Sharing her knowledge came naturally to Sonia."[28]

When Lacourciere took a year's leave of absence, Linda Olsen took over her position. She came to know Sonia through that work and because Olsen was the president of the Cariboo Art Society for a few years. Olsen thought "the shadows and lighting were fabulous" in Sonia's oil paintings. She states that Sonia's exhibitions "were always a success. People were just waiting for them. She was *our* artist, *our* Sonia Cornwall. You could see that in people's eyes and faces. People were proud that

she was ours." Moreover, when people were getting a special gift for someone, "they would go to Sonia's studio and choose a painting. That pleased her very much. Sometimes people heard about her and just went to look." Sonia asked Olsen to help her catalogue her work in photographs because "she needed to get organized. It was all in stacks."[29] Olsen managed to help somewhat, but William Matthews would finish the job.

Sometimes, Sonia gave art classes. Aleta Tiefensee, another former member of the Cariboo Art Society, attended a drawing class Sonia taught at the Station House Gallery. She remembers that Sonia insisted, "You have to learn to draw by what you see, not what you think you see." Tiefensee says, "For one of our exercises, she had us reach inside a paper bag, feel something, and then draw what we felt. I thought, 'This is weird. I've never done this before.'"[30] Tiefensee felt a leaf and was surprised to see that what she drew was exactly as the leaf looked.

Friends from Sugar Cane sometimes inspired Sonia to "see." In 1998, she recounted running into an old friend "who said she hadn't seen me painting lately at Sugar Cane. I replied I was getting old & couldn't sit on the ground for long. She said, 'Just come & look & look & then go home and paint.' So that's what I did today. No sketching, just looking. Smart Indian."[31]

Ellinore Milner says,

> Sonia loved painting the sunflowers [balsamroot] that bloomed every May. I was a nut about them, too. After we moved, I would go back almost every year at sunflower time to paint with her.... I think she was a great colourist and her compositions were very strong. She painted wonderful skies.... She would always try different techniques.... She felt isolated artistically but she wasn't unhappy. The winters were hard for her because she couldn't get out to paint as much.... Also, she suffered a little bit from Seasonal Affective Disorder, which is why she liked to get away for a break in the winter.... She painted a lot of watercolours in the winter: large ones, looking out of her big window down to where the cattle were wintered by the lake. They make their own wonderful lines and patterns in the snow. She called them studies. Occasionally, a watercolour would inspire her to do an oil. She also worked in pastels and had a large body of work in that medium. She could also work with pastels in the winter.... And she did many batiks. She actually batiked her living room drapes.

The autumn was an especially busy time for Sonia as she delighted in the vibrant foliage. On November 1, 1978, Sonia wrote Milner that after painting the local landscape until she "couldn't find another yellow leaf, Hugh, bless his heart, said I'll take off a few days & we'll follow the colour to Ashcroft, Lillooet, etc. We went via Dog Creek to Cache Creek … sketched through Marble Canyon to Lillooet … then sketched back through the Canyon & up the old Cariboo Road in Bonaparte Valley—the colours marvellous. I arrived home exhausted but had lots of drawings, pastels & a few paintings. Since then I've been working up the sketches."[32] Some of that work was displayed in Sonia's two-day exhibition (November 17 and 18) at Boitanio Mall (Williams Lake).

Milner believes Hugh and Sonia drew people to them because of their welcoming personalities. She says the two were so welcoming, "they always made you feel as though they were absolutely delighted to see you. That was a lovely feeling." Milner and her family left the Cariboo over forty years ago but she and Sonia "wrote constantly, talked on the phone and went on holidays together. We were very close." Sonia's "news from the Bush"[33] was similar to her art in that in both she detailed the mundane aspects of her environment; moreover, both provide a wealth of insights into Sonia's psyche.

A Real Cariboo Couple

Hugh and Sonia welcomed all types of people to their ranch: young and old, gay and straight, hunters, American draft dodgers, musicians, artists, First Nations people, authors, ranchers, academics and others. In the words of the writer Paul St. Pierre, their guests "always felt richer after a visit."[1] For Janet Wallace, Sonia has been a lifelong inspiration. In 1990, when Wallace was twenty-two, she was an ecology student at the University of Toronto. As part of her master's degree requirements, she was studying waterfowl in the Cariboo. With Hugh and Sonia's permission, Wallace and her field assistant were working at Red Lake on the Cornwalls' property. After a twelve-hour day, the researchers were fatigued. When they saw what looked like a shortcut back to the highway, they took it. Wallace recalls they came to an area "where most of the wheel ruts had filled with water. We couldn't tell how deep it was, but I thought I would just gun it…. We got stuck to the chassis … and there was a foot of water below the tire."[2] Wallace knew that ranchers loathed pulling out vehicles, and if they had to do so, the ranchers might deny further access. With that in mind, the researchers set off on a two-hour or longer trek to the Jones Lake ranch house.

Exhausted, tired, thirsty, filthy and expecting an angry response, Wallace knocked on the Cornwalls' door with much trepidation. The students were immediately invited in, shown the bathroom to wash up and then given glasses of water and wine. Moreover, although the Cornwalls had guests (Hugh's brother Ted and his wife were visiting from the coast), the ranchers insisted that the young scientists stay for dinner. Wallace emphasizes, "I've been to food conferences in Italy, and I do some food writing now. I've had amazing meals, but that one is still one of my best meal memories." Hugh's brother had brought crab that Sonia complemented with baby carrots and other vegetables and berries fresh from the garden. The Cornwalls offered the researchers beds for the night, but Wallace was anxious to get back to her field station near Lac La Hache. Therefore, after dinner Hugh and Ted went to extract Wallace's truck. She remembers that the men seemed to enjoy the prospect of a little "adventure." While the men were gone, Sonia showed the young people through her studio. According to Wallace, the work "was so unusual; it was so wild…. She wasn't following a style. She was doing some cubist cow stuff. She was bringing

artistic elements into her own landscape. I think that's the essence of art ... when you actually use what is around you when you create something." Although the cows Sonia painted sometimes "had amazing faces," Wallace was not fond of the ranch's cattle, especially as they sometimes chased her. There were also sinister-looking bulls with which she had to contend. However, Wallace explains that meeting the Cornwalls was "an epiphany. I glimpsed a life ... where you could actually be an artist, be back in the woods, be a farmer and create your own life—which I've gone on to do myself in the Maritimes. I write and also do pottery and weaving, and I have a small market garden." Wallace was further impressed that Sonia and Hugh "allowed each other independence, but they were also very connected." In addition, Wallace was delighted that the Cornwalls took such an interest in someone so much younger. They kept asking her questions and encouraging her to "tell different stories [about herself].... That was the first time I had spent so much time ... as a peer with people who were much older than I." Although she received an open invitation to return, Wallace never managed to do so.

Later, in 2004, when Wallace was working as editor of the *Canadian Organic Grower*, Laura Telford (whose parents once lived at 150 Mile House) suggested using one of Sonia's paintings in the magazine. Telford, who is now a business marketing specialist for Manitoba Agriculture, says she ran across Sonia's painting *Early Spring in the Barnyard* while searching online. She thought the "really beautiful" image with "cattle in a naturalistic setting" and their faces "slightly abstract with a natural feel"[3] would make a great cover for a magazine about organic agriculture and livestock production. At the time, though, the magazine's editorial policy was to use only photographs for the cover illustrations. Unfortunately, the whereabouts of the painting is currently unknown.

Carol and Bob Hilton, friends of Mabel's, were "kind of adopted" by Sonia and Hugh. The Hiltons learned that everyone was accepted at Jones Lake and recall a stripper from a local bar showing up at a branding party: "Sonia welcomed her like she would have welcomed anybody.... She was very gracious no matter who you were or what you looked like. You just had to be a good person."[4] One year, Sonia learned that a guest had AIDS. At that time, treatments for the disease were much less effective than they are today, and most people reacted fearfully. Typically, Sonia listened sympathetically and passed no judgements. She wrote a friend that she "sat up half the night philosophizing with him. I'm not used to trying to cheer up ... [someone] with AIDS. How is it possible? He was a brilliant young man.... It took a lot out of me."[5] Sonia was so empathetic that TV news items often upset her. She stated she would be agonized when viewing the plight of senior citizens "living in one room in the

east end of Vancouver—terrible life. I can stay awake all night thinking about it."[6] Sonia and Hugh's sensitivity extended to young people as well. Mabel and Mary laugh at the memory of a long-haired draft dodger cooking a vegetarian "concoction" on the stove. He then sat down with Hugh, who "ate bacon and eggs every morning," and the two engaged in a lengthy conversation.

One such long-haired vegetarian was Stephen Walker. He moved to the community in the late 1960s. He met the Cornwalls through the playwright Gwen Ringwood and her husband. Walker remembers that there was some intolerance in the area, but he found most ranchers open-minded and the Cornwalls particularly so. He worked for the Moon family and the Cornwalls. Walker found, "They respected me because I worked hard, and I learned practical skills from them." He looked after the Jones Lake Ranch a few times when Hugh and Sonia were on vacation. Walker recalls Sonia "being very warm to [him]" and that Hugh "let [him] use his welding equipment when he was away. Hugh made little sculptures, which was innovative for someone who was ranching."[7] Indeed, Hugh created several outdoor sculptures including a goose, a squirrel and a log cabin that adorned the patio railings. In addition, he welded a metal gate, constructed a jaunty chap in a red top hat and red shoes who hung on a fence and crafted andirons for their fireplace.

Hugh and Sonia Cornwall, Jones Lake Ranch, November 13, 1980. Courtesy of the Cornwall Family Archive.

Hugh also made the Mahons andirons in the shape of horse heads. Hugh Mahon says, "I still find it hard to understand how he was able to make the heads. They are so perfect."[8]

After they moved to Jones Lake Ranch, Hugh and Sonia had a smaller herd (about three hundred head), but they still needed ranch hands. Dennis Evans lived and worked on the Jones Lake Ranch for close to two years (autumn 1973 to early spring 1975). During warm weather, he woke "up early in the mornings and looked out at the lake. The sun was just starting to come up, the mist was coming off the lake, the birds were singing and there was Hugh standing in the mist, fly-fishing. Sonia was in the kitchen making breakfast over the wood stove." During the day, Hugh and Evans would hay, fence and feed, among other chores. Sonia would cook meals and paint. Sometimes as he and Hugh rode "through the trees, we would come across Sonia sitting there with her easel, painting in the forest or on a hillside. She would pack up her stuff early in the morning and be gone most of the day. Then she'd come back ... put the stove on and get supper ready." Evans further recalls the swimming pool Hugh built. "He dug it all out and put down ... rolled asphalt [roofing]. Cool spring water, running all the time, filled the pool. We'd finish a hot day on the ranch, sit around the pool, and relax and swim. Sonia and Hugh did a lot of swimming in that pool."[9]

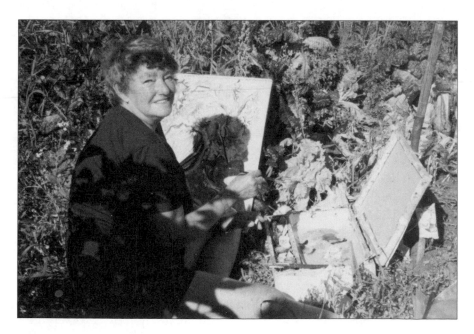

Sonia Cornwall sketching outdoors, circa 1987. Courtesy of the Cornwall Family Archive.

While working or resting, Hugh would regale Evans with stories. In particular, he liked to reminisce about rodeos: "Sonia would just shake her head and roll her eyes at some of the things he used to do at rodeos. One time, I think it was out at Anahim Lake, they put him on a steer backwards. He came out of the chute and he really wrenched his knee badly. It bothered him in later years, but he always used to laugh about how much fun he had at that rodeo." Evans remembers that Hugh did not wear a watch and he would say, "'It's lunch time.' We'd be getting in the house within ten of twelve o'clock.... It was the same thing in the late afternoon. Hugh always stopped around 4:30/5:00. We'd go in and Hugh always poured us a drink of gin or rye before supper. We would just sit, talk and relax. Being there was a fantastic experience.... Sonia had so much art on the walls it made the house feel so alive and so homey." Evans stresses that Hugh and Sonia's "gentleness and their way of treating people" influenced him. "They made me think of the way I treat people and try to do things.... It didn't matter to them what age you were or whether you were really poor or really rich or anything else."

One time a bear was hanging around the corrals near the house and ran up a tree. Hugh phoned the game officer who said if the animal was causing a disturbance, Hugh could shoot it. He did and Evans says Hugh gave the carcass to some First Nations people. "They were really good with Native people that way." If they butchered animals for local buyers, "Hugh and Sonia made sure they kept the tripe off the stomach fat for three or four Native Elders they knew.... Sonia was very good at keeping in touch with the Native people ... and treating them well." Moreover, Bob and Carol Hilton remember that Hugh loaned money to a First Nations man whose wife needed medical care in Vancouver. "There were a lot of people who would not have helped or would have made judgments [about the couple's lifestyle]. Hugh just said, 'Okay.'" Carol explains that Hugh loaned the couple money because they were "good people" in spite of some problems they had. She adds that Hugh's attitude was, "This is a guy who works for me, so I'll help him out."

An incident retold by Mabel and Mary further illustrates their parents' benevolence. A local trespassed on Jones Lake while hunting. Inebriated, the fellow came upon Hugh's large TD 20 Caterpillar sitting in a meadow and decided it would be a lark to drive the huge machine. As it bounced over the uneven ground, the intoxicated male fell out. The Cat lurched on into Red Lake until it stalled with only its stack showing. A passerby on a side road noticed the machine and recalled seeing a particular make and colour of car leaving the area. When he discovered his submerged Cat, Hugh alerted law enforcement. As there were only two vehicles in town that fit the description, the policeman followed up on

Hugh Cornwall and his TD 20, Jones Lake Ranch, circa 1969–70. Courtesy of the Cornwall Family Archive.

his suspicions. He approached a man, asking what he had done on the weekend. The man replied that he was home with his wife. Before the suspect could contact his wife, the officer went to the woman's place of employment and inquired what her husband did on the weekend. Apparently, she replied, "He went hunting. Why, what's he done now?" As the culprit was a mechanic, the officer and Hugh agreed that the man would repair Hugh's Cat on weekends. Before too long, the fellow was having coffee and lunch with Hugh and Sonia. When the offender went to court, he needed a character witness. Amusingly, the only person who agreed to speak on the malefactor's behalf was Hugh. They had not only forgiven the man, but Hugh and Sonia had come to know the person and recognized the positive aspects of his personality.

Another endearing trait of both Hugh and Sonia was that, while always sympathetic, they laughed with people over their tribulations (never at them). Furthermore, both Hugh and Sonia revelled in jests associated with their own experiences. One example involved a frightening occurrence on the ranch. Mabel and Mary remember that a hired man rode out to do some work. While he was dismounted, a bear charged him. He frantically climbed a tree and held the bear off by continually kicking its snout. The bear repeatedly attacked well into the night. The Cornwalls found their employee's dangerous encounter dismaying; however, to their amusement, the cowboy never complained about his scare but forever grumbled about ruining a new pair of boots. In addition, Carol and Bob Hilton recall hearing about one hilarious incident with Hugh that still makes them chuckle and for which Hugh took much teasing. Carol says Hugh and a helper were

> cutting some cows out in a deep valley. The hand was down in a gulley and ki-yi-ing to get the cows where Hugh wanted. He was on the rise looking down, tall and majestic on his horse. Hugh always smoked…. Of course, you never butted your cigarette on the ground because you couldn't be sure it would go out…. He usually butted his cigarettes out on his chaps because they're hard leather. He must have accidentally butted out on his saddle blanket. Then there was smoke coming from Hugh's saddle blanket. The horse was bucking, and Hugh was yelling. The helper said it was like watching *Blazing Saddles.*

The Hiltons stress that Hugh and Sonia were "a huge influence" and supportive of them as a family. Moreover, Sonia suggested that Carol and Pirjo Raits start a weavers' guild in the area. Carol says, "We put an ad in

the paper and sure enough people came and we started the guild. It's still going." Raits adds that Sonia made a difference in her life because Sonia taught her to have a "Yes, you can do it" attitude. "She's a really, really good example of someone who did what she wanted her whole life."[10]

That interest in the community and education was central to Sonia's life. Bob Hilton recalls going to Sonia's one day in her later years. "She was not very mobile. She was sitting in her chair and the first thing she said was hello. Then she said, 'I've had such a wonderful morning. I've learned so much today.' She was reading an art book. She was eighty years old and she was still learning. She was always searching." Carol adds that Sonia "encouraged everyone around her to think like that, too.... She was innately curious."

The Hiltons often helped at haying and branding times. Carol says branding was "smelly and smoky and noisy ... [and] we just worked and worked and worked. But, that doesn't mean we didn't have fun." Many other people, like the Mahons and Fletchers, would help. Mabel, Mary and their friends were often around. The Hiltons' daughters did not like branding, and Carol recalls the girls often went in the house where Sonia was preparing meals and working "her butt off." Crews helped to cut the calves for branding, inoculating and castrating. Afterwards, the ranchers and their helpers celebrated with food and drink into the wee hours. Today, with modern methods and equipment, fewer helpers are necessary.

Pirjo Raits also helped at the ranch one time. She stresses, "It was really a cool experience because your cowboy boots actually got shit on them. It made you feel connected to what the country was like before all the logging.... You felt connected to history ... and a fascinating way of life."[11] Other young people felt the same. Don Redgwell was part of a band called Starship. They had gigs in Williams Lake at the Chilcotin Inn during Stampede time from 1974 through to 1976 (the group disbanded in 1977). Mary and Ken Borkowski (who became Mary's husband) liked the band, and one night Hugh and Sonia came to listen. Hugh even ordered a round of drinks for the band. Mary emphasizes that few of her friends' parents went to clubs or listened to rock and roll.

One Sunday, Sonia was preparing dinner when Mary phoned and asked if she could invite a few friends. Sonia said okay. Mary phoned a second time to ask if a few more could come. Again, Sonia approved. When she called the third time, Mary laughs that her mother replied, "Well, you'd better pick up some chickens because this turkey isn't going to do it." Among the young adults Mary invited were the Starship members. Don Redgwell describes Hugh and Sonia as

incredibly friendly. Hugh loved to have his drinks at night and we would join him. We would get a boat and go fishin' on the lake for brook trout—catch 'em, clean 'em and cook 'em. It was quite an experience. We had Sundays off, and we used to stay at the ranch overnight, especially me and Joe Kane [now deceased]. He'd bring his guitar and we'd have campfires and sing. We rode horses and helped herd cattle. They'd feed us … and we slept on the verandah or in the back of our van. I have distinct memories of how accepting they were of us, of rock and roll and our way of life. They let us into their home and treated us like family.… When I met Trish, whom I'm married to now, I took her up there to meet them. We went out cattle driving with Hugh and helped with branding and castrating. We were like working tourists or people on dude ranches—we were the dudes. It was amazing.… It was a special time and they were special people. They were a real, true Cariboo couple.[12]

David Zirnhelt was another young person who found his visits with Sonia gratifying:

It was a comfortable place for young people because Hugh and Sonia weren't judgemental.… I brought girls I dated there.… Sonia loved Susan [whom he married].… They would welcome people from strange, far-away places.… When I was going to UBC, I took a distinguished World University Service exchange student from Russia to the Cariboo. He'd not seen a ranch or the Interior, so one weekend we got in the car and came up here. I took him to Jones Lake. Hugh made a horse available so he could have his first horseback ride. That was typical of how generous and gracious Hugh and Sonia were as hosts. The student didn't tell Immigration or his embassy that he was leaving town. When we got back to Vancouver, I was accosted by undercover people who wanted to know where I'd been with a Communist. I told Sonia that story and she laughed a lot.

When I came back from university, Sonia and Hugh's was always one of the first places I'd go. They were grounded … bohemians, ranchers. They were open to the ideas of the world … and you could have intellectual discussions with them.… They were also very much owners and stewards of the land … but they did find a work/life balance. Being open to who comes down the road … was a unique quality that Hugh and

Sonia had. I think that influenced Susan and I, and it became important to give our children more exposure to the outside world.[13]

Throughout her life, Sonia "was thankful" that she and Hugh had "such a strange variety of friends in every walk of life & have learnt & enjoyed so much from them. One never knows what next we'll be conversing about!!!"[14]

Eventually, age and physical ailments began to affect Hugh and Sonia. He was enfeebled from arthritis and, in his later years, a type of dementia. She suffered from arthritis and a form of acid reflux likely caused by a hiatus hernia. She had a miscarriage in 1961 (at age forty-two), was sometimes treated for depression and nervous rashes, required surgeries for a broken kneecap and a degenerated hip and cracked a vertebra in her back while caring for Hugh. When a problem with a tendon made painting difficult, Sonia learned to paint with her left hand until surgery retuned the flexibility to the fingers in her right hand. The work done with her left hand is, understandably, not as accomplished as that done with her right.

With their increasing infirmities, Sonia and Hugh relied more upon their family. As well, ranch help became even more important. In Septem-

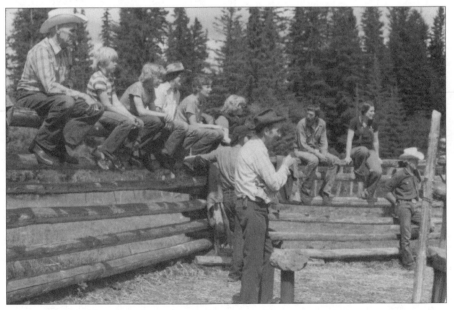

Branding at Jones Lake Ranch, circa 1977. Left to right seated on fence: Ted Cornwall, Stephen Mahon, Andrew Mahon, possibly Karen (Cornwall) Davidson, Mabel Cornwall, Carol Hilton, Bob Hilton, Mary Cornwall; standing are Hugh Cornwall, John Miller, and Hugh Mahon. Courtesy of the Cornwall Family Archive.

ber 1969, Mabel introduced her boyfriend, John Miller, to her parents. He spent four summers (1970 through 1973) working on the Jones Lake Ranch. John remembers that when he arrived for his first summer employment, Sonia picked him up at 150 Mile House as he had ridden the bus up from Vancouver. She was driving to the ranch when she saw a fire protection officer coming her way. She yelled at John to crouch down. John had no idea what was happening but Sonia's strong push made him comply. He says Sonia smiled sweetly and waved to the official as she drove past.[15] If the officer had seen him, John could have been commandeered to fight fires. Sonia obviously thought Hugh needed John's help more. After John and Mabel married, Hugh and Sonia asked the couple if they would like to become part owners. John and Mabel agreed and, in April 1975, they temporarily moved in with Hugh and Sonia. After a short time, the younger couple moved into a modular home not far from the main house. Hugh then had permanent help, and the Cornwalls were free to travel to warmer climes during the winter months. Their travels took them to Australia, Costa Rica, Fiji, Hawaii, Mexico and New Zealand. Sonia painted those landscapes as well, but few of those works are as competent as her Cariboo scenes.

Sonia was always interested in the works of other local artists. Claire Kujundzic (Zeljko's daughter) and her partner, Bill Horne, moved to the Cariboo in 1976. Claire remembered Sonia from her childhood and was happy to reconnect. Claire says meeting Sonia again was a "comfortable" experience "like slipping into slippers or old shoes." Claire enjoyed the "richness" of the Jones Lake house where some paintings

> were crooked, and some had slipped out of their [mats]. Her house was comfortable, very warm … and had a sort of gloriousness, a very full aliveness.… She always offered me a whiskey or gin. It didn't matter if it was ten in the morning.… She was an older, mature artist, but I didn't feel any difference in age or experience with her.… I was a peer. That was really valuable for me.… She loved my work. She came to a show I had at the Station House Gallery, and she was wearing one of my t-shirts that I had made a few years earlier: a plump, smiling naked woman with her arms folded lying in the crescent of the moon. She loved that t-shirt and bought bits of my work, so we had a mutual admiration.… I loved her work. It was so vigorous, confident, so deft and motivated.… She's a kind of Emily Carr to me. She's got that kind of stature.… To paint where you live, day after day, year after year, records something very unique.… Not that every painting she did was fantastic,

but individual ones really stood out and the body of work is significant. That more public galleries do not collect her work shocks me. It's sexism and rural oppression on some level. It's like we're not important out here.… Art history is very unkind to women but she did what she wanted to do. She didn't give a toss about the art world.… Cows are not romantic or ideal. They are big and lumpy.… She knew the nuances of the Cariboo landscape where the underbrush is as important as the trees. She made a special contribution and maybe someone will eventually notice.[16]

Corry Lunn was another artist who knew Sonia. Around 1976, Lunn had an exhibition at the Station House Gallery. Sonia attended and bought a sculpture of an otter from her. Sonia modestly told Lunn she was a painter and said if Lunn was "interested" she was invited to Jones Lake Ranch. Lunn went and was "in awe" because Sonia "didn't just paint—she was prolific. I was in my twenties and … she did these amazing, strong paintings, yet she made me feel I was the artist, not her. She endeared herself to people for that reason. She wasn't full of herself." Lunn bought

Hugh and Sonia with their immediate family in 1995. Over the years, several Cornwall reunions were held at Jones Lake Ranch. Left to right: John Miller, Christie Borkowski, Hugh Cornwall, Sonia Cornwall, Mabel Cornwall, Mary Cornwall, Natalie Borkowski and Ken Borkowski. Courtesy of the Cornwall Family Archive.

several paintings but "on layaway. If you couldn't afford" the work "she let you pay a bit at a time.... She did that for a lot of people. The fact that she would let you do layaway has been an inspiration because I do the same thing now." Moreover, because of Sonia, Lunn learned not to separate her life from her work. "Sonia's home was full of her work. And Hugh made iron sculptures. He did these fabulous andirons that were like loons. I always coveted them. They were very functional but with such flair. They lived their life without separating it from their art."[17]

Lunn did not see Sonia often because she lived a distance away at Black Creek. Her interactions with Sonia were important to her because living in such isolation, Lunn needed

> to feel that you are not creating in a void.... Sonia was very encouraging and inspiring.... And, she was fearless. She would go to cattle sales and do drawings and paintings. That's really putting yourself out there.... She wasn't copying anyone. She just put down what she saw. When you are creative, what you do is what you are. You can't fake it.... She was a ground-breaker for a lot of people. Everyone could relate to her and her family: the ranchers, the loggers, the young hippy people. We don't have many people of that quality. She was portraying a lifestyle ... everyday life ... her life, an autobiography in pictures.[18]

Lunn introduced another artist, Darrel Nygaard, to Sonia. Nygaard told his friend Harvey Chometsky that he should contact Sonia. Chometsky, an "artist, poet, philosopher ... much sought after for personal advice ... [and] perfectly candid," formed an immediate bond with Sonia. He dubbed her "the Matisse of the shorthorn."[19] They would have a vital impact on one another.

Painting from the Heart

Initially, Harvey Chometsky met Sonia through her paintings. In 1990, Darrel Nygaard took ten of her watercolours to Prince George, where Chometsky was running a private gallery, Other Art & Cappuccino (a gallery, coffee shop, restaurant and music venue). Chometsky's reaction was immediate: "The painting that captured my attention was, *Test of Power*, a watercolour of such primitive intensity that I became riveted by it; visions of the cave paintings of Lascaux sprang to mind. My eyes were opened, my own vision transformed."[1] From March 26 to April 29, Chometsky hung a collection of Sonia's oils, pastels and watercolours. He described her art: "Lyrical, spontaneous, and free, her work vividly expresses her connection to the land and to her vocation. Her landscapes are alive with movement and light."[2] The next year, Chometsky met Sonia when he travelled to Jones Lake to select paintings for a second exhibition: *Sonia Cornwall Watercolour and Mixed-Media Images of the Cariboo* (August 6 to September 7, 1991). In 1993, he was the guest curator of *Hometown Retrospective* at the Station House Gallery in Williams Lake; in 1994, he was the acting curator for *Retrospective*, an exhibition of Sonia's work at the Prince George Art Gallery (now Two Rivers Gallery). For those exhibitions, Chometsky wrote

> What a visit! I looked at art until my eyes bled! Although I never stepped ten feet outside of the house, I felt I had wandered all over the wonderful land, her landscapes were like windows into a magical geography: open, roll-y places, with trees that danced towards the sky, where patient cattle browsed and elegant horses grazed and glowed, orange and red in the setting sun. Or shivery wintry scenes in slanting snow. I could hear the winds scream, they were that real. And people lived there too: the raucous celebration of a Chilcotin rodeo dance, or hubble-bubble cattle sales, all manner of experience passed by my eyes as I looked through the window of the world, as seen by Sonia Cornwall.... My admiration and respect for her and her work only grows.... In the context of Canadian art, I believe Sonia Cornwall is a giant."[3]

According to Chometsky, Sonia's work sold well when exhibited at Other Art. Ever modest, she was shocked at what people were willing to pay for her paintings.

Chometsky and his partner Lilla Tipton became good friends with the Cornwalls, visiting when they could. Chometsky explains that he and Sonia were "unlikely friends in some ways, but we had a profound connection in art." He adds, "I was a conduit to the contemporary and she was my bridge to the past."[4] Chometsky remembers partying and discussing art until the wee hours. Sonia and Hugh

> were versions of bohemians … wild ranchers … yet, she projected this sort of noble reserve … a genteel presence that was kind of royal, and then she would reveal her wild perceptions.… I love those contradictions.… She told me that as she aged she cared less about recognition and more about the work.… She more than encouraged me to paint.… she was a profound influence.… Sonia acknowledged the value of creation and … she devoted her life to it.… I was lucky to encounter an elder artist that gave me the strength to continue, because it's hard to continue.… I cherished her support and encouragement.[5]

Chometsky left Prince George when he undertook a project called *The Imaginary Canadian*, an art car that he and artist Ken Gerberick toured through Canada and the United States. He financed the project by selling fifty-dollar nameplates that he applied to the vehicle as part of the ornamentation. Chometsky says Sonia was one of the first to invest. During one visit, an animal chewed the horns that sat atop the car. Some think it was Joey, Sonia's dog, or possibly a horse.

As with others, Sonia regularly corresponded with Chometsky and Tipton. In a letter dated November 9, 1994, she told Chometsky that during the fall she cooked 125 meals in ten days for "an interesting mix of visitors—hunters, and artists." She enjoyed that "artists get on with their opposites—perhaps not so amazing as artists are interested in *everything*. Isn't that what makes them artists?" When Sonia was not immersed in chores, entertaining or shooting the gophers, she was "doing a lot of painting. Cluttering up the place. It's an addiction." Furthermore, when the "weather [was] lousy … that did bring … wonderful strips of different colours on the hills." Another time she mentioned being "back with oils—watercolours all summer & now oils. I now go for walks with Joey & study different areas & then come home & paint a sort of composite.… I find it works better as the paintings are more thought out & then 'dashed' off!"[6] Working quickly was common for Sonia.

Sonia Cornwall and Harvey Chometsky at the 1994 Prince George Art Gallery exhibition of Sonia's art. Photograph courtesy of Derek Masselink.

In a letter dated November 27, 1995, Sonia told Chometsky she had joined the Alliance of B.C. Artists, "a group on the Internet." They were carrying eight of her paintings online and she said, "I hate to mention the prices they are putting on them—$1,300 for the small ones, $1,800 for the bigger ones! Sounds like highway robbery to me." She suggested that Harvey join as the $500 fee was "cheaper than having a show in W.L. [Williams Lake] or P.G. [Prince George] etc. & a bigger audience." On June 12, 1996, she wrote that her paintings online "showed up well" but jeered that only three people had seen them. The next year, Mabel finally had Internet service and checked on her mom's paintings. Bemused, Sonia said the prices had gone up to three thousand dollars and she had "not made a mint yet." In 2002, Sonia discovered that an Internet search of her name brought up numerous sites. She found "[that] really is scary.… I really like being a hermit hidden away."[7]

While her online sales may have been a disappointment, Sonia's works were selling elsewhere. William Matthews, then a Vancouver goldsmith, became familiar with her work in 1987 when he bought his first Cornwall painting (an image of the Jones Lake Ranch) through a Vancouver art dealer; he purchased his second, *Windy Day*, from a

Sonia and Hugh Cornwall in front of Harvey Chometsky's *The Imaginary Canadian*, Jones Lake Ranch, 1997. Photograph by Harvey Chometsky and courtesy of the Cornwall Family Archive.

second-hand shop. In spring 1996, Matthews drove to Williams Lake as part of a holiday and with the hope of meeting the artist. He stopped at the Station House Gallery and asked Linda Olsen about the possibility of visiting Sonia. Olsen telephoned Sonia and set up an appointment for Matthews on the next day. He vividly recalls that while he was excited, Sonia seemed "shy almost." As soon as he and his cat, which was travelling with him, stepped into the entryway, the kitten urinated on the floor. Matthews was embarrassed but Sonia and Hugh just laughed and, after the preliminary courtesies, offered a drink of rye or gin. After some introductory conversation, Sonia took Matthews to her studio. He found the room "tidy ... rectangular with a sloping roof. The walls ... filled with work.... [There were also] pastels on paper in 2 portfolios against the kitchen window wall and beside them 2 folios of oils on paper and 1 of prepped papers (for texture appearance) [for] the under base of the pastels. One work table, one large wooden easel. Several smaller tables and ... 3 piles neatly stacked of completed paintings."[8]

When he first saw Sonia's studio, Matthews felt overwhelmed: "There was such a variety and her work was so colourful. Yellow and blue were important to her." Matthews purchased three paintings: one titled *The Poplars*, a large landscape (oil on paper), because "its stark expressionism blew me away," and an oil study of deer that he found "rich and very expressive." When he asked the prices, he says Sonia "almost sounded apologetic" that the small oils (twelve by sixteen) were "$250 unframed and $300 framed; the paper works were $150." As they viewed her art and that of the work she had collected from other artists, Sonia told Matthews that, like Siebner, her favourite colours were orange and blue. She also explained that she was "still learning" from Siebner.

Matthews says that first visit in 1996 was the beginning of a close friendship. He became Sonia's "number 1 fan." He found the "liquid emotions" of her impressionist paintings striking, especially when she "crossed over into expressionism." In the mid-1990s, Matthews became her studio assistant, organizing, cleaning and re-hanging work during his visits. As a result, Matthews had many conversations with Sonia and often jotted down his insights. For example, he believes, "The single tree appears in many of Sonia's landscapes. It is a signature." While he acknowledges the Tom Thomson influence, Matthews thinks, "Sonia's trees are portraits ... models.... Her moods, her feelings are in those swaying beauties." Moreover, like Thomson and the Group of Seven, Sonia often depicted landscape through a screen of trees, thereby accentuating and revealing new aspects of the scene.

Matthews says they discussed hundreds of pieces. When during telephone conversations Sonia told him she had completed a "new batch" of

paintings, he would head to Jones Lake "and revel in discussing her new pieces and new experiments." Her "generosity made me more aware of how good she was as an artist. I saw what A.Y. Jackson, Joe Plaskett [and] Herbert Siebner saw—an individual talent.... Her art became as bold as her beloved cattle paintings, the wind whipped sunflower paintings, and the fauvist quietude of [her] Jones Lake Ranch paintings."

As he worked in her studio, Matthews discovered art that had been hidden away for years. While it had once been organized and tidy, age, health problems and Hugh's illness and care resulted in neglect. Sonia said, "[I] was so upset with the state of my studio that I pretended to ignore it—like the weather."[9] After one of Matthews's visits in 2000, Sonia called him "a priceless gem"[10] for his cleaning and sorting. That work was unpleasant, as a pack of mice had made a home in her sub-basement storage room. Matthews says, "It took me two or three trips before I could get the room into some semblance of organization." After the removal of an "unbelievable ... pile of mouse poop," disinfectants finished the job. Moreover, Matthews insisted that Sonia date and sign her paintings, something about which she had been negligent. After an hour or two of such drudgery, Sonia named Matthews the "slave driver." As soon as the work was completed, he and Sonia relaxed over drinks and conversation.

As with others before him, Sonia also looked to Matthews for critiques. While often enthusiastic, he could also be candid. In one letter, he reflected that some work looked "flat" because "it reflects and records you inside. The essence ... has disappeared from your oils." Matthews counselled, "Rise above it. Get motivated somehow ... look & feel again."[11] At the time, Hugh's health was deteriorating and that was taking a toll on Sonia. She had vowed that Hugh's care came above all else. Remembering when her children were small, Sonia lamented, "I never painted [then] & missed it as much as I do now."[12] Having constantly to supervise Hugh, she could neither relax nor find time to paint. Moreover, Sonia felt she did her best work "en plein air where the atmosphere about me somehow sifts in. The heat or cold, the mood of the weather, the excitement of being out in it."[13]

From working as her studio assistant, Matthews eventually became Sonia's agent, selling her work and trying to find exhibition venues outside of the Cariboo. She told him, "It is only recently I've presumed to call myself an artist due to encouragement from various knowledgeable people, primarily you & Harvey."[14] Wanting to highlight her work outside the Interior, Matthews visited Vancouver's Westbridge Fine Art Gallery. As he perused some publications in the gallery, he remarked to Anthony Westbridge that he did not see any entries for his "favourite artist." Matthews recalls that Westbridge asked, "'Who might that be?' I said,

'Sonia Cornwall.' He said, 'I'm not familiar with the name.' I said, 'She's a fantastic artist, an impressionist/expressionist. I've been collecting her work for a while and I think it's very special.' He said, 'I wouldn't mind seeing some of your Cornwall pieces.'" Shortly thereafter, Matthews took eleven pieces to show Westbridge, who instantly stated that he wanted to represent Sonia.[15]

Emboldened by Westbridge's interest, Matthews did "something un-orthodox." He telephoned a curator at the Vancouver Art Gallery and told him, "I think there's a place for her [Sonia] in your gallery." After the curator, Ian Thom, had viewed photographs of a selection of Sonia's paintings, Matthews received "a very polite refusal letter"[16] from him. Later, in 2002, Matthews contacted the Masters Gallery in Calgary to see if they were interested in carrying carry Sonia's work. They were not.

Westbridge was keen because at the time he was looking to repre-sent up-and-coming artists; Sonia had a basic, bold talent that appealed to him. In fact, he has called her "an in-your-face painter" whose work is "so gutsy and so real, I think it's like her diary."[17] Furthermore, "the forceful impact" of her paintings such as *On the Feed Grounds*, "the powerful, often humorous, always sensitive exploration of the Cariboo" and her "expres-sive brush"[18] impressed him. Westbridge explains:

> Matthews discovered her, and I feel gratified that I could bring her work to the forefront and give her a much broader mar-ketplace. When you think about British Columbia artists ... she's right up there.... And when you think that, like Emily Carr and Mildred Valley Thornton, she didn't paint with any groups, then she is all the more remarkable. Besides, who else has painted the Cariboo so prolifically? ... I am proud to be associated with her.
>
> But she's much more than just a local artist.... One of my favourite sayings is that what I look for in an artist is what's be-hind the canvas: in other words, take away the image or paint-ing and who is the person? What have they contributed to the cultural growth of the community or country, who have they associated with, what is their story? To me that's as big a part of the artist as what they've created. Sonia has a story and signifi-cance. I hope the public institutions recognize that her work is like a diary. You're honest in a diary.... She was building mem-ories and putting herself within the whole context of ranch life. What comes through is so strong because she painted from inside.... Many others paint from the outside ... for what the

market wants.... She painted from the heart and painted competently.... And all that other [historical] richness ... is behind her work. That to me is why she is a super artist.[19]

Westbridge considers Sonia's work impressive for its "freshness. Its unabashed pictorial, and emotional [naïveté]. It is not derivative." While he does see "hints" of inspiration from other artists, he insists her "style is singularly that of a painter with a strong sense and understanding of life." He finds her work audacious and her colours "rich, brash, ranchy!" Moreover, Westbridge states that Sonia's images contain "drama, allegory, and a dash of rural humour. And throughout all her images there is a wonderful sense of space and movement: the skies move, the hillsides move, the cattle and horses move.... There is also a certain ethereal quality running throughout her work, a sense of tranquility and comfortable solitude, from the almost ghost-like images in *Winter Sports*" to other more "dream-like vistas."[20]

Westbridge, who has represented Sonia since 2001, hosted an exhibition of her work. *Sonia Cornwall: Fifty Years at the Onward Ranch: A Pioneer's View of the Cariboo* ran from September 20 to October 6, 2001, and featured thirty of Sonia's oil paintings. Matthews asked Herbert Siebner, Joe Plaskett and Ted Lindberg to supply comments for the show's catalogue. The prices ranged from $1,100 to $6,800. Matthews says that by the end of the opening night, fourteen works had sold, and by the exhibition's closing, two-thirds were gone. Because of the exhibition and Matthews's labours, the Vancouver media, including CBC's Sheryl MacKay (host of *North by Northwest*), interviewed Sonia. After more than a decade, the engaging radio personality still remembers being "struck" with Sonia's "vitality" and "very energetic presence" as the eighty-one-year-old sat in the sound room. As well, MacKay found Sonia to be "passionate about her painting and her part of the world."[21] Peter Clemente's interview with Sonia, "Chronicle of a Life Lost to Time," aired on CKVU on October 16, 2001. Unfortunately, records of those conversations have not been saved by the respective institutions.

Recalling the opening night of the exhibition, Westbridge fondly remarks that the work "looked cracker." He believes that seeing her work professionally hung and well lit "knocked Sonia's socks off." Seated in an armchair in a corner of the room with a long queue of guests waiting to speak with her, Westbridge says Sonia was so charming and regal, like a queen giving an audience, that he dubbed her the "Grande Dame of the Cariboo." She chatted with the guests and told "fascinating" stories "about each painting.... The evening tired her out, but it was her moment ... and it was wonderful." While Westbridge still carries Sonia's work and

Sonia Cornwall's 2001 exhibition at Westbridge Fine Art in Vancouver, BC. Left to right: Mary Cornwall, Sonia Cornwall and William Matthews. Photograph courtesy of William Matthews.

says her flower and landscape scenes sell, he laments that cattle scenes do not receive much interest in Vancouver. Yet, in his opinion, Sonia's images of cattle "are the most powerful and forceful works she created." He regards *Last Snowdrifts of Spring* (mixed media on paper, 1976) as "special. She captures the snow and the animals, and the stories about going around and dropping feed and the cattle following the truck.... The image is one of my favourites. That image works, and a good artist is one who can make it work."[22] The same can be said of her oil *On the Feed Grounds* (1967), which is in the collection of the Kamloops Art Gallery.

Sonia was most appreciative of both Westbridge's and Matthews's efforts. She told Matthews, "I can't thank you enough ... unbelievable that anyone would do so much for so little." Matthews never accepted payment, except in the way of the odd painting. In her humble manner, Sonia continued, "I really can't believe that my paintings are worth anything—not as money, but as art. Anyone could do better. Never mind. I continue to have fun & experiment."[23]

Eventually, friction arose between Matthews and Westbridge; Matthews resigned as Sonia's personal representative. Before doing so, however, he set up a website for her work and sold some paintings.

He eventually had to quit his work on the site, and it has not been kept up over the years since her death. While saddened by the turn of events, Matthews insists that having Westbridge take over "was about Sonia— not me." He feels that with Sonia's art, like Emily Carr's, "we feel their presence—one [Carr] recording ... her passion, mood, and psychological wave in nature; the other [Sonia] recording her passion ... in everyday life ... expressing her values. I sense Sonia in every piece she did." Sonia gives a good example of that "recording" of her daily experiences in the following anecdote she recounted to Matthews: "I once was painting sunflowers some years back and a bunch of curious heifers surrounded me—put their noses in my paint box. At first, I was mad at my view being spoilt & then I decided to do them. I pastelled a close view of a bunch of noses & eyes & later sold it!"[24] In that moment, Sonia followed the advice she had once given Matthews: "If you wanna paint, you learn the rules and then you forget them."[25]

Work Without Parallel

Sonia's later years were ones of hardship and joy. Both she and Hugh endured physical ailments and emotional difficulties. First, Sonia lost her mother. Then her dear pal Harriet Zirnhelt died. In Harriet's final months, Sonia wrote her weekly, apprising her of the commonplace details of the Cornwall household: small disasters to laugh over, family events and anything that they would have shared in person. During their last visit together at Jones Lake Ranch, Sonia says, "We hugged & ... I talked my head off & we laughed & laughed." Sonia insisted that Harriet view one of the gnarled poplars outside the house. Once while out riding, they (and Marg Malette) had twisted the saplings into odd shapes, permanently altering their growth. When Harriet's daughter Margaret reacted with surprise, Sonia quipped, "Little do the young know what we did when we were young!"[1]

Starting in the early 1990s, Hugh suffered increasingly with dementia. Sonia insisted on keeping him at home. As a result, they had many misadventures. An avid fisher, Hugh yearned to be out on the lake, but he could not go alone. One day when Sonia consented to accompany him, Hugh somehow lost his balance and they both fell into the water. Swimming was not a problem but making their way through the reedy shore was. The mud pulled their feet so strongly that each step was an effort. Sonia told her family that struggling to shore took over an hour, and both she and Hugh were exhausted. However, Hugh persisted in his attempts to fish, drive or undertake chores, thereby causing conflict and stress for the couple. Sonia maintained her sense of humour and laughed at one hilarious mistake that Hugh made in attempting to obtain a urine sample at home. She heard him yelling, "It's leaking out of the jar," and ran to the bathroom to find a green substance foaming over the specimen container. Somehow, Hugh had decided that the container needed a Polident tablet. Sonia "laughed & laughed"[2] and related the incident to the doctor, who was also amused.

When Hugh wanted to make a return trip to Fiji, a country they had both enjoyed on earlier vacations, Sonia thought they could undertake the holiday alone. They managed without incident until their return to Canada. Staying overnight in a Vancouver hotel, Sonia woke to find Hugh missing. He had risen and gone wandering, causing her much

worry and a prolonged effort to find him. As his health worsened, Hugh began to lose his balance. One day, in trying to lift him after a fall, Sonia injured a vertebra in her back. At that point, her family stepped in and insisted that Hugh enter a facility for twenty-four-hour care. Even though Hugh happily thought he was in a hotel, the decision caused Sonia much distress and sadness.

While she was recuperating from her back injury, Sonia was unable to cook, clean or paint. Her granddaughter Christie moved in and describes Sonia as "the best roommate I ever had."[3] After her recovery, Sonia was no longer stable on her feet and she had shoulder and back problems. Her son–in–law John suggested that the family purchase Sonia a golf cart so she could travel the 2,500-acre ranch. She relished her new freedom but gave up working on large pieces and painted on smaller twelve-by-sixteen boards.

Sonia's granddaughter Natalie was once having a horse shoed when suddenly Sonia appeared at the barn. Shocked at seeing her grandmother out walking, Natalie asked what Sonia was doing. Sonia sheepishly explained that her golf cart was caught on a hummock and needed dislodging.[4] After they freed the vehicle, off Sonia went, paints and brushes stowed in a special compartment. She must have sometimes worried about travelling the pastures alone, especially when mother bears and their cubs were about.

Sonia Cornwall riding around Jones Lake Ranch on her golf cart in search of scenes to paint, circa 2002. Courtesy of the Cornwall Family Archive.

She joked to Ellinore Milner, "Many old ladies have disappeared leaving only their paint boxes."[5]

Author Elizabeth Godley travelled to Jones Lake in the autumn of 2002 and published "Sonia Cornwall's Cariboo" in the winter 2003 issue of *Beautiful British Columbia* magazine. Regarding Sonia's work, Godley wrote, "Beneath the earthy palette, strong brushwork, and bold lines lies an intimate knowledge of ranching life, and a keen sense of form and colour. Whatever her subject—a copse of poplars on a hill, cattle clustered around a hay manger, wooded hills and scudding clouds, or First Nations women walking to a village church—the artist's work radiates affection and respect for the land and those who live on it."[6]

Despite her hardships, Sonia also found more and more artistic success. After the 2001 exhibition, Westbridge continued to exhibit and sell Sonia's work. Since her death, several other prominent auction houses have sold Sonia's paintings. Public galleries outside of Vancouver also began collecting and exhibiting her art. In 2003, the Grand Forks Art Gallery held an exhibition of Sonia's work; in 2007, *Highlights from the Permanent Collection: Sonia Cornwall (1919-2006)* was exhibited at the Penticton Art Gallery (January 19 to March 11). The curator for both galleries was Paul Crawford. In 2009, he selected work from Sonia's and her mother's collections for *At Home at the Onward: The Legacy of Sonia Cornwall and Vivien Cowan* (May 15, 2009 to July 3, 2009). For that show, Crawford, who views art history as a form of social history, noted that Sonia created "a vast body of work unparalleled in the region.... Today, Sonia Cornwall is considered one of British Columbia's most important artists.... Her paintings embrace more than just the land's natural beauty, and serve as an invaluable record and document of the Cariboo and the cattle ranching way of life."[7] During a 2012 interview, Crawford stated that Sonia's art is "accessible.... There was no pretence to her work." Crawford credits Sonia and her mother for "introducing a whole generation of artists to the Cariboo.... I don't think Tak Tanabe would ever have done his Chilcotin series if he had not gone up there.... Sonia's work is important because she is one of the few people that dedicatedly and consciously documented that region.... The relationships she also continued to foster ... brought a much more national spotlight to the region and to her work."[8]

Crawford explains that some of Sonia's work may look awkward at first, but "once you get an appreciation for the landscape, then the paintings seem to have a greater and deeper sense of meaning." He believes that Sonia studied the work of other artists and incorporated those influences into hers but managed to "overlay" the work with "her own sensibility. If you walk into a room and see a Sonia Cornwall, you know whose painting it is.... Her portraits remind me a little bit of Maxwell

Bates, that kind of German Expressionism. I don't think I've ever seen a portrait that she's done that I would say is a beautiful rendering … but they are intense portraits." Like many others, Crawford says Sonia had a big influence on him: "She embodies everything I love about the visual art world: that being that art should be universally accessible."[9]

In 2007, Julie Fowler, the artistic director/curator for Island Mountain Arts in Wells, BC, founded the Sonia Cornwall Scholarship for emerging Cariboo artists. Fowler did so because she views Sonia as an "important Cariboo artist" who is significant to the "history of art" in the region. Moreover, Fowler wanted to honour Sonia's "passion for making art, teaching art and sharing art."[10] The next year (July 18 to August 11, 2008), with the assistance of Mabel and Mary Cornwall, Fowler exhibited over thirty of Sonia's paintings at the Island Mountain Arts Gallery in *Cariboo Cowboy, An Exhibition of Work by Cowboy and Artist Sonia Cornwall (1919–2006)*. That exhibition travelled to the Langham Gallery (Kaslo, BC) and ran from May 1 to May 31, 2009. Fascinated by Sonia and her mother, in 2013 Fowler published her creative nonfiction memoir *The Grande Dames of the Cariboo: Discovering Vivien Cowan and Sonia Cornwall and Their Intriguing Friendship with A.Y. Jackson and Joseph Plaskett.*

In 2013, the Kamloops Art Gallery exhibited forty of Sonia's paintings in *Roundup*. Roger Boulet, author, art historian and former head curator and director at the Edmonton Art Gallery, was the guest curator for the show. He states that Sonia's work "had a lasting impression" on him. "It was kind of raw, and very expressive … very direct. I think her strength is in that directness. The work has a lot of integrity." He says that while the influences of other artists are sometimes obvious, Sonia's work is nonetheless "quite unique." He adds that "BC art history always seems to focus on Victoria and Vancouver.… I think the Interior has its own art history, an alternative one … and very different from the prevailing trends which affect the art of Vancouver and Victoria. If the art history of the Interior is ever written, artists such as Sonia Cornwall will have a big place in it."[11]

Judith Guichon, BC's 29th Lieutenant-Governor, concurs. She first encountered Sonia's work at the 2013 Kamloops exhibition and knew immediately that she "had to have some for my office so that [she] could show visitors to Government House the beauty of our Interior." Her Honour "loved" the work, especially "the way it expresses the countryside" and "spoke of our [ranching] way of life." Furthermore, Sonia's paintings convey "the warm colours" prevalent outside of the Lower Mainland (sage greens, ochres and umbers). A rancher herself, the Lieutenant-Governor says that Sonia's images of cows "are very real, warm, alive." Beside that personal connection, Her Honour finds

that when writing speeches or working on Stewards of the Future, a program she has spearheaded for use in BC high schools, she looks to Sonia's work "for inspiration." Guichon considers Sonia's art important because the images reflect "the importance of the health of the land that supports us." As she points out, the Guichon Ranch is part of an industry that "is in the business of harvesting sunshine" because the rays make the grass grow. Cattle then "harvest the grass and replenish the nutrients [with their droppings] as they walk around, and we harvest a percentage of the cattle…. It's very, very sustainable … [and] uses very little fossil fuel … because we are a grazing outfit."[12] With the United Nations International Year of Soils in 2015, Sonia's art serves to remind people (especially urbanites) of their connection to agricultural and rural endeavours.

Sonia's influence and lifestyle is acknowledged through various other undertakings. In 1966, she contributed the illustrations to Harry Marriott's *Cariboo Cowboy*. The next year *Beautiful British Columbia* (winter 1967) published Sonia's depiction of horses on a snowy hillside. She and her son-in-law John Miller appear in the Museum of the Cariboo Chilcotin's video *Ranching, Living with the Land*. A chapter in Diana French's *Women of Brave Mettle: More Stories from the Cariboo Chilcotin* is devoted to Sonia and her mother.[13] In 2010, Bruce Fraser published *On Potato Mountain: A Chilcotin Mystery*. In the novel, a young Chilcotin boy with an artistic bent receives some pastels and paper as a gift, along with a painting by Sonia Cornwall. The lad appreciates that "there's freshness in the painting. She has a strong sense of the understanding of life with space and movement…. Mrs. Cornwall has found a style for the Cariboo."[14]

Sonia Cornwall in her Jones Lake studio, 1981. Courtesy of the Cornwall Family Archive.

Conclusion

Sonia Cornwall lived and worked according to her own axioms and reflected them in her art. Without formal schooling, she developed an original, evocative style. Sonia kept learning and experimenting, driving her creativity to new levels. She wrote that she agreed with the writer Anaïs Nin, who believed that the elements of creation come "from living, from the personality, from experience, adventures, voyages.... The technique is merely a way to arrange the flow, to chisel, shape; but without the flow from deep inner riches of material, everything withers."[1] Sonia struggled to convey her "inner riches of material" in personal interpretations of her environment and eventually found her style. In the semi-arid hills of the Central Interior, abundant with poplars and jack pines, dotted with pothole and larger lakes, grasslands and snow-laden winters, she recognized a beauty not always apparent to others. She strove to capture the subtleties of the austere topography in a robust, often lyrical style. She is unique in her representations of that landscape, the ranching practices and lifestyle of the early twentieth century, including the engaging characteristics of cattle and horses, as well as the First Nations people of the area and their interactions with the community. Furthermore, Sonia was a beacon of inspiration and influence in the local and broader BC arts scene. Her story and the agricultural and arts history of the area and province intimately intertwine. She is an inductee of the BC Cowboy Hall of Fame, and the Museum of the Cariboo Chilcotin has a permanent display of Sonia's paintings. Her work is in the collections of the Kamloops Art Gallery, the Penticton Art Gallery and Station House Gallery in Williams Lake; one painting is part of the BC Art Collection. The Cariboo Art Society holds several works, four are currently hanging in Government House (Victoria, BC), one painting is in the collection of the Cole Harbour Rural Heritage Society (Nova Scotia) and her art is in some corporate collections. Furthermore, Sonia's images are in private collections in BC, Canada, Europe and the United States.

The people of the Cariboo Chilcotin are proud of its famous citizens, such as Secwepemc Chief William, author Paul St. Pierre, "Man in Motion" Rick Hansen, Montreal Canadiens goalie Carey Price, Secwepemc author Bev Sellars (chief of the Soda Creek Band), playwright Gwen Ringwood, Secwepemc photographer Helen Sandy, Tsilhqot'in extreme

athlete and filmmaker Trevor Mack and photographer Liz Twan. Those individuals belong to the community, as does Sonia Cornwall. To know her work is to know the region. In the words of her fellow rancher David Zirnhelt, Sonia left the province and country "a rich reflection of what she saw in the land and the people. She painted like she spoke— simply and beautifully—about the subject she knew so intimately."[2] For those unfamiliar with the area, her art is a vivid portrayal that immerses the viewer in the universal, everyday aspects of rural life; for those already acquainted with the locale, Sonia's work is resplendent with imagination and a rough-hewn sincerity and humour. Her art transforms the commonplace and homely into the transcendent. Viewers not only observe Sonia's world, they enter the starkness and sanctity of rural Canada. Her work reminds us that the artist "makes us see and feel what we ordinarily ignore or are immune to.... Nothing is vile or hideous, nothing is stale, flat and unpalatable unless it is our field of vision. To see is not merely to look. One must ... see into and around."[3] Sonia Cornwall's work takes us "into and around" other realms: that is a precious legacy from a powerful artist.

Acknowledgements

My heartfelt thanks to Sonia's family: Mabel Cornwall and John Miller, Mary Cornwall, Christie Blackwell and Natalie Borkowski. They welcomed my visits and unending questions with Cariboo hospitality and good humour. Without their memories and access to the Cornwall Family Archive, this book would not have been possible. I am also indebted to other family members, Devereux and David Hodgson, Colleen and Tom Hodgson and Marion Graham, for their invaluable assistance.

Anthony Westbridge first suggested this biography to me in 2012 and piqued my interest in Sonia's story. Then, at a wedding at Little Lake, standing in a field late on a summer evening, a lengthy discussion with David and Susan Zirnhelt convinced me to undertake this book. I am happy I heeded these three passionate advocates.

When he heard about this book, Harvey Chometsky immediately offered his assistance and provided me access to his correspondence, photographs and personal records. Furthermore, Harvey photographed most of the reproductions in this book, for which he has my abiding appreciation. I also owe a huge debt of gratitude to Ellinore Milner for her trust in giving me access to a wealth of information contained in the letters she received from Sonia over several decades. My gratitude to Dorothy Elkington and Sharon Acker for sharing much information and for their permission, along with that of Kim Elkington and Caitlin Elkington Levy, to publish excerpts from Peter Elkington's stories of the Onward Ranch. My deepest appreciation to William Matthews for providing a treasure trove of material from his personal archive of correspondence, memories, notes and photographs, as well as his audio-recorded interview with Sonia. Special thanks to Julie Fowler (director, Island Mountain Arts) for kindly letting me read her master's thesis on Vivien Cowan and Sonia Cornwall and for her ongoing support.

I warmly thank Dave Abbott, Lisa Anderson, Jacquelyn Bortolussi (Open Space), Colleen Hodgson, Brandon Hoffman, Dallas Kempfle Photography, Derek Masselink, John Miller, Kirk Salloum, Jane Shaak, Nicholas Westbridge and James Hung (Wonder Bridal Studio) for their photographic reproductions. My abiding gratitude to Glenn Woodsworth for his technical guidance.

Thank you to the many others who enthusiastically contributed to this biography (with apologies to anyone I may have inadvertently forgotten): Robert Amos, Molly Bobak, Roger Boulet, Dr. Timothy Bowman (University of Kent), Gisela Brinkhaus, Michael Cecil, Shelley Corbin, Anita Crosina, Roy and Shirley Crosina, Terry and Willie Crosina, Bill and Pam Damon, Mario Doucet, Carol and Dennis Evans, Ginny Evans, Margaret Ferrier, Chris Foster, Bruce Fraser, Maurita and Rudy Geddert, Elizabeth Godley, Anne Goyette and John Sontag, John Graham, Her Hon. Judith Guichon, Dmitri Hardman, Bob and Carol Hilton, Carole Hutchinson, Imogene Jackson, David Karchere and the Emissaries of Divine Light, Lona Joe, John Kemp, Ann Kujundzic, Claire Kujundzic and Bill Horne, Sue Lacourciere, Gregor Lee, Mary Lee, Corry Lunn, Gillian MacDonald, Sheryl MacKay, Hugh and Pam Mahon, Jim and Phyllis McCallum, Archie Miller, Mary and Michael Milner, Tom Mosley, Angela Nielsen, Jan Norman, Darrel Nygaard, Linda Olsen, Joe Plaskett, Lily Hoy Price, Pirjo Raits, Don and Trish Redgwell, Penny Robart, Anna Roberts, Linda Rogers, Diane Rustemeyer, Paul St. Pierre, Helen Sandy, Don and Linda Savjord, Anny Scoones, Jane Shaak, Gary Sim, Carsten Sorensen, Lise Sorensen, Laura Telford, Aleta Tiefensee, Audrey Thomas, Denise and Morrie Thomas, Karen Thompson, Lilla Tipton, Eileen Truscott, Kathleen and Mark Waldron, Stephen Walker, Janet Wallace, Gladys Wheatley, Ingrid Wolf, Teresa Zahorodna, John and Yvonne Zirnhelt, Judi Zirnhelt and Norman Zirnhelt and Candace Collier.

Several institutions and their staff went out of their way to assist me. Thank you to Kris Andersen (program manager), Arts, Culture and BC Arts Council Branch, Ministry of Community, Sport and Cultural Development; Jann Bailey (director), Charo Neville (curator) and Krystyna Halliwell (registrar) of the Kamloops Art Gallery; Paul Crawford (curator), Penticton Art Gallery; Sandra Dyck (director), Carleton University Art Gallery; Terry Eyland (curator) Cole Harbour Heritage Farm Museum and the Coal Harbour Rural Heritage Society (Nova Scotia), Arin Fay (curator) and the Langham Cultural Society; Ted Fogg (curator), Grand Forks Art Gallery; Helen Hadden (librarian), Art Gallery of Hamilton; George Harris (curator), Two Rivers Gallery; Ron Hatch (publisher), Ronsdale Press; Holly Jackson and the BC Cattlemen's Association; Brian Lam (publisher), Arsenal Pulp Press; Elizabeth Levinson and Winchester Galleries; Dale Miller and *British Columbia* magazine; Nataley Nagy (executive director), Kelowna Art Gallery; Colin Preston (library coordinator), CBC Media Archives; Sharon (Cat) Prevette (president), Cariboo Art Society; Jon Roberts (director), Art Gallery of Greater Victoria; Cheryl Siegel (librarian), Vancouver Art Gallery; Pat Skoblanuik and the Museum of the Cariboo Chilcotin; Diane Toop

(gallery manager), Station House Gallery; Kelly-Ann Turkington and the staff of Royal BC Museum, BC Archives; Kealy Wilkinson (executive director), Canadian Broadcast Museum Foundation; and Erwin Wodarczyk (archivist), University of British Columbia Archives.

Cheers to Vici Johnstone of Caitlin Press for undertaking this publication, and to Kathleen Fraser for her fine copy editing and Patricia Wolfe for her careful proofreading.

And finally, a special thanks to my family for the loving encouragement that sustained me every day of this project. I thank Alyssa and Gary for always being interested. For Kirk's loving support as an early editor, research assistant, coffee maker and an ear that I can always bend, I am forever grateful.

Selected Exhibitions

Records of Sonia Cornwall's exhibitions are incomplete. During her lifetime, she showed her work in commercial and public galleries, libraries, shopping malls and various other venues across BC.

1950—*B.C. Artists, 19th Annual Exhibition*, Vancouver Art Gallery, Vancouver, BC

1954—*Sixth Annual Winter Exhibition*, Art Gallery of Hamilton, Ontario

1960s (exact date unknown)—Hallway, BC Provincial Government Library, Victoria, BC

1965—Summerland Art Club, Summerland, BC

1967—The Little Gallery, New Westminster, BC

1967—*Impressions of the Cariboo*, Cariboo Art Society, Williams Lake, BC

1972—Kelowna Public Library, Kelowna, BC

1975—Station House Gallery, Williams Lake, BC

1989—*Cariboo Expressions*, Group Show, Station House Gallery, Williams Lake, BC

1990—*Sonia Cornwall Retrospective*, Other Art & Cappuccino, Prince George, BC

1991—*Sonia Cornwall: Watercolour and Mixed-media Landscapes of the Cariboo*, Other Art & Cappuccino, Prince George, BC

1993—*Hometown Retrospective*, Station House Gallery, Williams Lake, BC

1994—*Sonia Cornwall*, Prince George Art Gallery, Prince George, BC

1994—*Cariboo Impressions: Works by Vivien Cowan, Sonia Cornwall, Dru Hodgson, Devereux Hodgson and Premier Showing of Works by A.Y. Jackson, Joe Plaskett*, Onward Ranch Cultural Centre, BC

1997—*Warmer Climes* (impressions of Fiji and Mexico in oils and pastels), Station House Gallery, Williams Lake, BC

1999—*Sonia Cornwall and Zeljko Kujundzic*, Station House Gallery, Williams Lake, BC

2000—*Sonia Cornwall: Cariboo Ranch Scenes*, Kelowna Art Gallery, Kelowna, BC

2000—*A Group of Five: Dave Abbott, Sonia Cornwall, Harvey Overton,*

Lynda Sawyer, Randy Moe, Station House Gallery, Williams Lake, BC

2001—*Sonia Cornwall: Fifty Years at the Onward Ranch: A Pioneer's View of the Cariboo*, Westbridge Fine Art Ltd., Vancouver, BC

2002—*Sonia Cornwall & Mildred Valley Thornton: Doyennes of Canadian Art! Pioneer Painters of the B.C. Landscape*, Westbridge Fine Art Ltd., Vancouver, BC

2003—*Cariboo Snapshots*, Station House Gallery, Williams Lake, BC

2004—*Three Artists from the Cariboo: Paul Scott, Marie Nagel, and Sonia Cornwall*, Grand Forks Art Gallery, Grand Forks, BC

2007—*Highlights from the Permanent Collection: Sonia Cornwall (1919–2006)*, Penticton Art Gallery, Penticton, BC

2008—*Cariboo Cowboy: The Life and Art of Sonia Cornwall*, Island Mountain Arts Gallery, Wells, BC

2009—*Cariboo Cowboy: The Life and Art of Sonia Cornwall*, Langham Gallery, Kaslo, BC

2009—*At Home at the Onward: The Legacy of Sonia Cornwall and Vivien Cowan*, Penticton Art Gallery, Penticton, BC

2013—*Western & Sonia Cornwall Roundup*, Kamloops Art Gallery, Kamloops, BC

Notes

Unless otherwise indicated (in an endnote or the text), where multiple quotations (or references) from the same source appear in a paragraph or a block quotation, the appropriate endnote will appear at the last quotation (or reference) from that source.

Introduction

1. Carsten Sorensen, telephone interview with author, May 15, 2013.
2. Ibid.
3. Emily Carr, *Growing Pains: The Autobiography of Emily Carr* (Toronto: Oxford University Press, 1946), 265. Carr did not paint during that trip but said she was indebted to the Cariboo for the psychological solace she gained during her sojourn. She also learned to ride astride a horse, rather than sidesaddle.
4. Al Purdy, "The Country of the Young," *Rooms for Rent in the Outer Planets: Selected Poems 1962–1996* (Madeira Park, BC: Harbour Publishing, 1996), 49–50.
5. Corry Lunn, telephone interview with author, March 19, 2013.
6. Sorensen, telephone interview.
7. John Miller, journal entry, March 15, 2006, courtesy of John Miller.
8. Mabel Cornwall, interviews with author, September 16, 2014; February 9, 2015.
9. David Zirnhelt, tribute for Sonia Cornwall, 2006. The Hon. David Zirnhelt was the minister of economic development, small business and trade (1991–1993); minister of agriculture, fisheries and food (1993–1996); minister of forests (1996-2000); and minister of Aboriginal affairs (2000–2001).

A Wild Irish Type

1. According to UK Census Online, in 1871 Cowan was three years old. His estimated year of birth is given as 1868 and his place of birth as Hemsby, not Wells, which was likely Wells-next-the-Sea, Norfolk, England. UK Census Online, Norfolk 1871 census, http://www.ukcensusonline.com/search/index.php?fn=Charles+&sn=Cowan&phonetic_mode=1&event=1871&to

ken=LtylkIQVnJYuSdfeDCp9mBUKj4GRzFlS84YEs_OhXIE. For the purposes of this book, Cowan's birth date will be considered 1869, and his place of birth as Wells, as recorded in the Royal BC Museum, BC Archives, Charles George Cowan fonds, 1905–1930 (MS 1647; MS 1691), and Cowan family fonds, 1887–1970 (MS 1197).

2. Vivien Cowan, "We Raised Cattle and Artists or One Woman's Life," unpublished autobiography, Cornwall Family Archive. Unless otherwise indicated in an endnote, further references to Vivien Cowan's unpublished writings in the text are from this manuscript. Where necessary for clarification, the author has corrected spelling and grammatical errors found in the manuscript.

3. Charles George Cowan, "Reminiscences I" and "Reminiscences II," Cowan family fonds, 1887–1970 (MS-1197), Royal BC Museum, BC Archives, Victoria, BC. Unless otherwise indicated in an endnote, all further quotations from or references to C.G. Cowan's unpublished writings are from Cowan's "Reminiscences I" or "Reminiscences II." Where necessary for clarification, the author has corrected spelling and grammatical errors found in the manuscripts.

4. Cowan used the Cherokee name for the river but misspelled it as Takiosti. The river, which has had several names, is now generally known as the Broad River.

5. Library and Archives Canada, "'Without Fear, Favour or Affection': The Men of the North West Mounted Police," November 14, 2007, http://www.collectionscanada.gc.ca/nwmp-pcno/025003-1203-e.html.

6. Library and Archives Canada, medical examination for Charles George Cowan, "North West Mounted Police (NWMP)—Personnel Records, 1873–1904," 5, http://www.bac-lac.gc.ca/eng/discover/nwmp-personnel-records/Pages/item.aspx?IdNumber=25519&. While Charles would tell his wife he was younger than his years, he seems to have made himself out as older for his NWMP examination. He was recorded as being twenty-two years and eleven months old, thereby incorrectly placing his birthdate in 1866.

7. Ibid., 23; 46.

8. LAC, "Without Fear, Favour or Affection."

9. *Forest and Stream*, November 10, 1906, clipping, page unknown; in Cowan, "Reminiscences I" and "Reminiscences II."

10. Irene Stangoe, *Looking Back at the Cariboo-Chilcotin* (Surrey: Heritage House Publishing Company, 1997), 34.

11. Vivien Cowan wrote that her husband was in the South Irish Horse, but that regiment was first raised in 1902 as the South of Ireland Imperial Yeomanry and renamed as the South Irish Horse in July

1908. The regiment was disbanded in 1922. "The History," South Irish Horse, March 3, 2001, http://www.southirishhorse.com/documents/history.htm.

12. Vivien Cowan, "We Raised Cattle and Artists."

13. "Why Does Mr. Roosevelt Leave Home—When He Has Big Game Like This in His Own Dominion?" *Bystander,* February 17, 1909, 338–339; Add. Mss 1647, C.G. Cowan, scrapbook, Royal BC Museum, BC Archives.

14. C.G. Cowan, "With the Indian," *Rod and Gun in Canada* 6, no. 6 (November 1904): 273–277; Add. Mss 1647, C.G. Cowan, scrapbook, Royal BC Museum, BC Archives.

15. C.G. Cowan, "Two Thousand Miles Down the Yukon River in a Small Boat," *Rod and Gun in Canada* 7, no. 9 (February 1906); no. 10 (March 1906); Add. Mss 1647, C.G. Cowan, scrapbook, Royal BC Museum, BC Archives.

16. For the full story of the historical episode, see David Ricardo Williams, *Trapline Outlaw: Simon Peter Gunanoot* (Victoria: Sono Nis Press, 1982).

17. "West Praised By Noblemen," undated article in the *Daily Province,* Cornwall Family Archive.

18. "British Noblemen Buy Big Ranches," undated and unidentified newspaper article in Cornwall Family Archive. That article states that between them, Lord Exeter and Lord Egerton had twenty thousand acres. According to Michael Cecil (email to author, January 23, 2015), the Cecils' Bridge Creek Ranch had fifteen thousand acres and Lord Egerton's Highland Ranch at 105 Mile had thirty-five thousand acres.

19. Michael Cecil, telephone interview with author, July 18, 2013.

20. Ginny Evans, interview with author, January 16, 2013.

21. Vivien Cowan, "We Raised Cattle and Artists."

The Cowan/Tully Family

1. Devereux Hodgson, interview with author, January 16, 2013.

2. Carr, *Growing Pains,* 264–266.

The Onward Ranch

1. Members of the Sugar Cane community are from the T'exelc or Williams Lake Band, part of the Secwepemc Nation.

2. Stangoe, *Looking Back at the Cariboo-Chilcotin,* 29.

3. "Williams Lake Valley—The Magnificent Farms of Pinchbeck & Lyne—C.B. Eagle's Onward Ranche," *Daily British Colonist,* Novem-

ber 20, 1886. According to John A. Roberts, in *Cariboo Chronicles* (Williams Lake Golden Jubilee 1929–1979, copy courtesy of William Matthews), William Lyne and William Pinchbeck travelled to the Cariboo in search of gold in 1862. For a time they were partners before Lyne moved to Deep Creek, was arrested for drunkenness and, ironically, became the first occupant of the log jail he had earlier constructed. Pinchbeck ran several enterprises including a ranch, hotel, brewery and gristmill. He was buried on a hill overlooking the Williams Lake stampede grounds.

4. Stangoe, *Looking Back at the Cariboo-Chilcotin*, 32; 33. Over the decades, the Onward Ranch has had several owners and reincarnations. In 1994, Jo-Anne Strong and European investors renovated the ranch building that was used as a store into an art gallery and gift shop. The restored house became a space for musical entertainments, art workshops and artists' retreats. The exhibition that ran from May 10 to June 23, 1994, *Cariboo Expressions*, featured work by Lilias Torrance Newton, Joe Plaskett, Takao Tanabe and three generations of Cowan women (Vivien Cowan, her daughters Sonia Cornwall and Dru Hodgson and Dru's daughter, Devereux Hodgson). Some metal sculptures by Hugh Cornwall were also included. Sonia recorded that over one hundred people attended the opening. Unfortunately, the business venture was short-lived. Now subdivided into smaller properties, the ranch house and barn still stand as some of the region's unique and historic architecture.

5. Sarah More McCann, "Old Barns Get New Attention," *Christian Science Monitor*, September 2, 2008, http://www.csmonitor.com/The-Culture/Home/2008/0902/p17s01-lihc.html; "Dutch barn," *Wikipedia*, http://en.wikipedia.org/wiki/Dutch_barn.

6. Several of Sonia Cornwall's paintings of the Onward Ranch (as well as some by A.Y. Jackson, Joe Plaskett, Herbert Siebner and Takao Tanabe) are reproduced in Julie Fowler's *The Grand Dames of the Cariboo: Discovering Vivien Cowan and Sonia Cornwall and Their Intriguing Friendship With A.Y. Jackson and Joseph Plaskett* (Halfmoon Bay, BC: Caitlin Press, 2013). According to Sonia's agent, William Matthews, in the 1960s the Vancouver Art Gallery's "art rental department had no less than twelve different paintings of the renowned Onward barn by various artists." "My friend Sonia Cornwall," *Sonia Cornwall: Fifty Years at the Onward Ranch A Pioneer's View of the Cariboo* (Vancouver: Westbridge Fine Art, 2001).

7. The Cornwall family agrees that Edgar Moore, not Mr. Carew-Gibsons as has sometimes been mistakenly reported, sold the Onward Ranch to Cowan (also see Irene Stangoe, *Looking Back at the Cariboo-Chilcotin*, 34). In her unpublished autobiography, "We

Raised Cattle and Artists," Vivien Cowan noted that for a time, Carew-Gibsons managed the 150 Mile Ranch for the Cunliffe family in England. During the Great War, Cowan managed the 150 Ranch, and in 1929 he purchased that property.

8. Sonia Cornwall, unpublished writings, Cornwall Family Archive. Unless otherwise indicated in an endnote, further references to Sonia Cornwall's unpublished writings are from these archives. Where necessary for clarification, the author has corrected spelling and grammatical errors found in the writings.

9. Carole Hutchinson, telephone interview with author, September 13, 2013.

10. Sonia Cornwall, unpublished writings.

11. See Joe Plaskett's depiction of the Onward water tower in Fowler's *The Grande Dames of the Cariboo*.

12. Stangoe, *Looking Back at the Cariboo-Chilcotin*, 35.

13. Sonia Cornwall, undated remembrance as quoted in Vivien Cowan, "We Raised Cattle and Artists."

14. Ibid.

15. Sonia Cornwall, unpublished writings.

16. Karen Thompson, in conversation with author, June 5, 2014.

17. Sonia Cornwall, letter to Ellinore Milner, July 13, 1998. All further references to letters from Sonia Cornwall to Ellinore Milner are from copies provided courtesy of Ellinore Milner.

18. Vivien Cowan, "We Raised Cattle and Artists."

19. Sonia Cornwall, unpublished writings.

20. Ibid.

21. Sonia Cornwall, letter to Ellinore Milner, January 31, 1998.

22. Sonia Cornwall, unpublished writings.

23. Ibid.

High Society and Insolvency

1. In 1934, Martin Cecil became the first vice-president of the newly formed Cariboo Stockmen's Association; in 1943, Cecil and George Mayfield helped found the Cariboo Cattlemen's Association. Cecil was that group's president until 1954. Sometimes regarded as the founder of the town of 100 Mile House, he helped plan the town and donated land for a park, a bird sanctuary and several public buildings. In 1980, Cecil received the first 100 Mile & District Historical Society award for Pioneer of the Year.

2. Michael Cecil, telephone interview with author.

3. Chris Foster, *One Heart, One Way: The Life and Legacy of Martin Exeter*

(Denver, Colorado, & Vancouver: Foundation House Publications, 1989), 54.

4. Irene Stangoe, *History and Happenings in the Cariboo-Chilcotin: Pioneer Memories* (Surrey: Heritage House Publishing Company, 2000), 66.

5. Foster, *One Heart, One Way*, 63.

6. Eventually, the Red Coach Inn was built on the Bridge Creek Estate property. That hotel and restaurant (currently named Red Rock Grill) have welcomed travellers for decades. The lodge Martin Cecil built still stands.

7. Foster, *One Heart, One Way*, 71.

8. Martin Cecil, as reproduced in Foster, *One Heart, One Way*, 71–72.

9. Lord Martin Exeter, undated article, *Field* magazine, as reproduced in *One Heart, One Way*, 74–75.

10. Vivien Cowan and Sonia Cornwall, interview by Chris Foster, in *One Heart, One Way*, 68.

11. C.G. Cowan, letter to Lord William Exeter, July 10, 1930, as reproduced in *One Heart, One Way*, 68.

12. Michael Cecil, telephone interview with author.

13. Ibid. From Martin Cecil's death in 1988 until 1993, Michael Cecil headed the four-thousand-member Emissaries of Divine Light. With his second wife, Barbara, Michael currently co-directs the Ashland Institute in Ashland, Oregon.

14. Sonia Cornwall, letter to Ellinore Milner, August 10, 2001.

15. Told by Sonia Cornwall to William Matthews in April 2002 and recorded in his personal notes, courtesy of William Matthews.

16. Hodgson, interview with author.

17. Mary Cornwall, interviews with author, 2012 to 2015. Unless otherwise indicated in an endnote, further comments in the text from Mary Cornwall, Mabel Cornwall and John Miller from 2012 to 2015 are from these interviews.

Cowboys and Quagmires

1. Excerpt from Alice Tully's diary in Vivien Cowan, "We Raised Cattle and Artists."

2. David Zirnhelt, "Short History of the Zirnhelts at 150 Mile House," *Williams Lake Tribune*, 2011, copy courtesy of David Zirnhelt.

3. Ibid.

4. David Zirnhelt, interview with author, March 19, 2013.

5. Pam Mahon's recollection, quoted in David Zirnhelt, "Short History of the Zirnhelts at 150 Mile House."

6. Zirnhelt, interview with author, September 18, 2013.

7. Ibid., March 19, 2013.

8. References to Mrs. Tully's diary come from excerpts that Vivien Cowan included in her unpublished autobiography. Unless otherwise indicated in an endnote, further quotes from Mrs. Tully come from Vivien Cowan's manuscript.

9. Alice Tully, diary entry, as quoted in Vivien Cowan, "We Raised Cattle and Artists."

10. Vivien Cowan, "We Raised Cattle and Artists."

11. Roderick Mackenzie's daughter, Anne Stevenson, became a highly respected educator and community leader in the Cariboo, and a school in Williams Lake was named after her.

12. Diana French, *Women of Brave Mettle: More Stories from the Cariboo Chilcotin* (Halfmoon Bay, BC: Caitlin Press, 2012), 159.

13. Vancouver Art Gallery Library, Arthur S. Grigsby Sous-Fonds 1931–1947; folder 76-7, BC Artists Summer Exhibition, July 8–27, 1947.

14. Sonia Cornwall, unpublished writings; letter to Ellinore Milner, March 25, 1998.

15. Sonia Cornwall's recollections as recorded in Vivien Cowan, "We Raised Cattle and Artists."

16. Ibid.

17. Sonia Cornwall, letter to Peter Gwozski, *The Fourth Morningside Papers* (Toronto: McClelland & Stewart, 1991), 269.

18. Morrie Thomas, telephone interview with author, December 13, 2013.

19. Sonia Cornwall, unpublished writings.

20. Sonia Cornwall, letter to Ellinore Milner, September 25, 1997.

21. Mary Cornwall, interviews with author.

22. Harry Aoki (1921–2013) was a composer, musician and pioneer in world music. He and James Johnson hosted the CBC TV program *Moods of Man*. He received the Living Heritage award from the Asia Pacific Foundation for his work in preserving Asian culture. He believed in and worked for intercultural harmony. Aoki visited Jones Lake Ranch on at least two occasions.

23. Margaret Ferrier, email to David Zirnhelt, March 29, 2006, courtesy of Margaret Ferrier and David Zirnhelt.

24. Zirnhelt, interview with author, March 19, 2013. Harriet Zirnhelt had a diploma from, and was an associate of, Trinity College London.

25. Mary Cornwall, interviews with author.

26. Sonia Cornwall, letter to Ellinore Milner, August 3, 1998.

27. Zirnhelt, interview with author, March 19, 2013.

28. Mary Cornwall, interviews with author.

29. Zirnhelt, "Short History of the Zirnhelts at 150 Mile House."

30. John Zirnhelt, email to David Zirnhelt, March 31, 2006, courtesy of David and John Zirnhelt.

Painters and Inspirations

1. The University of Calgary houses the Margaret P. Hess Collection, and Hess is known for her invaluable contributions to Alberta's and Canada's art, culture and history. Hess owned a cattle and horse ranch in Alberta.

2. For information on Mildred Valley Thornton, see Sheryl Salloum's *The Life and Art of Mildred Valley Thornton*, The Unheralded Artists of BC 4 (Salt Spring Island, BC: Mother Tongue Publishing, 2012).

3. A.Y. Jackson, *A Painter's Country: The Autobiography of A.Y. Jackson* (Toronto: Clarke, Irwin & Company, 1958), 124.

4. Ibid. There has been some confusion over the years as to when the Cariboo Art Society was formed. Vivien seems to have started an art society prior to Jackson's arrival in 1945, but the official name of that group is no longer known. With Jackson as honorary president, the Cariboo Art Society was initiated in the autumn of 1945.

5. Vivien Cowan, "We Raised Cattle and Artists."

6. A.Y. Jackson, *A Painter's Country*, 13.

7. A.Y. Jackson, notes to Sonia Cornwall, Cornwall Family Archive. The correspondence of A.Y. Jackson with Sonia Cornwall is copyright Carleton University Art Gallery, Ottawa, and is printed with permission.

8. David Milne (1882–1953) is one of Canada's foremost artists. He worked in oil, watercolour and drypoint printmaking. He is known for his austere representations of ordinary subjects and the use of black in his oil paintings.

9. A.Y. Jackson, notes to Sonia Cornwall, Cornwall Family Archive.

10. A.Y. Jackson, letter to Sonia Cornwall, January 29, 1951, Cornwall Family Archive.

11. Helen Hadden, letter to author, November 4, 2013. Sonia is included in the Canadian Women Artists History Initiative (Concordia University).

12. Sonia Cornwall, unpublished writings.

13. Sonia Cornwall, interview by William Matthews, January 28, 2001, audiotape courtesy of William Matthews.

14. Sonia Cornwall, interview by Peter Clemente, "Chronicle of a Life Lost to Time," CKVU, October 16, 2001, videocassette courtesy of Devereux Hodgson.

15. A.Y. Jackson, letter to Sonia Cornwall, February 4, 1969, Cornwall Family Archive.

16. Naomi Groves, letter to Sonia Cornwall, March 27, 1992, Cornwall Family Archive. The correspondence of Naomi Jackson Groves with

Sonia Cornwall is copyright Carleton University Art Gallery, Ottawa, and is printed with permission.

17. Lilias Torrance Newtons's portraits of Hugh and Sonia Cornwall are reproduced in *The Grand Dames of the Cariboo*.

18. Alice Tully, diary entry, in Vivien Cowan, "We Raised Cattle and Artists."

19. Sharon (Cat) Prevette (president) and Gladys Wheatley (past president), conversations with author at the Cariboo Art Society exhibition opening for *Brushes with History: Our Cariboo Roots*, June 5, 2014.

20. A.Y. Jackson, review of Cariboo Art Society Exhibition, *Williams Lake Tribune*, October 17, 1946, clipping in the Cornwall Family Archive.

21. Alice Tully, diary entry, in Vivien Cowan, "We Raised Cattle and Artists."

22. Mabel Cornwall, interviews with author. Dru Hodgson eventually became a skilled and enthusiastic potter.

Coyotes and Sophisticated Sodbusters

1. Pam Mahon, interview with author, September 17, 2013.

2. *Bittersweet Oasis: A History of Ashcroft and District, 1885–2002* (Ashcroft, BC: Corporation of the District of Ashcroft), 32–33. Clement and Henry Cornwall were also descendants of Admiral Sir Alan Gardner; see *Heart of Oak: Letters from Admiral Gardner (1742-1809)*, edited by Francis Davey, United Kingdom: Azure Publications, 2015.

3. Clement F. Cornwall, "Diary of Clement F. Cornwall, Cornwall, Esq., Ashcroft Manor British Columbia, 1862–1873," Cornwall Family Archive. Unless otherwise indicated in an endnote, further quotes from Clement Cornwall in the text come from this diary. Where necessary for clarification, the author has corrected spelling and grammatical errors found in the diary.

4. Grant MacEwan, *The Sodbusters* (Toronto: Thomas Nelson & Sons Limited, 1948), 146.

5. Ibid., 150; 149.

6. According to Grant MacEwan, the Cariboo Wagon Road, constructed under the direction of Walter Moberly and Edgar Dewdney, "was one of the most famous pioneering road-building undertakings in history." *Sodbusters*, 148.

7. MacEwan, 150.

8. Clement Cornwall, undated letter to *The Field*, as reprinted in Clement Cornwall's diary.

9. Mabel Cornwall, interviews with author.

10. *Casual Country*, 1991, newspaper clipping, Cornwall Family Archive.

11. Ibid.

12. Morrie Thomas, *Fifty Years—Three and a Half Million Cattle: A History of B.C. Livestock Producers Co-operative Association: Commemorating Fifty Years of Service to the Livestock Industry of British Columbia, 1943–1993* (Kamloops, BC: BC Livestock Producers Co-operative Association, 1993), 81.
13. Ibid., 18–19.
14. *Casual Country*, undated newspaper clipping, Cornwall Family Archive.
15. Thomas, *Fifty Years—Three and a Half Million Cattle*, 19.
16. *Casual County*, undated newspaper clipping, Cornwall Family Archive.
17. Thomas, *Fifty Years—Three and a Half Million Cattle,* 19–20.
18. Lorne Leach, "A visit with BCAA president John Miller, past president Hugh Cornwall and their wives," *Beef in BC*, September/October 1991, 15.
19. Thomas, *Fifty Years—Three and a Half Million Cattle*, 20.
20. "Hugh and Sonia Cornwall, 2005 Hall of Fame, Ranching Pioneer and Artistic Achievements," Cowboy Hall of Fame, Museum of the Cariboo Chilcotin, 116. Hugh served terms as president of both the Cariboo Cattlemen's and the BC Cattlemen's Associations. He was also a director of the BC Beef Growers Association.

Marriage and Children

1. Willie Crosina, telephone interviews with author, August 23, 2012; September 7, 2012. Unless otherwise indicated, all further quotes from Willie Crosina in the text come from these interviews.
2. Sonia Cornwall, letter to Ellinore Milner, May 12, 1997.
3. Sonia Cornwall, letter to Ellinore Milner, July 2, 1998.
4. Sonia Cornwall, letter to Ellinore Milner, November 23, 1998.
5. Crosina, telephone interviews with author.
6. *Washing Day, Onward Ranch*, is reproduced in the Westbridge Fine Art Ltd. catalogue *Sonia Cornwall: Fifty Years at the Onward Ranch*, 2001, n.p.
7. Zirnhclt, interview with author, March 19, 2013.
8. Several books have been written on St. Joseph's Mission. For a synopsis, see Wanda Story's chronology of the mission and information on its cemetery at http://www.rootsweb.ancestry.com/~bccaribo/StJoseph.html. Story's cemetery listing gives names and spellings for the Eagles that differ from other records: Charles is listed as "George Barimo" and Annie is listed as Anna (née Tatqua). Johnny McLuckie appears as "Johnie."
9. John Miller, interview with author, August 20, 2012.

10. The Church of the Immaculate Conception or the Sugar Cane Church opened in 1895 and has been in use ever since. The exterior of the structure is distinctive for its red steeple, arched doorway, bull's-eye stained-glass windows at the front and back and cedar shake roof. Not all early First Nations churches (usually built by the community members) are still standing. For an illustrated history of such buildings, see John Veillette and Gary White, *Early Indian Village Churches: Wooden Frontier Architecture in British Columbia* (Vancouver: University of British Columbia, 1977).

11. William Matthews's personal notes; William Matthews, interview with author, May 27, 2013.

12. Sonia Cornwall, letter to William Matthews, January 3, 1999, courtesy of William Matthews.

Art and Artists

1. Joseph Plaskett, *A Speaking Likeness* (Vancouver: Ronsdale Press, 1999), 147–148. Plaskett, an Officer of the Order of Canada, died on September 21, 2014. His work is in numerous institutions, including the National Gallery of Canada.

2. Plaskett as quoted in George Woodcock's foreword to *A Speaking Likeness*, xix.

3. Dorothy Elkington, telephone interview with author, July 2, 2013. Tanabe's *Onward Barn*, 1957, mixed media on paper, is reproduced in *The Grande Dames of the Cariboo*.

4. Paul Crawford, "Joseph Plaskett: Reflections Contextualizing the Legacy," *Arts Letter* xxxiii, no. 5 (September/October 2012): 4 (Penticton Art Gallery publication).

5. Joe Plaskett, letter to Sonia Cornwall, March 14, 1962. Use of Joe Plaskett's correspondence with Sonia is courtesy of Joe Plaskett and Mario Doucet.

6. Joe Plaskett, letter to Sonia Cornwall, December 4, 1994.

7. Joe Plaskett, letter to Sonia Cornwall, November 8, 2005.

8. Plaskett as quoted in George Woodcock's foreword to *A Speaking Likeness*, xxviii.

9. Harvey Chometsky, telephone interview with author, January 7, 2013.

10. Sonia and the Cariboo Art Society encouraged local artists such as Martin Place and Jack Simon. As Sonia explained in an undated article by Bal Russell ("Sonia Cornwall opens window on landscapes," in the *Williams Lake Advocate*, copy courtesy of Ellinore Milner), Sonia and the society were "very interested in getting young people into art" and in expanding their views of the world.

11. Bertram Binning, undated letter to Dorothy Somerset, Department of University Extension Fonds, 1918–1969, "Social Education, the Humanities and Summer School—Fine Arts—Music, Art, Arts and Crafts, Creative Writing (1938–49)," Box 8, Folder 19, University of British Columbia Archives.

12. Ibid., letter dated only "Sunday—Nelson."

13. Gordon M. Shrum (director of University Extension), letter to Dr. F.T. Fairey (deputy minister and superintendent of education), July 14, 1949, Department of University Extension Fonds, "Social Education, the Humanities and Summer School—Fine Arts—Music, Art, Arts and Crafts, Creative Writing (1938–49)," Box 8, Folder 19, University of British Columbia Archives.

14. G.M. Shrum, letter to Donald Cameron (director, Banff School of Fine Arts), August 8, 1949, Department of University Extension Fonds, "Social Education, the Humanities and Summer School— Fine Arts—Music, Art, Arts and Crafts, Creative Writing (1938–49)," Box 8, Folder 19 and Folder 20 (1950–1954), University of British Columbia Archives.

15. Frances Gibbins (secretary, Prince George Art Club), letter to Hon. W. Straith (BC minister of education), November 25, 1949; Ruth Harvey (secretary, Prince Rupert Art Club), letter to G.M. Shrum, November 4, 1951, Department of University Extension Fonds, "Social Education, the Humanities and Summer School—Fine Arts—Music, Art, Arts and Crafts, Creative Writing (1938–49)," Box 8, Folder 19 and Folder 20 (1950–1954), University of British Columbia Archives.

16. Sonia Cornwall, "Workshops at the Onward Ranch," *Sonia Cornwall: Fifty Years at the Onward Ranch*, n.p.

17. University of British Columbia Department of University Extension, *Annual Report*, 1951–1952 and 1952–1953, Folder 18; 1961–1962, Folder 26; University of British Columbia Archives.

18. Cliff Robinson, letter to Sonia Cornwall, February 14, 1963, Cornwall Family Archive.

19. University of British Columbia Department of University Extension, *Annual Report*, 1959–1960, Folder 24, University of British Columbia Archives. Bobak also gave courses in Alberni, Armstrong, Courtenay, Cranbrook, Crofton, Kitimat, Parksville, Prince George, Prince Rupert, Squamish, Trail and Windermere.

20. Molly Bobak, telephone interview with author, December 3, 2012.

21. Ibid.

22. Molly Bobak, letter to Sonia Cornwall, June 24, 1991. Bobak's letters are in the Cornwall Family Archive and excerpts are reprinted with the permission of the late Molly Bobak (1922–2014). Unless other-

wise indicated, further references to Bobak's correspondence with Cornwall are from these archives.

23. Sonia Cornwall, "Workshops at the Onward Ranch," *Sonia Cornwall: Fifty Years at the Onward Ranch*, n.p.

24. Sonia Cornwall, interview by William Matthews, January 28, 2001, audiotape courtesy of William Matthews.

25. Sonia Cornwall, "Workshops at the Onward Ranch," n.p.

26. Ibid. Kujundzic taught Sonia and Dru the technique of raku and ways to smooth their pottery rims and bases. This was important to Dru, who helped found the area's pottery guild.

27. Bill Horne, "In Memory of Zeljko Kujundzic," January 28, 2003, http://www.claireart.ca/zk/zktrib.htm. Claire Kujundzic and Bill Horne operate the Amazing Space Studio & Gallery in Wells, BC. In 1957, Kujundzic published *Torn Canvas: An Autobiography of Zeljko Kujundzic* (Great Britain: Patterson), and during his lifetime he published articles for a variety of arts-related magazines, as well as a children's play. In Kelowna, Kujundzic founded the Art Centre, the Okanagan Summer Arts Festival and, with four other artists, the Contemporary Okanagan Artists group. For a short biography of Kujundzic, see Jessica Demers's exhibition catalogue *Zeljko Kujundzic and the Early Years of the Kootenay School of the Arts* (Nelson, BC: Touchstones Nelson—Museum of Art and History, 2014); see http://www.claireart.ca/zk/zkcv.htm for Kujundzic's curriculum vitae. Information regarding Kujundzic's time in Nelson is from Ann Kujundzic, telephone interviews with the author, September 24, 2013; February 11, 2015.

28. For reasons unknown, Vivien appears in the first row of the "Official 1962 KSA graduation photo" on the back cover of *Zeljko Kujundzic and the Early Years of the Kootenay School of the Arts*.

29. Anna Roberts, telephone interview with author, February 5, 2015. According to Roberts, Vivien phoned one day in 1967 and invited Roberts over while Kujundzic was visiting. Roberts walked across the frozen Williams Lake to the house on the eastern shore that Vivien had purchased after the sale of the Onward. During their discussion, the three decided that people besides those living on the reserve might be interested in pottery. Two workshops were given and soon thereafter, the Cariboo Potters Guild was formed with Roberts as the group's first president.

30. Zeljko Kujundzic also taught lino printing, and images of him and his young Cariboo protégés appeared in the *Williams Lake Tribune* in the issues dated September 2, 1964, and May 1, 1968.

31. Helen Sandy, telephone interview with author, October 31, 2013.

32. Sonia Cornwall, letter to Ellinore Milner, March 14, 1999.

33. Sonia Cornwall, "Workshops at the Onward Ranch," n.p.

34. Robin Skelton, *Herbert Siebner: A Monograph* (Victoria: Sono Nis Press, 1979), 28. The founding members of the Limners were Siebner, Maxwell Bates, Richard Cicimarra, Robert de Castro, Nita Forrest, Elza Mayhew, Myfawny Pavelic, Robin Skelton and Karl Spreitz.

35. Robin Skelton, *The Memoirs of a Literary Blockhead* (Toronto: Macmillan, 1988), 207–209.

36. Herbert Siebner, "Sonia, a natural artist," *Sonia Cornwall: Fifty Years at the Onward Ranch*, n.p.

37. Claudia Cornwall, "Jack Hardman," *The Life and Art of Frank Molnar, Jack Hardman, LeRoy Jensen* (Salt Spring Island, BC: Mother Tongue Publishing, 2009), 79.

38. Sonia Cornwall, "Workshops at the Onward Ranch," n.p.

39. Jack Hardman, letter to Sonia Cornwall, March 24 (no year), Cornwall Family Archive. Excerpts from Jack Hardman's letters to Sonia Cornwall (Cornwall Family Archive) are reproduced courtesy of Dmitri Hardman. Unless otherwise indicated, further references to Hardman's correspondence with Cornwall are from this archive.

40. Clemente, "Chronicle of a Life Lost to Time."

41. Ellinore Milner, interview with author.

42. Dmitri Hardman, email to author, January 31, 2015.

Ranch Vignettes

1. The name of the production is unknown, and the film cannot be located in the National Film Board archives. According to Sonia's daughters, the horse had to be Romany.

2. Information on the films is courtesy of an email from Colin Preston, archivist, CBC Vancouver, August 8, 2013. Although Elkington's films were completed and aired later, according to Sonia (letter to Harriet Zirnhelt, October 19, 1998), he first met the Cornwalls in 1958. Biographical information on Peter Elkington can be accessed through the Canadian Broadcast Museum Foundation.

3. Dorothy Elkington, telephone interviews with author, July 2, 2013; July 19, 2013. Unless otherwise indicated in the text, all further quotes from Dorothy Elkington come from these interviews.

4. Sonia Cornwall, letter to Harriet Zirnhelt, October 19, 1998, courtesy of the Zirnhelt family.

5. Excerpts from Peter Elkington's stories are reprinted courtesy of his heirs. Where necessary for clarity, the author has corrected spelling or

punctuation errors.

6. Sharon Acker, telephone interviews with author, July 9, 2013; August 27, 2013. Unless otherwise indicated in the text, all further quotes from Sharon Acker come from these interviews.
7. Sonia Cornwall, letter to Harriet Zirnhelt, October 19, 1998, Zirnhelt family archive.
8. Dorothy Elkington, telephone call with the author, February 5, 2015.

Anxiously Extending

1. Sonia Cornwall, interview by William Matthews, audiotape.
2. Zirnhelt, interview with author, March 19, 2013.
3. Sonia Cornwall, interview by William Matthews, audiotape.
4. Geraldine Anthony, S.C., *Gwen Pharis Ringwood* (Boston: Twayne Publishers, 1981), 166. Ringwood is described as a "significant voice in the development of drama in Canada" in *The Gwen Pharis Ringwood Papers: An Inventory of the Archive at the University of Calgary Libraries (Canadian Archival Inventory)* (Calgary: University of Calgary Press, 1988).
5. Gwen Pharis Ringwood, excerpt from "The Road," as printed on a Christmas card from the Ringwood family to the Cornwall family, undated; Cornwall Family Archive. The poem was printed in the *Williams Lake Tribune Centennial Issue*, 1967.
6. Pam Mahon, telephone interviews with author in 2013; interview with author, September 2014. Unless otherwise indicated in an endnote, further quotes from Pam Mahon in the text come from these interviews.
7. Hugh Mahon, interview with author, September 17, 2014. Unless otherwise indicated in an endnote, further comments from Hugh Mahon in the text come from this interview.
8. Ellinore Milner, telephone interviews with author, 2012 to 2015. Unless otherwise indicated in an endnote, further quotes from Ellinore Milner in the text come from these interviews.
9. Pirjo Raits, telephone interview with author, November 18, 2013.
10. Aaron Drake, digital copy of article in the *Advocate* (no date or page number), courtesy of Pirjo Raits.
11. Diana French, *Women of Brave Mettle,* 159.
12. Sonia Cornwall, undated letter to Ellinore Milner.
13. Ron Thody, "TRUDEAU HAS 'CARIBOO FEVER' PM swings in cowtown," *Advocate,* August 12, 1970; copy courtesy of the Museum of the Cariboo Chilcotin.
14. Hugh Mahon, interview with author.
15. Sonia's murals are of artistic, cultural and historic importance. In a letter

dated February 13, 2002, Sonia wrote Ellinore Milner that art consultant Anthony Westbridge had assessed one mural to be worth $11,800.

16. Natalie Borkowski, interview with author, August 20, 2012.
17. On page 22 of *To Paint is to Love Again* (Alhambra, California: Cambria Books, 1960), Henry Miller states that he would "sneak" up on his work "and gaze in amazement." Sonia underlined several sections in her copy of Miller's book; copy of that book courtesy of Harvey Chometsky.
18. Sonia Cornwall, unpublished writings.
19. Colin Graham (director of the Art Gallery of Greater Victoria), letter to Sonia Cornwall, December 11, 1963, Cornwall Family Archive; reprinted with the permission of John Graham.
20. There are three letters from the Art Gallery of Greater Victoria's art rental program in the Cornwall Family Archive, dated April 19, 1983, December 6, 1983, and July 11, 1984, and one letter from William Matthews to Barry Ceilson, Burnaby Art Gallery Association, April 1, 2001. Two Rivers Gallery has a letter from Susan Faoro, manager of art rental, Prince George Art Gallery (now called Two Rivers Gallery), July 12, 1985 (copy courtesy of Two Rivers Gallery).
21. Letter to Sonia Cornwall from Ruth (no last name) of the Little Gallery, 512 Fifth Avenue, New Westminster, BC, February 9, 1967, Cornwall Family Archive. Unfortunately, records for the Little Gallery do not appear to be extant.
22. C. E. Holder, letter to Sonia Cornwall, January 9, 1978, Cornwall Family Archive.
23. *British Columbia Art Collection, 1974–1980* (Victoria: BC Ministry of Provincial Secretary and Government Services, 1981). Between April 1974 and December 1980, the government of BC collected seven hundred works of art from 217 creators. They were chosen by regional selection panels. Those works were exhibited nationally and internationally. According to Kris Andersen, MMSt., Arts Culture and BC Arts Council Branch, the works are circulated in BC government offices and are available to public galleries and museums, cultural institutions and public agencies. When not on loan, the art is stored in a secure storage facility. Furthermore, art continues to be collected, but since 1994 funds to do so have been limited.
24. Sonia Cornwall, unpublished writings.

Jones Lake Ranch

1. Anthony Emery, director, Vancouver Art Gallery, *Carrs On Wheels*, "Report," Vancouver Art Gallery, Extensions Department, 1970s, 1. Jim

Shearer was an assistant curator (education), Vancouver Art Gallery, in the summer of 1968.

2. Ibid. E. Theodore "Ted" Lindberg (1931–2008) wrote articles for several art publications including *artscanada, Vanguard* and *Preview of Visual Arts*. Under the name E. Theodore Lindberg, he published exhibition catalogues for artists Alfred Currier, Robert Keziere, Leslie Poole, Rick Ross and Toni Onley. In 1998, Lindberg published *Pnina Granirer: Portrait of an Artist* (Vancouver: Ronsdale Press). Lindberg was the first director of Charles H. Scott Gallery (Emily Carr College of Art and Design) and was there from 1968 to 1986. He served a short term as curator of the Burnaby Art Gallery.

3. E. Theodore Lindberg (assistant curator, extensions), *Art For The Province 70/71* (Report on Extension Services Programmes, 1970–1971), Vancouver Art Gallery, 708.21, V267 Ar 7 PCAT. During that academic year, the travelling exhibitions covered twelve thousand miles and attracted forty-two thousand visitors.

4. Sonia Cornwall, letter to Ellinore Milner, February 20, 2000.

5. Ted Linbdberg, letter to Sonia Cornwall, December 12, 1997, Cornwall Family Archive.

6. The Blue Rider or Der Blaue Reiter (1911–1914) was an organization of artists that included Wassily Kandinsky, Franz Marc and August Macke. Their work was diverse but reflected spirituality and spontaneity in abstract compositions.

7. Ted Linbdberg, "The Interior World of Sonia Cornwall," *Sonia Cornwall: Fifty Years at the Onward Ranch*, n.p.

8. Sonia Cornwall, letter to Harvey Chometsky, June 19, 2001. Ina Lee was born in 1954 and died in 2009. From 1997–2003, she exhibited paintings in Bamfield, Nanaimo and Qualicum Beach, BC; in 2003 she participated in a Victoria College of Art Staff Exhibition; in 2007, she showed work in juried and non-juried group exhibitions in Victoria, BC, and took first prize in that year's Arts Council of Greater Victoria's juried exhibition; she also showed work in To the Lighthouse Gallery and Gifts (Summerside, PEI). Ina had a solo exhibition in September 2007 at the Station House Gallery (Williams Lake, BC) titled *The Jones Lake Ranch Series*.

9. Mary Lee, telephone interview with author, November 11, 2012.

10. Sonia Cornwall, letter to Ellinore Milner, October 22, 1998.

11. Ina Lee, letter to Sonia Cornwall, July 3, 2001, Cornwall Family Archive, used with the permission of Ina Lee's heirs.

12. Ginny Evans, interview with author, November 15, 2012; telephone conversation, January 4, 2014; and email to author, January 5, 2014.

Unless otherwise indicated in an endnote, further quotes from Ginny Evans in the text come from these interviews and this email.

13. Ina Lee, undated letter to Sonia Cornwall, Cornwall Family Archive.
14. Ina Lee, letter to Sonia Cornwall, July 3, 2001.
15. Eileen Truscott, telephone interview with author, July 2, 2013.
16. Eileen Truscott, "Sonia Cornwall," *British Columbia Historical News* 33, no. 4 (Fall 2000): 36.
17. Eileen Truscott, guest curator, "Opening Invitation," *Sonia Cornwall Cariboo Ranch Series* (July 8 to August 27, 2000), Sonia Cornwall Exhibition folder, Kelowna Art Gallery.
18. Eileen Truscott, "Sonia Cornwall," 37.
19. "Pioneering art," *Okanagan Sunday*, July 9, 2000, Sonia Cornwall Exhibition folder, Kelowna Art Gallery.
20. Reprinted with permission from *First Son: Portraits by C.D. Hoy* by Faith Moosang, 108; 150, (Arsenal Pulp Press/Presentation House Gallery, 1999).
21. Lily Hoy and Lona Joe's comments are reproduced with their permission from the Kelowna Art Gallery's "Exhibition Comments," Sonia Cornwall Exhibition folder, Kelowna Art Gallery.
22. Sonia Cornwall, letter to Roslyn McKitrick, Kelowna Art Gallery, July 15, 2000, Sonia Cornwall Exhibition folder, Kelowna Art Gallery.
23. Sonia Cornwall, letter to Ellinore Milner, November 12, 1997.
24. William Matthews, interview with author, July 16, 2014.
25. Jane Shaak, interview with author, October, 26, 2012.
26. Ibid.
27. Susan Lacourciere, telephone interview with author, July 2, 2013.
28. Ibid.
29. Linda Olsen, telephone interview with author, June 22, 2013.
30. Aleta Tiefensee, telephone interview with author, June 24, 2013.
31. Sonia Cornwall, letter to Ellinore Milner, July 13, 1998.
32. Ibid., November 1, 1978.
33. Ibid., January 21, 1996.

A Real Cariboo Couple

1. Pierre St. Pierre, email to author, December 20, 2012. While St. Pierre was a regular visitor, some others were not; for example, Audrey Thomas and her ex-husband, Ian, visited the Jones Lake Ranch once in August 1971. He was teaching art in summer school in the area, and she was conducting a writing workshop for children.
2. Janet Wallace, telephone interview with author, November 10, 2013.

Unless otherwise indicated, further references to Wallace are from this interview.

3. Laura Telford, telephone interview with author, October 25, 2013.

4. Carol and Bob Hilton, telephone interview with author, October 17, 2013. Unless otherwise indicated in an endnote, further recollections from Carol and Bob Hilton in the text come from this interview.

5. Sonia Cornwall, letter to Harvey Chometsky, November 9, 1994, Cornwall Family Archive.

6. Sonia Cornwall, audiotape interview by William Matthews.

7. Stephen Walker, telephone interview with author, November 17, 2013.

8. Hugh Mahon, interview with author.

9. Dennis Evans, telephone interview with author, September 23, 2013. Unless indicated in an endnote, further references to Evans are from this interview.

10. Raits, telephone interview with author.

11. Ibid.

12. Don Redgwell, telephone interview with author, March 6, 2013.

13. David Zirnhelt, telephone interview with author, 2013. Unless indicated in an endnote, further quotes from David Zirnhelt in the text come from this interview.

14. Sonia Cornwall, letter to Ellinore Milner, January 20, 1998.

15. John Miller, telephone interview with author, November 22, 2012.

16. Claire Kujundzic, telephone interview with author, September 24, 2013.

17. Lunn, telephone interview with author.

18. Ibid. Both Corry Lunn and Darrel Nygaard now live in Union Bay, BC, where they run Vancouver Island Studio.

19. John Harris, *Other Art* (Vancouver: New Star Books, 1997), 4; 208. Chometsky is a Powell River–based artist and the author of two books of poetry: *Random Pulse* (Prince George: Repository Press, 1986) and *Speaks a Human Tongue* (Prince George: Repository Press, 1985). On April 7, 2013, he presented "Sacred Matter: Revelations from an Art Heretic," TEDx Powell River.

Painting from the Heart

1. Harvey Chometsky, curator, Prince George Art Gallery, "Hometown Retrospective: Sonia Cornwall Paintings 1929–1992," courtesy of Harvey Chometsky.

2. Chometsky, "Sonia Cornwall Retrospective, March 26 to April 29, 1990," courtesy of Harvey Chometsky.

3. Chometsky, "Hometown Retrospective." Two Rivers Gallery (Prince George) has a listing of the twenty-one works hung in the exhibition.
4. Chometsky, email to author, January 7, 2013; May 24, 2013.
5. Chometsky, telephone interview with author, January 7, 2013; July 15, 2013.
6. Sonia Cornwall, letters to Harvey Chometsky, November 9, 1994; November 11, 1996; October 15, 2005; December 16, 1997; copies courtesy of Harvey Chometsky.
7. Sonia Cornwall, letter to Ellinore Milner, October 11, 2002. With the assistance of Brenn Kapitan, William Matthews set up a website for showcasing and selling Sonia's work, but eventually, he could no longer run the site. No one took over the site.
8. William Matthews, written notes from his visits with Sonia Cornwall, courtesy of William Matthews; interview with author, May 27, 2013. Unless indicated in an endnote, further comments from William Matthews in the text come from these notes and this interview.
9. Sonia Cornwall, letter to William Matthews, September 7, 2000, courtesy of William Matthews.
10. Ibid.
11. William Matthews, copy of letter to Sonia Cornwall dated September 2000. This and further references to Matthews's letters to Sonia Cornwall are courtesy of William Matthews.
12. Sonia Cornwall, letter to William Matthews, September 8, 2000, courtesy of William Matthews.
13. Ibid.
14. Ibid.
15. Matthews, interview with author.
16. Ibid.
17. Anthony Westbridge, interview with author, August 22, 2013.
18. Anthony Westbridge, "Sonia Cornwall—A True Pioneer!" *Sonia Cornwall: Fifty Years at the Onward Ranch*, n.p.
19. Westbridge, interview with author.
20. Westbridge, *Sonia Cornwall: Fifty Years at the Onward Ranch*.
21. Sheryl MacKay, email to author, January 8, 2014.
22. Westbridge, interview with author.
23. Sonia Cornwall, letter to William Matthews, August 22, 2002.
24. Ibid., May 12, 2005.
25. Ibid., May 14, 2005. Matthews is following Sonia's advice in his painting career.

Work Without Parallel

1. Sonia Cornwall, letter to Ellinore Milner, July 15, 1998.
2. Ibid., March 28 (year unknown).
3. Christie (Borkowski) Blackwell, telephone interview with author, November 14, 2012.
4. Natalie Borkowski, interview with author, September 16, 2014.
5. Sonia Cornwall, letter to Ellinore Milner, June 24, 1991.
6. Elizabeth Godley, "Sonia Cornwall's Cariboo," *Beautiful British Columbia* 45, no. 4 (winter 2003): 23.
7. Paul Crawford, "At Home at the Onward: The Legacy of Sonia Cornwall and Vivien Cowan," Penticton Art Gallery, 2009, http://www.pentictonartgallery.com/scms.asp?node=exhibitions&past=1&ex-id=15.
8. Paul Crawford, interview with author, October 25, 2012.
9. Ibid.
10. Julie Fowler, interview with author, October 25, 2012.
11. Roger Boulet, email to author, February 24, 2013.
12. The Honourable Judith Guichon, OBC, interview with author, December 9, 2014. Stewards of the Future uses a holistic approach to develop respect and responsibility for land usage and sustainability. For information on this Government House program, see http://www.ltgov.bc.ca/lg/priority-programs/stewards/default.html.
13. Harry Marriott, *Cariboo Cowboy* (Sidney, BC: Gray's Publishing Ltd., 1966); Greg Miller, *Ranching, Living with the Land* (New Perspectives Video, 2002), copy courtesy of the Cornwall Family Archive; Diana French, "Vivien Cowan and Sonia Cornwall," *Women of Brave Mettle: More Stories from the Cariboo Chilcotin* (Halfmoon Bay, BC: Caitlin Press, 2012), 155–160.
14. Bruce Fraser, *On Potato Mountain: A Chilcotin Mystery* (Vancouver: Granville Island Publishing, 2010), 86. Sonia Cornwall is also mentioned in Fraser's second novel *The Jade Frog,* Vancouver: Granville Island Publishing, 2015.

Conclusion

1. Sonia Cornwall, letter to Ellinore Milner, March 20, 1976.
2. David Zirnhelt, "Sonia (Cowan) Cornwall: Artist, Rancher, Citizen, Homemaker, 1919–2006," dedication for Art Walk Program, Williams Lake, circa 2007–2008, copy courtesy of David Zirnhelt.
3. Henry Miller, *To Paint is to Love Again,* 17.

About the Author

PHOTO KIRK SALLOUM

SHERYL SALLOUM was born and raised in British Columbia, and for ten years called the Cariboo home. She is a graduate of Simon Fraser University and taught in the public school and college systems. A freelance writer for over twenty-five years, she has published articles in several Canadian magazines and newspapers. She is the author of three books, including *The Life and Art of Mildred Valley Thornton* (Mother Tongue, 2011), *Underlying Vibrations: The Photography and Life of John Vanderpant* (Horsdal & Schubart, 1995) and *Malcolm Lowry: Vancouver Days* (Harbour Publishing, 1987). She has been a finalist for two BC Book Prizes: the Hubert Evans Non-Fiction Prize and the Roderick Haig-Brown Regional Prize.